*Making a Living
as an Artist*

Making a Living as an Artist

The Editors of *Art Calendar*

THE LYONS PRESS

Designed by Desktop Miracles, Inc., Dallas, Texas

Printed in the United States of America

10 9 8 7 6 5 4 3 2 1

Library of Congress Cataloging-in-Publication Data

Making a living as an artist / by the editors of Art Calendar.
 p. cm. (An Art Calendar guide)
 Updated ed. of: The Art Calendar guide to making a living as an artist. c1993.
 ISBN 1-55821-729-0
 1. Art—United States—Marketing. 2. Insurance, Art—United States. 3. Art—United States—Management. I. Art Calendar (Upper Fairmount, Md.) II. Art Calendar guide to making a living as an artist. III. Series.
N8600.M34 1998
706'.8'8—dc21 98–10803
 CIP

Dedicated to artists and writers everywhere.
Special thanks to the folks who contributed
to this book.

Table of Contents

Table of Contents

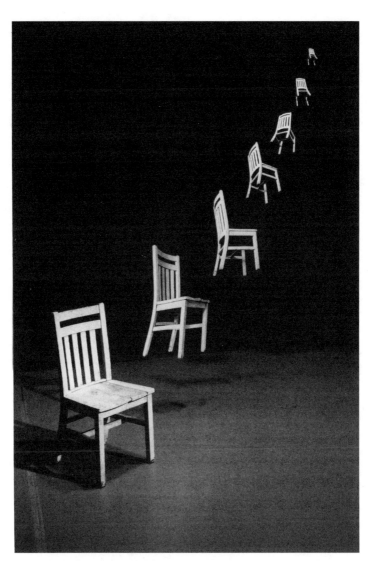

Escaping Chair, 1990, Photographic sculpture, David Joyce, Eugene, Oregon

Foreword

Artists learn to translate what they see or imagine into two- or three-dimensional images called art. That "learning" experience can either be formal training at an art school or on-the-job experience while they are actually creating art. The one thing artists are not taught is how to turn their art into a livelihood. *Making a Living as an Artist* is a response. The most often asked questions from artists seeking successful careers in the arts are answered out of the experience of the editors and writers for *Art Calendar*. The magazine was created on a kitchen table in 1986 primarily as a listing of marketing opportunities for artists in the Washington, D.C. and suburban Virginia and Maryland areas. The geographic scope was so limited in the first issue that the title of the twelve-page publication was *Art Calendar/DC*. By the third issue, artists were sending calls for entry and other opportunities from California and New York so the "DC" was dropped and the publication became national. As it grew, articles on marketing art and managing a career in the arts were added. In time, regular features such as "Art Law," "Marketing Strategies," "The Psychology of Creativity," and "Perspective" were added. Advocacy for artists' rights and early warning about questionable "opportunities" in the arts were added in "Editor's Notes," and "Rip-Off Alerts," which later became "Art Scuttlebutt." In 1997, I purchased *Art Calendar* from its founders, Drew Steis and Carolyn Blakeslee, and made a number of changes, adding color, new departments, products, and services. But I kept the old *Art Calendar* commitment to helping artists help their art careers.

The first *Making a Living as an Artist* was published in 1992 in response to frequent requests for reprints of articles from the first five years of *Art Calendar* issues. It has held up remarkably well. This updated edition retains the layout, content, and flavor of the first edition. Articles that had become outdated were deleted, and contact names, addresses and telephone numbers have been verified. When appropriate, "Editor's Notes" have been added at the end of some articles to give pertinent information.

As art is not static, neither is art marketing. *Making a Living as an Artist* is being used as a teaching text in many college art courses. We at *Art Calendar* are confident that this updated edition will be valuable to all artists who sincerely want to make a living from their art.

— Barb Dougherty
Publisher, *Art Calendar*

Industry Standards

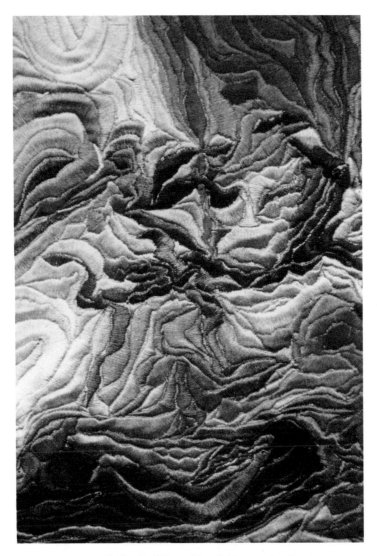

Bungy Attitude (detail), 1991, machine stitching on painted canvas,
26" x 19", B. J. Adams, Washington, DC

An Art Career

Overcoming Myths About Being an Artist

Carolyn Blakeslee

The more I learn about building a career as an artist, the more convinced I am that the artist's own strong psychological makeup is the most important factor of all in successful marketing. Artists live inside an invisible web of myths and mystiques. Mystique, as distinguished from myth, can be positive and can actually help an artist. However, most of the myths are pretty destructive and are largely subconscious but terribly influential. This article pinpoints some of the most harmful myths and hopefully will help you learn to defeat them in your own mind.

Myth: Artists must be "discovered." (By someone else.)

How can you be discovered if nobody knows you and your work exist? Even if an "important" collector buys your work, s/he isn't going to support you, and s/he isn't going to act as your representative. An art career is built with foundations made of bricks like any other career. Each sale, award, show experience, contact, etc., is a brick. But it's pretty much up to you, the artist, to plan where the bricks are going to go, and to do what you need to do to obtain your bricks. *You* are the architect, not someone else.

Myth: It's not what you do or how well you do it, but who you know.

It might help to know who the players are, and it might help when they know who you are. But each of us starts out as a baby, and each has to pave his/her own path through life. Everybody makes contacts of one kind or another. If you have integrity it comes across; if your work has validity, then with the right balance of blowing your own horn the "right people" for you—your

personal bricks—will be walking along with you on your path and you'll suddenly realize you've become the "right people" together.

Myth: Artists must compromise their ideals in order to be successful.

Many artists wonder if they have to do work that is "more commercial" in order to make it. "Should I change what I am doing, in order to sell more?" If the change is something you *want* to do, then sure, why not? But if the change is something that makes your face go funny when you think about it, then probably not.

I have found that I am happiest being around people who are excited by what I am doing, by what I want to do, and by what I believe in; for the most part I have stopped trying to win the attention and approval of those who are negative. There are all kinds of permutations of "negative." For example, there are people who will be "brutally honest" with you, telling you ways you can "improve," while claiming to be on your side.

Nobody can please everybody, so please yourself first and there *will* be others who will be interested and supportive. I suggest actually making a point of hanging out with the supportive folks. "Supportive" doesn't mean always gushing with awe over your work, it means *respecting* who you are, and recognizing your work as a reflection thereof.

Myth: The art world is filthy, so why bother?

Some dealers, some print distributors, some show sponsors might be bad. But not everyone is. Just exercise reasonable caution and good business practices. Check the background of any gallery to which you are thinking of applying: call the Better Business Bureau, find out how long they've been in business, call people you know who are familiar with the gallery and ask what they think of it, ask other artists affiliated with the gallery if they are satisfied. Have your lawyer go over any contract which is offered, or present a contract of your own which you and your lawyer feel confident about.

Myth: Artists have to suffer and be poor in order to produce quality work.

OK, I admit it, I've done some really good work when I've been terribly upset. But most of the good work I do gets done when I am in a peaceful state of mind; peace has its own intensity. Also, poor artists usually buy poor materials,

and it shows. Money can't buy freedom or happiness or peace of mind, but it can take the pressure off. If the pressure is off, pretty soon you might get the feeling that you *do* have freedom, peace of mind, or even happiness. With care and frugality money can literally be made, and making money usually brings self-confidence and a myriad of other positive feelings.

Myth: Artists are by nature poor businesspeople.

While people can earn the title of "Master of Business Administration," unfortunately "Master of the Business of Art" is not the title of an earnable degree. However, even degreed businesspeople learn the *real* meat of their professions on the job, the same way artists do. The basics of business can be learned fairly easily while actually taking care of the business. The principles include planning, implementation, record-keeping, and regular evaluation of results and appropriate readjustment if necessary. Art is like any other small business. You can't stop after you have bought art supplies: that would be like a CPA stopping after buying pencils and ledgers. What self-promotion can you do this week? Are there follow-up calls to be made? An opening to attend? Slides to send out? Business courses which might be helpful? Sure, all these activities cost money, but with vision, money spent generates returns.

Myth: The business end of doing art is not fun.

Taking care of business can accomplish several things for you. (1) You take a break from the immersion in your artwork, and balance your mind with a different kind of thinking. (2) You will get to know new people. That's all "networks" and "contacts" are—people. (3) The business end is like a frame around your whole body of work, even like an artwork in itself. You can watch this separate-yet-connected creation grow and change, and enjoy its development along with the development of your artwork. Even if only one out of every 100 packets you send out generates a positive response, all you need are a few of them a year to find yourself making a decent living. The "one out of 100" then becomes the fun, rather than the ninety-nine rejections being so awful.

Myth: Artists don't really get recognition until they die.

Translated, this statement means "*I* don't believe *I* will earn recognition or money until I die." Further translated, it means "I believe I will *never* get

recognition." What it really means is, "I don't *want* recognition." If you hear yourself thinking or saying this, realize that you have just rolled over and played dead, and that everyone who hears you say this will believe you, and so you *won't* get any recognition. Recognition during one's lifetime is much more fun than playing dead, but it is more risky and it takes planning.

Myths, demons, nasty little voices. They are legion. There are a dozen more little myths demanding equal time, screaming in high-pitched voices as I write. Do you wear an emotional bumper sticker that says "I'd rather be Rembrandt?" or a filmmaker?

Resisting negativity, whether it comes from within yourself or from others, is a necessary life process if you are going to "succeed." *Your* unique talent is built into the miracle of your own unique being and it emerges with practice, life experience, and time. It is *your* talent, unique and precious, and only you can mine it and discover its depths.

I like Thomas Wolfe's definition of success. He said, if a person "has a talent and learns somehow to use the whole of it, he has gloriously succeeded, and won a satisfaction and a triumph few men ever know."

Is Contemporary Art Temporary?

René Joseph

In November 1988, Hilton Brown, artist and Professor of Art at the University of Delaware, gave a workshop on Materials and Techniques at the University of Minnesota. His information has been gathered from years of talking to conservators. Following is a synopsis of his workshop.

Horror stories are unfolding in art collections. Mutilation of artwork from within is taking place—in slow motion or before our eyes. Colors fade or darken, sometimes chemically mutating so dramatically that the color completely changes. Paper deteriorates until the work upon it is lost. Paint flakes or crumbles into dust. Pasted materials fall off.

From a long list of artwork having—or expected to have—extreme fading and other worse-than-average conservation problems, most examples are contemporary. Most modern museums house examples: works by Held, Dine, Oldenburg, Kelly, and so on. Brown believes that part of the twentieth century aesthetic is to ignore time-tested techniques. Joseph Beuys, for example,

embraced the idea that nothing in life is stable so no one should expect stability of his art. According to Brown, this attitude is common now. It is also commonplace for artists to use "found" or everyday objects and experimental techniques.

Upon seeing a Newman painting in a European museum recently and not understanding how this relatively old modern art piece could look so freshly painted, Brown asked about it, to be told that it was a new "reconstruction." The original painting was in storage, unable to be exhibited due to its condition.

Is this going to be the norm? The idea that one collects but does not look at original art in an attempt to conserve it? A Chicago museum's just-finished state-of-the-art storage facility will house some modern work in low-illuminated rooms with freezing temperatures, because polymers are proving to be just as light-sensitive as photographs. Too late for an Eva Hesse artwork destroyed by gases due to the oxidation of its latex materials, which crumbled into dust. Restoration procedures are unknown; the piece's self-destruction was simply documented, and the piece was discarded.

Harvard's famous Rothko murals are no longer on display. Some of the paintings shifted in color so dramatically that the original reds turned into blue. What people now see is not what Rothko made.

Brown told of an artist whose thick paintings weighed around three hundred pounds. Canvas stressed in this way cannot support a work for long. Before purchasing one of his paintings, a Canadian museum insisted that conservation begin immediately at the artist's expense.

Brown feels that museums will take this approach more frequently as awareness grows. Art does not come with spare parts to replace those that wear out. Conservators face the decision of whether to focus their money, time, and expertise to fix a piece or to wait for the ultimate disintegration built into it. A restoration of a large painting can cost a museum $25,000.

Obviously even artworks made with "permanent" materials must be taken care of and conserved. Bronze gets "bronze disease"; oil paintings must be painstakingly cleaned and renewed. Conservation must be done regularly over the life of any work. But the question is how often and how radically. With the current climate of acceptance of industrial and everyday—even disposable—materials, artists might have to reconsider using acquired materials, unstable surfaces, and untested techniques. Warning artists of the implications,

Professor Brown said that curators' acquisition decisions might be influenced by projections of conservation expenses.

Travelling and repeated installations and take-downs are hard on art too, even if the art has been executed with archival attention. Artwork is not immune to the ravages of handling even in museum environments. A worker at the Walker Art Center knows of Jackson Pollock paintings which were forced into warped travelling exhibition cases with a hammer.

Some Specifics on Preventing Eventual Deterioration

Paintings done in the 1960s are problematic because of oil painted over acrylic gesso. Contrary to claims by the manufacturers, there is documented evidence showing deterioration after 25 years.

In colder climates, any paint—but especially acrylic paint—is subject to freeze/thaw cycles unless care is taken with moving and temperature control. Alcohol is used in acrylic paints as an antifreeze-type stabilizer, but at 10 below 0°F, it is ineffective.

In high quality paper there is still deterioration, but the artist can at least slow down the process. Papers of neutral pH ("acid free") don't have the built-in destruction wood pulp papers have, but if brighteners and whiteners have been added to the paper they can have a fluorescent effect, heat up the paper, and contribute to its destruction.

According to Professor Brown, uncovered paper rapidly disintegrates and darkens, even if it is of the highest quality. Brown recommends coating paper on both sides with titanium oxide or "any kind of acrylic emulsion." This will preserve the whiteness while allowing workover with oil pastel. For the picture's health, he prefers acrylic emulsions as an adhesive because they are the least acidic.

Compatibility of surface, preparation, and medium is important in choosing materials. For example, the problem with rabbit skin glue gesso used on paper is that the glue contains acids; it is rigid and brittle when dry, and subject to mold and contamination. But it is good on solid panels or museum board.

Many fixatives contain hydrocarbons which make the resins soluble. Brown pointed out that these fixatives are not good for one's lungs, and one must wonder whether they hurt the paper as well. Water-based fixatives have their own problems, causing paper to buckle out of flatness. He recommends the use of casein fixatives on 300-pound paper to avoid the buckling effect.

Brown advises artists using colored paper to get documentation from the manufacturer on pigment stability. Also, the artist should test it by masking part of it with a metal strip and exposing it to the sun for several weeks. In fact, he recommends testing *all* materials for colorfastness instead of relying on what the manufacturer says.

Brown showed several samples of pigmented media he tested in 1982. It was shocking to see the evaporation of color that had occurred, in some cases, in less than four days. All Winsor & Newton inks deteriorated in four months and he said they should not be used. Pelikan inks faded too, proving not to be made of stable carbon as many artists assume. Speedball watercolors were the most lightfast. Significantly, he found colored pencils to be the most unstable material of all. In the oil paint department, he found Liquitex and Winsor & Newton to be equal although the latter sometimes is more expensive. One interesting and consistent finding was that colors of long wavelength, such as pinks, are less stable than colors of short wavelength.

He stressed the importance of doing such experiments continually and not relying on his 1982 results, because the ingredients do change.

Brown also recommends using only those art products with the A.S.T.M. (American Society for Testing and Materials) insignia. If a tube of paint is marked A.S.T.M., the artist at least knows that it conforms to national standards on light-fastness, binding, adulterants, and oxidation rates. A.S.T.M. defines "archival" as lasting 100 years. However, the A.S.T.M. labelling will only appear on relatively new tubes of paint; some rare and expensive colors do not sell frequently, and they might or might not be old tubes. The only way to tell the age of a paint is to note the batch number crimped on the tube and write to the manufacturer. In the case of acrylic paints, Brown has found that the shelf life is no more than five years.

Brown cautions against the use of too much turpentine. Turpentine turns yellow when exposed to ultraviolet. He recommends mineral spirits universally—one can both paint with it and clean one's brushes. A mixture of turpentine and lead is also archival, although the artist must be careful in handling both materials. He said that the basic principles found in Ralph Mayer's *The Artist's Handbook of Materials and Techniques* are advisable.

Painters must be careful to use sound, straight, unwarped wood canvas supports sealed with varnish. It is also crucial to match the wood size to the canvas dimensions—a larger painting requires wider lumber. Although pre-cut

stretchers in wider sizes might not be quite so easy to find, the relatively flimsy pre-cut canvas stretchers on the market today warp easily, especially when used in paintings larger than 2 feet. For oil paintings on panels, pine or mahogany supports can be used without ground if the artist likes the color of the wood—it can be sealed with linseed oil. Heavy work is more susceptible to damage, so for larger pieces a product composed of two pieces of hardboard with a resin-impregnated honeycomb core is useful because of its lighter weight. Brown addressed the "mythology" that linen is better than cotton. In spite of somewhat different expansion/contraction factors, cotton can be used successfully if it is well prepared. But it is always best to prepare and gesso the canvas or linen yourself.

Brown feels that cheap materials should never be used for serious art. "If you are using cheap materials, then you are saying this is throw-away art." Citing Dürer's letters, where money was requested for expensive but superior pigments, he sees the history of art as one of pre-preservation by the knowledge-able artist.

On the other hand, Brown admitted understanding why artists might not feel that using archival materials is important. For one thing, some artists have limited financial resources. Also, it could be a too-narrow definition of professionalism—for example, Picasso used sparklers for drawing in the air, "works" which were instantly created and are now known only through photos. For that matter, some collectors do not seem to care whether an artwork outlives them or not.

Still, would you buy art supplies if the label acknowledged the pigment would fade in four days, or the paint would crack in two years? If you are making art which is not by its nature temporary and ephemeral, then study, research, and experimentation are in order.

You Be the Judge
Dorothy Roatz Myers

Don't lose heart if "they" don't like your art.

Being rejected can be disappointing or even devastating to an artist. But as frustrating as rejection is, artists should consider several points before getting too discouraged.

Although the art world has changed dramatically in recent years, it still recognizes skill and talent. Every artist misses the mark sometimes—not everything can be acceptable. But if a work is reflective of an acute eye, an honest and searching mind, and an underlying talent, it is almost certainly worthy of being classified as "good."

When preparing to enter a juried show, read the prospectus carefully. If your work doesn't fit the specifications, it will be rejected, regardless of how good it is. Read between the lines. Who is on the jury? Academicians may prefer traditional styles; impressionists will probably prefer impressionism.

Following are ten questions to ask about the work itself that put you in the position of judging your own work as impartially as possible.

1. Does this piece of work express an idea or a feeling? Does it say something? Or is it primarily a study, an exercise in solving a problem?

2. Is the work done appropriately? Or is it overdrawn? Do the shapes appear to have been drawn and filled in? If it is a painting, is it "painterly," or is there a paint-by-number appearance? Is the paint too thinly applied? Is there otherwise an amateurish look about the artwork?

3. Is anything out of proportion? Out of key? Unintentionally exaggerated?

4. Is the perspective correct in every respect: Linearly? Atmospherically? And with regard to color and tone?

5. Is the composition appropriate? Or is it cluttered, crowded, too monotonous, too busy? Is there a focal point, a place for the eye to rest? Is there a feeling of balance and a rhythm throughout?

6. Is the picture split in half in any respect? Is anything "sitting on," "growing out of," or "cutting off" something else? Are there any parallels better avoided? Do any contours emerge? Does the horizon or another horizontal "drop off," sag, appear weak, "slip by," or move too fast? Is there a disconcerting "bull's eye" anywhere?

7. How is the color? Is it muddy, chalky, sooty, milky, woolly? Is there a fatty "bloom" over the picture surface? Are brilliant colors jarring or gaudy, visually noisy and disturbing? Do the colors work?

8. Has consideration been given to color harmonies, values, contrasts, and dominants?

9. Are shadows warm and luminous with reflected lights, or are they dead?

10. Is this piece of art in good condition? Clean and immaculate? How about the matting and framing or other presentation? Will it say that it was created by a professional artist, one who is proud of it and its presentation?

The following is a checklist you can use to judge your own artwork.

EVALUATIONS	Excellent	Just OK	Not Good
1. Subject Matter			
2. Technique			
3. Proportion			
4. Perspective			
5. Composition			
6. Errors			
7. Color quality			
8. Color harmony, values			
9. Shadows and reflected lights			
10. Condition			

OPINION: Finished_____ Needs work_____ Scrap it_____

After you have finished evaluating the work itself, you must then look at the slides. Many jurors, faced with the knowledge that they must choose just a few pieces from hundreds of entries, sit through the slide show and reject some pieces very quickly, reserving perhaps half for a closer look on later go-rounds. Richard Andrews, former director of the Visual Arts Program at the National Endowment for the Arts, said in 1985 that on the average at least half of the applicants for the Artist Fellowships are rejected immediately because of poor slide quality. Out-of-focus images, poor color, and interfering background matter—the easel, or the grass and trees in the front lawn—are the usual culprits. So, when entering a show or any other competition which will be judged from slides, make sure your slides are excellent.

View the slides yourself, projected, before sending them to anyone. Slides may look fine on a light table, but faults such as spots, poor color saturation, glare due to improper placement of lights during the photo shoot, sloppy masking, etc., will show up when your slide is projected and enlarged a hundred or so times.

After evaluating your work and your slides, when entering the show, follow the directions explicitly. While many deadlines are actually flexible, don't take the chance if you don't have to—be on time. Send in the proper materials, including the filled-out application form, and a SASE for the return of your slides.

Do not give up if your work has not yet been accepted. It makes no real difference if your work is rejected. Rejection is not a valid evaluation: it represents only one opinion. Cezanne, Degas, Van Gogh, and all of the other greatest painters and sculptors of all time were rejected on some (or all!) occasions.

For a copy of Ms. Myers' self-judging brochure, from which this article was adapted, send a SASE and 50¢ to Dorothy Roatz Myers, P.O. Box 204, FDR Station, New York, NY 10150.

Pricing and Contracts

Pricing Work: It's All a State of Mind
Caroll Michels

Marsha is in her forties and has had a successful career as a real estate agent, but she plans to leave her job to paint full-time. She arranged to have a weekend exhibition at a suburban library located in a community where she has many friends. In one afternoon she sold $18,000 worth of work. The highest priced painting sold for $6,000. Prior to the weekend, she had never had an exhibition.

Katherine is also in her forties, but has worked full-time as an artist for more than 20 years. She has been included in three exhibitions at the Whitney Museum of American Art, and is represented by galleries on the east and west coasts. She has been the recipient of two fellowships from the National Endowment for the Arts as well as grants from state agencies and private foundations. She has been published and reviewed in American and international arts magazines. Her paintings range in price from $5,000 to $7,500.

Why is an artist new to the art world and without art world recognition able to sell her work in the same price range as an established artist whose six-page resumé is filled with glitzy credentials?

Marsha brings to her new career the philosophy and concerns she learned in the business world. She recognizes the value of her time and she values her talent. Her goals are clear-cut: to derive a decent income from doing what she likes to do. It is inconsequential to her whether her work finds a home on the walls of a museum or over a friend's living room couch. Unlike Katherine, she is naive to the criteria used by the art world in pricing work. In this case, ignorance is bliss.

Setting a price on work can be a grueling task. Most artists tend to undervalue their work, believing their careers haven't "measured up" to whatever self-imposed standards they believe are necessary to justify charging higher prices.

This tendency is reinforced by galleries whose pricing agenda is rarely in an artist's best interests.

A dealer's primary concern is to move work quickly, and unfortunately, low prices are often correlated with making a fast buck. Exceptions to the fast buck policy are pricing policies exercised by "blue chip" galleries. However, because there exist far fewer blue chip galleries than non-blue chip galleries, this article will concentrate on the majority of galleries, whose pricing policies basically reflect the amount of money they think their constituencies will spend on art.

Few dealers understand that they could sell more work, and at higher prices, if they took the time to help the public understand an artist's vision and the multi-layered process and rigorous discipline involved in creating visual art-from conceptualization to actualization. Many dealers act as if "art appreciation" is reserved for history books.

Most dealers' pricing range is based on past performance, and few will admit that they are vying for a particular market. Consciously or subconsciously, they camouflage the fast buck policy—the adherence to the status quo—and undermine an artist's career by stating or implying that s/he does not have the "right" credentials to justify selling work at a higher price. And more often than not, artists acquiesce with the erroneous belief that dealers know best.

Setting a price on artwork necessitates homework. Three factors need to be addressed and integrated:

1. Pragmatic pricing, understanding how much it is really costing you to create a work of art.
2. Market value considerations.
3. Confidence in the price you set. Self-confidence is paramount to being able to stick to your guns or negotiate with strength to get what you want.

Pragmatic pricing can be achieved with careful record keeping: keep tabs on the amount of time spent creating work, including conceptualization, development, and the length of anxiety attacks during the working process. Pragmatic pricing also must include the costs of overhead and materials, pro-rated accordingly.

After determining a general time range, assign an hourly or weekly value. In many instances, after going through the exercise of determining time, overhead,

and materials, and comparing the net proceeds from a sale, many artists discover they are working for a dollar an hour—or even less.

Be sure that the price set for your work includes a 100 percent reimbursement of labor, overhead, and materials expenses, *in addition to* any obligatory sales commission. In other words, a commission should not be paid on labor, overhead, and materials. For example, if labor, overhead, and materials total $1,000, and the work is sold at $2,000 without a dealer, you have been reimbursed 100 percent, and you have made an additional profit of $1,000—actual profit is a concept unfamiliar to many artists. However, if the work is sold through a dealer who charges a 50 percent commission, your additional profit is zero. But if your labor, overhead, and materials costs are $1,500, and the work is priced at $2,000 and sold through the same dealer, you have actually lost $500. A rule of thumb is to set a price that builds in a sales commission *and* a profit margin (This is your career "safety valve" to make up for the times when few or none of your works are selling), whether you sell through a dealer or not. The amount of profit is a personal decision.

If fabrication costs are high—for example, foundry fees—these costs must be figured into the price of an artwork *before* a dealer's commission is calculated and added. By the way, this "understanding" should not be left to a verbal agreement; it should be stated in a written contract. Ditto for discounts to the trade and any other potential price adjustments.

A market value—which might seem elusive to the artist who is just beginning to think this firmly about pricing—can be determined by visiting many (not just a few) galleries. Find work that is allied to your own, look at prices and the artists' resumés, and compare their career levels to your own. But keep in mind that other artists' price ranges should serve only as guidelines, not gospel, because many artists make the mistake of letting dealers determine the value of their work.

Knowing the amount of labor, materials, and overhead spent on creating work, and familiarization with market values, can help build confidence for establishing prices. Of course the process of gaining self-confidence is quickly accelerated when work is sold at the price you want.

Now for presenting price lists to dealers. *Always* use the retail price, and make sure the word "retail" appears on your price sheet. The danger in stating the wholesale price, or artist's net price, is that it encourages unethical business practices. For example, a temptable dealer might think, "the artist is happy with

$2,000. I'll charge $6,000. S/he won't know the difference." When establishing a retail price, assume the dealer will take a 50 percent commission. Do not adjust the retail price if a dealer's commission is lower. (Your prices must be universally consistent, whether your work is sold in Vienna, Virginia or Vienna, Austria. Otherwise *you* are doing business unfairly—if someone buying your work in the Midwest pays less than someone buying your work in New York, then you are actually penalizing your New York market.) On the other hand, if the dealer's commission is actually higher, only you can decide whether you can afford to do business with him/her.

Happy sales.

Advantages of Written Contracts

Peter H. Karlen, Attorney-at-Law

A man's word is no longer his bond, and the "handshake" agreement is the subject of scorn, not praise.

Written agreements are now recommended for artists, dealers, and collectors because, even though oral agreements are usually binding, the other party often denies their existence, claims that original terms have been changed, or otherwise tries to squirm out of contractual obligations. Or, conversely, the other party tries to stick you with an imaginary oral agreement. In short, the oral agreement is the cheapskate's paradise, or rather the fool's or thief's paradise.

We discuss here two principal advantages of written agreements from both "offensive" and "defensive" perspectives. First, written agreements are more enforceable; second, "getting it in writing" prevents claims based on bogus oral agreements.

Statute of Frauds

Legislation throughout the U.S. (usually called the "statute of frauds") ensures that particular contracts will be binding only if put in writing and signed by the party to be bound thereby. Such contracts include those which by their own terms are not to be performed within one year from the making thereof; promises to answer for the debts of another person; agreements for leasing real property for a period of more than one year (or other time period) or for purchasing real property or any interest therein; agreements which by

their terms are not to be performed during the promissors' lifetime; promises to lend money in more than specified amounts (e.g. $100,000); and sales of goods over certain specified amounts (e.g. $500).

In other words, oral agreements to do these things are invalid. However, the written agreement does not have to be a formal one; a note, memorandum, letter, or other informal writing will suffice.

Some art-related contracts possibly subject to the statute of frauds are agreements for dealers to represent artists for more than one year, since this involves a contract whose performance couldn't be completed within a year from the making of the agreement. Another such contract could be one permitting a dealer to represent an artist's estate after the artist's death. Also, a dealer cannot rely on an oral promise from a third party to guarantee the purchase price of an art object if the buyer defaults.

Thus, anyone dealing with contracts involving long performance periods should be concerned about the statute of frauds. The same is true with any agreements to be performed after the death of one of the parties.

The Copyright Act

The Copyright Act has its own statute of frauds at Section 204 which says that copyright transfers must be in writing. To be valid, all outright sales of copyrights and copyright interests, including grants of exclusive licenses under a copyright, must be in writing. The most that one can grant orally is a *nonexclusive* license. Thus, unless a work is created within the scope of employment on behalf of an employer, the artist will own the copyright in his/her work notwithstanding any contrary oral agreements. That is, without a written transfer or written work-for-hire agreement, the owner of a copyright cannot lose any part of the copyright unless s/he creates the work within the scope of employment, in which case the employer owns the copyright automatically.

One interesting effect of the Copyright Act is on artist/dealer contracts. We must remember that a copyright includes the exclusive rights to reproduce, adapt, publicly distribute copies of, publicly perform, and publicly display a work. Dealers who take exclusive rights to sell an artist's works are essentially taking an *exclusive* license to publicly distribute copies of the artist's works, which, of course, requires a written agreement. Arguably all artist/dealer exclusive contracts must be in writing to be enforceable, although

the exclusive right to act merely as an agent, without the exclusive right to sell, may possibly be created by oral agreement.

Commercial Code

The Uniform Commercial Code as adopted in various states sometimes requires that sales agreements involving amounts greater than certain specified amounts (e.g., $500) be memorialized in writing. This means that some oral sales agreements for artworks over the specified amounts might not be enforceable.

Moral Rights

Another "statute of frauds" provision relates to moral rights. In order for an artist to waive moral rights, including rights to receive or disclaim credit and rights to prevent mutilation or destruction of a work of art, many state statutes and the federal law require a writing. This is a very important protection for artists, and an important concern to art buyers wishing to acquire works free of moral rights.

Conveyance of Physical Artwork

California has an interesting statute (Civil Code Section 988) which says that, even when an artist grants a copyright or other rights under a copyright to a client, rights to the physical art object do not go to the client without a written agreement to that effect. The statute primarily benefits commercial artists and photographers who grant reproduction rights without losing their physical artwork. However, the fine artist commissioned to create a work for commercial reproduction may also use this statute.

The Freedom Not to Contract

Getting it in writing also prevents claims based on bogus oral agreements. The way to avoid these frivolous claims is to insist that all agreements be in writing, so you can create your own *private* statute of frauds.

There are two well-known rules of contract. One is that whenever the parties have orally agreed to all principal terms and conditions of the contract, and have agreed to memorialize the same in writing, the oral agreement is binding even if the written instrument is never executed. The other rule is that if there is an understanding or intention that no agreement will arise until put in writing, then all oral negotiations and understandings will not yield a binding agreement.

If you want to prevent being bound or to avoid false claims based on imaginary oral agreements, you must do more than agree to memorialize your understandings in writing. Whenever you finish oral negotiations and reach an oral understanding, you will not prevent an agreement from coming into effect merely by insisting that it be memorialized in writing. The best protection is a preliminary written agreement that no understandings will be binding unless in writing and signed by the party to be bound thereby. If you can't get the other party to sign this preliminary agreement, then at least communicate *in writing* your intention not to be bound by any oral understanding and to be bound *only* by written agreement. This approach usually enables you to avoid obligations until you sign on the dotted line. But you must carefully document in writing your intention not to be bound and ensure that the other party receives copies of the writings. Moreover, any writings preliminary to the final written agreement should contain a reminder that you will not be bound until a final agreement is put into writing.

Conclusion

Written contracts allow you to enforce your rights and avoid claims based on bogus oral understandings. To paraphrase Robert Frost, good contracts, particularly written contracts, make good commercial relationships since the parties can always refer to a document confirming their understanding. However, a bad written contract, etched in stone, can be your undoing. Once you sign a written contract, particularly one binding you to purchasing expensive art or granting exclusive rights, it is difficult to escape. Therefore, written agreements require more work and transaction costs, but whatever you spend on attorneys' fees to protect your rights is the best legal expenditure you can make since it reduces the chances of a dispute and the chances of getting involved in litigation, a process too long, too time-consuming, and too painful.

How to Negotiate Contracts
Peter H. Karlen, Attorney-at-Law

The following advice represents the distillation of years of experience in negotiating contracts for artists, collectors, arts administrators, and other people involved in the arts. Probably any experienced attorney would tell you many of the same things, perhaps in a different way, but the essence would be the same.

Background Investigation

You cannot negotiate until you know what you are negotiating about. Usually contracts come about when people know approximately what they want and are willing to agree to certain terms. However, just because you know some of the essential items of an agreement, such as price, delivery dates, and subject matter of the contract, doesn't mean that you are prepared to write a contract. If the contract is important in terms of money, prestige, reputation, or career, you should be prepared to investigate all of the issues that could come into play. After all, a contract represents an agreement between the parties as to various factors that affect their transaction. With transactions becoming ever more complex, you will find that even the simplest arrangement involves ramifications in many different areas—for instance, sales taxes, income taxes, copyrights, moral rights, resale royalties, repairs, insurance, warranties, indemnification, enforcement, theft and loss, in addition to the more commonplace considerations.

In order to determine all of the considerations, you will have to make your own list culled from sample contracts and checklists. Your attorney can help you in determining these considerations, or you can go to books that have sample contracts. Obviously, you should look at the most comprehensive contracts to learn about every possible consideration involved. Once you determine all of the possible considerations, you have to narrow them down to those which realistically affect your transaction. Having determined these considerations, you will have to decide what you want with respect to each consideration. For instance, if you want warranties or insurance, you will have to determine what warranties and what types of insurance are desirable.

Having completed your compilation of contract considerations and having written your "wish list" for each of these considerations, you must then determine what the other party wants with respect to each of the considerations and whether s/he has other considerations in mind. Once everyone has compiled all the considerations and wish lists, you are ready to negotiate in earnest.

Negotiations and Drafting

It is best to talk about these things first rather than begin by putting them in writing. This saves time, because if one party drafts a proposed contract, that party may become inflexible after having invested time and effort in the written instrument. If attorneys participate at this stage of the oral negotiations, all the

attorneys and their clients should meet together, in person or by telephone conference, at one time. Otherwise you will waste a lot of time and money in having attorneys talk to their clients and then to each other. My experience is that having attorneys relaying the wishes of their clients to other attorneys usually quadruples the bill.

Once everyone has met and arrived at certain conclusions, someone will be chosen to write the first draft. If the other party undertakes this task, you will obviously save time and money—on the other hand, the first person to draft the agreement is usually able to slant it in his/her favor even though the terms may appear to be very similar to those agreed upon at the negotiating sessions. Moreover, for the same reason mentioned above, the person investing time and money in the drafting is often reluctant to make changes. Therefore, it is my recommendation that you submit the first draft, unless cost and time are major considerations for you.

If the other party does the drafting, you must ensure that the proposed agreement reflects exactly what was agreed upon at the initial negotiations. Any deviations should be immediately pointed out and corrected if they are harmful to your position, and you should make all corrections which will protect your position. Thus, if the other party submits the first draft, you should submit a corrected draft. To save time and money, it is often best to use the other party's draft and change it by interlineation and excision. If you come up with your own "counter" draft, sometimes it will be very difficult to see what portions have been changed unless you use underlining or other devices to show the changes.

If the other party writes the first draft, it is a good practice to make all of your corrections, additions, and deletions at the time of submitting your counter-draft, rather than repeatedly coming back with further changes. Continually making changes is a very exasperating practice, and you should insist that the other party make all his/her changes at once for any draft that you submit. A corollary of this rule is that you should not repeatedly change the contract language to strengthen your position. Thus, if you commit yourself to certain language, you should maintain this commitment except under extraordinary circumstances, because constantly changing your position often suggests bad faith and that you may have been negligent in investigating your own position.

An alternative arrangement for saving time and money, which is useful in some cases, is to have one attorney act for both parties. Undoubtedly, this

attorney has to be someone of unquestioned integrity and impartiality. Also, this practice is only advised where the parties are well acquainted, have dealt with each other in the past, and are not viewing each other as adversaries. If you have one attorney working for both parties, make sure that the attorney honestly advises both parties as to their rights and liabilities. If you don't do this, the lone attorney may be encouraged to write a contract which s/he feels is fair to both parties, but a "fair" contract may not be what you want under the circumstances. You are entitled to know what your rights are and how to assert them if that is necessary.

Impasses and Deal-Breakers

In many negotiations there are impasses. If you will remember that the goal of negotiation is to allow all parties to come out ahead so that everyone can win, you will try to avoid impasses by developing creative solutions. There are always ways to concede a major point in exchange for the other party's concession of a major point or perhaps a number of minor points. Many times the concessions will even have to go outside of the scope of the contract. Thus, if you have to make a major concession, you might want to extract promises from the other party in relation to other transactions. In other words, you must explore every possibility in relation to all of your dealings with the other party, even into the future.

Of course, there is always the "deal-breaker." For instance, the other party may insist upon having the copyright in your work, which may be out of the question. Sometimes the deal-breaker is not a substantive point but rather relates to contract interpretation or enforcement. My advice is never to sign an agreement which doesn't contain adequate enforcement provisions and remedies for an aggrieved party. After all, an unenforceable contract is something of a nullity. For instance, if you are going to collect royalties from the publication of your work and you are dealing with a complete stranger, a refusal to give you the right to audit and inspect the records of the other party should be fatal to the agreement, as far as you are concerned. Also, if you are dealing with an out-of-state party, you had better make sure that your home state courts have personal jurisdiction over that party, otherwise you will have to go outside of the state to enforce your rights, which is not a viable alternative in many cases.

Miscellaneous Considerations

Never accept oral "side agreements" that go along with the written agreement. Every relevant consideration that you can think of should be put into the written agreement. If the other party says that you can trust him/her and that it is really not important to record a promise in the written agreement, please disregard such an opinion. Anyone who promises something orally should be willing to put it in writing, and a person who won't do that shouldn't be trusted. Moreover, under most circumstances the "parol evidence" rule compels a court to disregard oral side agreements, which can be unenforceable. Also remember that the statute of frauds prevents enforcement of many oral understandings, so that some of your understandings must always be in writing.

My recommendation is that you not only follow these steps but that you also inform the other party before negotiations what steps you wish to follow. After all, streamlining the process of arriving at an agreement can have beneficial effects on the agreement itself and on the relationship between the parties. Smooth negotiations often lead to better relationships, whereas harsh negotiations are often harbingers of contract disputes later on. My advice is even to propose a timetable for the drafting of the agreement, so that negotiations do not drag on interminably and cause the deal to collapse.

Other practical advice is never lose your temper, and never object to proposals by other parties unless and until you are prepared to explain the objections. Always be willing to listen and be persuaded, yet at the same time don't be bulldozed into an unfair understanding as to any matter, even if it is very tempting to sign an unfair agreement.

And, of course, if you are going to use an attorney, always use an attorney intimately familiar with the work that you do. Otherwise the attorney will have less knowledge of your trade and a decreased ability to deal with the other party. Try to pick an attorney who would act as you would—someone who is neither too timid nor overly aggressive, but rather firm and understanding at the same time.

If an attorney is working on the contract, make sure that you ask him/her how comprehensive the agreement is. Many attorneys will draft a contract which they feel is suitable for your transaction and for your pocketbook, but you have to ask the attorney how many things are not covered by the contract and how the contract can be improved. If you are only spending $300 on a contract that is

worth $100,000, you should ponder whether the contract is comprehensive enough. The more you spend, the more you are going to get. Of course, do not spend any more than is absolutely necessary. For each marginal dollar spent you should be getting at least one marginal dollar of benefits. Transaction costs, i.e. the costs of negotiating and drafting the agreement, must be consonant with the value of the agreement and the risks and liabilities involved.

Another way to save time and attorneys' fees is to organize your comments and criticisms relating to rewriting the contract. In other words, if an attorney supplies you with a draft of a contract for your comments and criticisms, don't just respond with oral remarks that could be misinterpreted or forgotten. Put it all in writing. And it is best to note your comments and corrections on the draft itself by interlineations and deletions and to accompany this corrected draft with comments that are annotated as to page, paragraph, and line number. Do not submit a completely rewritten contract, since the recipient may not be able to determine what changes you have made.

If you have a computer that is compatible with your attorney's computer or any other computer being used, try to get a disk with your contract on it so that, with boldfacing and underlining, you can make additions and deletions that are clearly seen.

Executing the Agreement

Once the agreement is fully satisfactory to both parties, it is time to sign the contract. Contrary to popular assumptions, the original typewritten copy need not be used. In fact, I often use photocopies of a typed agreement because they are more difficult to tamper with. Furthermore, when there have been interlineations and handwritten changes on a typewritten agreement, I often recommend that the parties photocopy the altered agreement and then sign the photocopy so that there can be no disputes about what interlineations were made before or after the signing of the contract. If interlineations must be made on an original copy, the parties should initial all of the changes. In addition, I strongly recommend that there be a space for the parties' initials at the bottom of each page to eliminate any claims that altered or new pages were substituted later on. You should keep an original signed copy and not merely a photocopy of the signed agreement. Your attorney should also maintain a copy so that if yours gets lost, there will be something on file.

Sometimes the order in which people sign may be important. For example, you may not want to mail a contract signed by you to the other party and wait for that person's signature, because s/he may sit on the agreement until such time as it becomes convenient to make a decision one way or another. In such cases, the submittal letter sent with the signed contract should indicate that a fully executed copy should be returned to you no later than a certain date, and otherwise your acceptance is revoked. Another alternative is to send an unsigned copy, but this does not eliminate all problems. If the other party executes the agreement but you refuse to honor it because you did not execute it, the other party could still argue that you made a contractual offer which was accepted and which s/he relied upon. Another problem with sending unsigned copies is that it may affect venue for court proceedings because, in the absence of an express provision to the contrary, the agreement may be deemed made where the other party accepted, and a proper place for a trial in a breach of contract action is often where the contract was made.

Studio Management

After Dinner, 1992, Oils, 30"x40", Diana Moses Botkin, Dallas, Oregon

Nuts and Bolts

Managing a Studio in the Home
Carolyn Blakeslee

Many artists have realized an important dream: a room of one's own. A place away from the madding crowd, a place where one can shut the door and work in peace. Perhaps you have commandeered a bedroom, converted your garage, or are working in your newly finished basement; perhaps for now you have to settle for part of your living room.

In any case, maintaining a studio in the home has its obvious blessings— and problems. For those of you deciding where to set up shop, or who are experiencing some dissatisfaction with your current home studio arrangement, this article will outline some problems and solutions.

Not enough privacy; too many distractions.

If your studio is in your home, you will be besieged with "normal" day-to-day interruptions. Phone calls will interrupt you: calls from well-meaning friends, organizations wanting you to support them or do other kinds of favors or volunteer work, invitations to go play tennis or go to a party instead of doing your artwork, etc.

You must decide that your artwork is just as important as anyone else's job. You must also decide that your job—your artwork—is more important than "just taking a moment" to water the plants, read your magazines, or do other chores or errands. Set up specific and regular working hours, and get the word out that no one should call you at work. Set up an answering machine so you can monitor calls; you can always pick up the phone if there is an emergency. Run your errands and do your chores at other times. Stick with it. And just say no.

Of course, if you have been doing regular self-promotion, you will be getting phone calls from people interested in buying or carrying your artwork. Get

a separate phone line, call it your studio number, put that phone number on your promotional materials, and answer that phone during your business hours.

You might also consider renting a P.O. box. This will allow you to receive mail without disclosing your home address, adding to your sense of privacy.

Too much privacy and isolation.

Unless you share your home studio with someone else, you work alone, with no one to give you feedback and criticism, and no one to encourage you to do the business side of your artwork or to help you get over a creative block. Set aside some of your work time to go visit galleries and museums, and join at least one group of artists with whom you can interact. It is inspiring to meet with other artists, and such contact can help your career along too. And stick with this: if you feel lonely and sluggish, then maybe it's time to head for town and see a show or two, not give up and do other things.

Stuck with working in the living room.

OK, you'd love to have a bedroom where you could put your studio, but at this time it's not possible for you. Surprise: it might not be the worst thing.

Here's a personal anecdote. One of the many things that drove me nuts about the house we lived in until last summer was that I didn't have a room of my own; I worked in the living room. I prefer to work at night; folks would drop in, my husband would watch me paint, the kids would be having a powwow in the next room, whatever. But the room was comfortable. The piano was there—when I got tired of concentrating on a painting, I could let loose on the piano. The only serious stereo in the house was there. And when I finished with a session, I would go sit across the living room, and "watch" my painting from my favorite chair. Lo and behold, we moved into our new house, I decided which bedroom I wanted for my studio, and . . . I couldn't back up from the painting any more than 12 feet, the maximum dimension of the room! I actually *miss* the old living room now.

Not enough room.

Since I need to "distance" myself regularly from my canvases, I took down the wooden sliding closet doors and replaced them with mirrored doors. This had the effect of doubling the distance from myself to my canvas when I stood

back, giving me another fresh perspective as well: the fresh view of seeing the painting backwards, and not as I had grown used to it as I painted.

But too much stuff can be a problem in a small room. Storage problems can be addressed with several floor-to-ceiling bookshelves. Place your supplies neatly on the shelves, rather than horizontally on table space. A table next to your easel or other workspace will hold the tools you need at the time.

Remember, the most important marketing strategy of all is to *work*. As Timothy Rose of Sausalito, California says, "My marketing ploy is that I have three meals a day and work eight hours a day. I keep my slides up-to-date, I keep my resumé up-to-date, and I regularly apply to competitive exhibitions. And I keep my eyes open for new ideas."

Insurance for the Working Artist
Peter H. Karlen, Attorney-at-Law

Insurance has been defined as: "An act, business, or system by which pecuniary indemnity is guaranteed by one party (as a company) to another party in certain contingencies, as of death, accident, damage, disaster, injury, loss, old age, risk, sickness, unemployment, etc., upon specified terms."

In short, insurance is a financial arrangement whereby one party, the insured, is guaranteed compensation by another party, the insurer, for a specified loss. Typically, the insured party pays for this indemnification by remitting premiums to the insurer. These premiums are usually relatively small amounts of money payable in periodic installments.

Naturally, one can "insure" oneself merely by setting aside reserves of money to cover losses which may occur. One way of doing this is to put aside small sums on a periodic basis and build up a reserve. However, for most individuals, including artists, self-insurance makes little sense. Either one puts away a large sum to cover the loss, in which case one might as well not be insured at all, or one saves small sums and earns money on the savings when invested in the hope that no loss will occur, at least until the fund has been built up to considerable proportions.

It makes more sense, of course, to pool one's contributions in an insurance fund along with the contributions of others, in other words, to distribute the risks and liabilities and financial responsibilities among many insured persons.

Such a system, if established among many individuals, or perhaps even by associated artists, would be viable to insure against their losses. However, most persons, including artists, do not have the time to run insurance programs—to fill out policies, to pay out claims, and to collect premiums. This is the justification for insurance companies. In exchange for the above services, the insurance company receives the moneys of numerous subscribers. It invests the moneys for its own benefit, makes a profit from investments and premiums, and maintains a reserve to pay out on all valid claims. Or put another way, the insurance company acts as a conduit for the moneys of subscribers and claimants, and acts as the mediator in this system of allocation of risks and benefits.

In the case of artists, insurance protects against many losses. Naturally, artists, like other persons, may procure life, disability, and medical insurance. They may also insure their inventory just like any other businesspeople. However, even ordinary insurance policies for artists present special considerations, and, of course, artists may have special types of insurance policies that are not common to other occupational groups.

The purpose of this article is primarily to discuss the insurance needs of working artists, including painters, sculptors, graphic designers, and photographers.

Insuring One's Work

Most artists do not command extremely high prices for their work, and perhaps they do not need insurance policies and the burden of premiums when they start their careers. Nevertheless, many artists have a deep attachment to their works because the works may be considered expressions of their personalities or emotions, or simply because the works are the products of considerable time and effort. Therefore, artists are concerned with protecting their works against loss or damage.

There are several ways in which the works may be lost or damaged. In geographic and temporal terms, loss may occur in the studio, or in transit to or from a purchaser, dealer, museum, agent, publisher, advertising agency, licensee, or printer (hereafter collectively referred to as "client" or "user"), or on their premises.

Studio Insurance

If the artist works at home, and perhaps enjoys the home office income-tax deduction, insurance problems are not necessarily complex, especially if the

artist does not have many visitors to the studio. Fire insurance, extended to cover other perils such as lightning and explosion, plus theft insurance, should protect the works of the artist as well as his/her equipment, supplies, and library. Even a package policy, such as a homeowner's or commercial package policy, may be adequate in some cases. Of course, one must bear in mind that a shortcoming of the homeowner's policy is that it will not usually cover property held for sale or sold but not delivered; nor will it usually cover business property away from the premises. This means that the artist who holds a homeowner's policy while maintaining a home studio is taking a chance when it comes time to make a claim for loss occurring in the studio. Moreover, the artist might not be able to gain protection from a floater (the term "floater" is used to describe a policy under which specific listed articles of personal property are protected while they float from one location to another) policy, covering personal property that is subject to removal from one place to another, because the artist's works may be considered inventory not protected under personal property floater policies. Nonetheless, the floater policy might cover works of other artists collected by the insured artist, who is considered a collector just like any other collector.

In any case, the insurance policy for the home studio should at least cover loss by fire, theft, and vandalism. In addition, some artists may want to carry valuable papers insurance, an all-risk policy for almost all perils. This type of insurance may be recommended for photographers, graphic designers, and architects, whose plans, drawings, negatives, or blueprints are particularly valuable. One drawback of valuable papers insurance is that it will usually cover only reproduction costs of the papers in question, and will not provide reimbursement for the full value of the papers. No matter what type of policy the artist procures for works in the home studio, s/he should ascertain what types of damage give rise to proper claims under the policy. Many policies will not cover minor damage to the work such as scratches or chipping unless the artist demands such coverage, in which case the premiums will rise sharply. Also artists cannot expect to be covered for perils such as earthquakes (unless they have earthquake insurance), wars, insurrections, or certain "acts of God."

If the studio is not located at or about the home but is in a separate business location, a commercial package policy will be required. The commercial package policy, unlike the homeowner's package policy, can be structured to

cover inventory and business property. It is possible, of course, to procure separate fire, theft, and vandalism policies, but once again the package policy will cover more perils and will be relatively cheaper and easier to administer than the separate policies. The comprehensive commercial package policy can cover the artist's works, library, equipment, and supplies.

When the studio insurance is procured, the artist should mention to the agent that his/her works are to be covered, in order to make sure that both parties are aware of the extent of coverage desired and provided. If the works reach a certain value, the insurer will probably request an inventory of the works to be protected. Thus, the artist will have to provide a list of the titles, descriptions, and values of the works. Of course, the artist should maintain photographs of the works, preferably transparencies, not only because they might be requested, but also to prove his/her claims, and for other purposes including preservation of moral rights and other intellectual property rights. The description of the works should at least include dimensions, year of creation, medium, and colors, if any. The value of the work should be its selling price, or at least its fair market value, that is, what a willing purchaser would pay for the work in an arm's length transaction. The artist should not underestimate value because, if valuation is to be negotiated at the time of making a claim, the insurer may attempt to lower the valuation. Past sales proceeds for similar works are a good gauge for valuation. Evidence will include gallery records, sales slips, invoices, and contracts for sales or licensing. If new works are placed in the studio, they, too, should be included on supplements to the inventory, which should be kept updated at all times.

Works in Transit

Many times losses take place not at the studio but in transit from the studio to other locations. For example, a work may be lost or damaged while being delivered to a client or user. The results may not only be calamitous but also embarrassing, and the ordinary policies for home or office/studio will not often cover these losses. The artist may try to compensate for these losses in certain cases by making claims against other parties or by resisting the demands of purchasers. For instance, the artist may sue the carrier that transported the work. Also the risk of loss may pass to the purchaser who buys a work in the artist's studio and leaves it there for later pickup or delivery, and the artist could possibly

keep the purchase price even though the work was later lost in transit. However, this is no way to conduct business in the absence of insurance. The artist must either make the carrier, client, or user liable for the loss in an explicit prior agreement or must insure works that are being delivered.

The usual policy, before the advent of specialized policies to protect artists, was "inland marine insurance," a species of floater policy used to cover merchandise in transit including artworks to be sold on consignment. Other alternatives for artists who have infrequent shipments, and who do not need a policy which is in force continuously, are parcel post insurance, trip transit policies, registered mail and express shipment insurance, and other minor policies which only cover the shipment in question. The transaction costs and premiums per shipment are probably higher, in the aggregate, for such limited insurance, and the broader transit insurance policy may be justified for artists who ship too many works to be bothered by constant paperwork.

With transit insurance, complete records must be kept that not only indicate the title, description, medium, and value of the work, but also its destination and mode of shipment. The insured must also be aware that the transit policy may only cover works shipped in a certain manner by specified channels, packaged in specified ways, to limited destinations (for example, in the United States only).

Unlike the insurance policy that covers the studio, which in a few cases may come under the rubric of a home or office package policy, the policies that cover art in transit might not be procurable from every insurance agent. In fact, if high valuations or unusual risks are involved, many agents might duck the policy or ask for policies that carry exorbitant premiums. It is best in some cases, therefore, to deal with those agents, brokers, and companies that routinely insure works of art. Transit insurance is usually procurable from agents and brokers who deal heavily in commercial insurance.

The problem of loss during shipment, of course, is particularly acute when purchasers are involved, because often money has changed hands and the purchaser has a strong interest in receiving a particular piece. And usually there is no diplomatic way to foist insurance costs upon the buyer unless they are surreptitiously included in the purchase price. However, in the case of museums, the situation may be remedied somewhat. When a museum wants to grace its interiors with the artist's work, the artist may be able to insist upon "wall-to-wall"

insurance carried by the museum. This insurance protects the works in question from the time of removal from the artist's studio until after their exhibition and return to the studio. Thus, the museum's policy should guarantee payment for the full value of the work as stated by the artist. If the museum refuses to insure, the artist should either refuse to lend the work or have a provision included in a written lending agreement making the museum absolutely liable for all damage incurred during exhibition and transit both ways. In the case of original graphic artwork that is being shipped for reproduction, the artist should at least ask the advertising agency or other user to pay for insurance or be responsible for loss. After all, the loss of a work not only deprives the artist of the full sale price of the work but also effectively destroys the copyright in the work and, if applicable, the right to resale royalties.

Artists, however, might not be in the same position with respect to galleries and dealers. Normally most museums and large advertising agencies have broad and effective insurance policies. But gallery owners who may wish to economize and reduce overhead might not carry insurance policies, or might try to shift the burden of insurance to the artist. Again, there are alternatives. Either the artist should bargain for an insurance clause in a written consignment agreement or insist upon a clause making the dealer absolutely liable. Sometimes the artist and dealer arrive at an agreement whereby they will split the costs of insurance to and from the gallery. That is, they will divide the costs of insurance payments for individual shipments, not the cost of a long-range policy unless there is to be a long-term relationship. Or the artist may insure the work on its way to the gallery while the gallery pays the premium for the return shipment, or vice versa. If the dealer will not pay for insurance he may be persuaded to accept responsibility for loss in transit, though this might be limited to the return shipment for which he will determine the manner of shipping. Probably, in most cases, the dealer will not accept responsibility. Nevertheless, the special statutes that regulate artist-dealer relationships and consignment sales, which are discussed below, may automatically place the responsibility for the return shipment on the dealer.

Works on Display or in Process of Reproduction

Once the work is actually on the premises of the client or user, the artist's problems may ease. In most cases, museums, dealers, and advertising agencies

have insurance for property on their premises, though in all cases it is wise to obtain some written promise that the insurance is in force and covers the artist's works adequately. Again, in the case of a museum, the artist should not lend the work if there is neither insurance nor an agreement to accept absolute liability. If the work is to be reproduced and is valuable and irreplaceable, the artist should not let it remain on the premises of the advertising agency, printer, or publisher without similar assurances. Although some dealers may carry an art dealer's floater policy or an all-purpose floater policy, with an uninsured dealer the situation is slightly different. Naturally, a dealer may not want to accept absolute liability in the absence of insurance, but he may have no choice under the artist-dealer statutes throughout many jurisdictions that call for absolute liability of the dealer (e.g., California Civil Code §1738-38.9). The Uniform Commercial Code, which deals with consignment sales in general, also usually shifts the responsibility to the gallery. Moreover, under the special artist-dealer statute, artists cannot even be forced to waive their statutory rights, and any agreement that shifts the responsibility for loss or damage is unenforceable. Nevertheless, despite these statutory rules, where there is no insurance, all that the artist can do is demand compensation from the dealer. If the dealer refuses, the artist must go to court, and though s/he must certainly win, litigation is an unpleasant prospect. Perhaps a comprehensive insurance policy that covers business property or inventory off premises would be a more appropriate alternative.

Casualty/Liability Insurance

Artists who run an active studio with many visitors may want to consider a policy that covers personal injuries to other persons. Of course, personal injuries are covered under most home and office package policies so that there sometimes need be no new policy if the artists are already using home or office policies to insure their works. However, as mentioned before, a homeowner's policy will usually not cover inventory or business property, and it will not cover the artist for injuries sustained on business premises.

If the artist is not protected by a package policy, a separate liability policy should be secured especially for artists who work in hazardous areas or with materials that present dangers to visitors. For instance, artists who run a small foundry on their premises or who produce large sculptures may wish to have

fairly high coverage for personal injuries. Sometimes even chemicals in a dark-room may be potential hazards. Failure to procure such insurance can result in exposure to enormous claims. A very large judgment against an artist can be a burden for the rest of that person's life. And coverage is relatively inexpensive.

The problems of personal injury insurance are particularly vexing for per-formance artists, especially those who are not covered because they do not per-form in traditional venues such as auditoriums and theaters whose proprietors carry insurance. Artists who perform dangerous works of performance art out-doors (as does Chris Burden of Los Angeles), should be judgment-proof, have accommodating relatives who live abroad, or somehow obtain insurance to cover their performances. Strange as it may seem, insurance to cover the risks of daring performance art may be available. There is always a species of public liability insurance available for performers or theater owners, if one is willing to pay for it.

Artists are not only liable for slip-and-fall accidents on their premises or for injuries caused by their performances, but they can be held liable for injuries resulting from defects in their products. The sculpture that tips over, the mobile that falls from the ceiling, or the electric work that starts a fire may cause claims against the artist.

These types of claims ordinarily cannot be referred to home, office, or per-sonal liability policies unless the incident occurs on the insured person's premises. What is first indicated is a products liability policy. However, the artist who produces only oil paintings or manufactures small sculptures may not always need a products liability policy to insure against such claims. These types of works will probably not cause injury, and the artist, after all, is not responsible if someone else uses the work as a weapon or projectile. Nonetheless, if the artist's works are incorporated in useful articles such as furniture or kitchenware where they are in physical contact with people, or if the works are large and made to hang from walls or ceilings, a products liability policy may be recom-mended. If the artist is producing work for use in many locations, it is impera-tive to procure such a policy.

The artist should remember that in products liability cases, the court may impose "strict liability" in such a way that the artist will not be able to avoid financial responsibility for the injury if the claimant can establish that a defect in the work contributed to his injuries. The best thing is for the artist to procure insurance, which in most situations is relatively inexpensive. The expense must

be viewed only as another cost of doing business. Artists should ensure that the policy covers all of their line or products for all intended uses. It does not help to have a policy with a rider clause. When the artistic works are produced in large quantities, the cost per item is very small.

Another type of insurance needed by some artists is completed operations liability insurance, which is akin to products liability insurance. Unlike the products liability policy, which covers injuries resulting from defects in the goods produced and sold by the artist, the completed operations policy covers injuries arising from the use of the goods by others. For instance, the artist whose large suspended mobile fell on someone may be covered by a completed operations policy.

If artists subcontract with others to work for them, independent contractors' liability policies will cover for claims arising from operations by subcontractors on the artists' behalf.

Where artists run a large business such as a manufacturing enterprise, a comprehensive general liability policy, which covers most of the liabilities faced by the business, is recommended. Please don't forget workers' compensation policies to cover employee injuries.

Disability and Dismemberment Insurance

Many professionals are solicited by insurance agents to buy disability and dismemberment insurance policies. This type of coverage is often associated with well-to-do physicians, lawyers and corporate executives. Artists, however, especially the chosen few who make their living almost exclusively from their art, must consider certain types of insurance to cover them for their own injuries. That Betty Grable obtained insurance for her legs, which were considered income-producing assets, does not mean that all artists should immediately insure their hands. Nevertheless, certain artists who receive a high return for their work must view their hands as capital assets, and insurance for severe injury or dismemberment, which would compensate them for a catastrophic accident, should be considered.

Basics

Insuring Your Artwork

Carolyn Blakeslee

One of the greatest concerns to artists is the insuring of artwork. Damage and losses can occur when the work is on exhibit, or while it is in the studio, in transit, or in the possession of others but not on exhibit—printers, photographers, agents, even prospective purchasers.

If your studio is in your home, one option is to ask your home insurance company about a floater policy. This policy protects personal items that "float" from location to location. However, your artwork could be construed to be business property, not personal property, so make sure that both you and your insurance agent understand your position clearly.

If your studio is in a separate location, a commercial "package" policy is probably in order. This would protect your space, your supplies, your artwork, and might also cover liability for visitors/clients. The policy might protect your business property off-premises as well.

Insurance for works in transit is usually best handled each time you ship. Unless you ship out a tremendous volume of work, the costs of a blanket works-in-transit policy might be prohibitive. Check with your shipper to determine your options—UPS, USPS, and other shipping firms all have insurance policies available to their customers.

No matter what kind of insurance policy you have, most policies will not cover minor damage to the work, such as scratches, without a major increase in your premium.

Following are some companies who insure artwork.

The National Artists Equity Association has a fine art insurance policy, underwritten by Northbrook Property & Casualty. It covers artwork "during the course of completion, or work which has been completed and is being held for

sale, or work that has been sold but not delivered . . . [and] artists' materials, tools and supplies. The policy does not cover studio furniture, an art library, or works of art by others in your possession or care." The policy covers work on the premises, while "on exhibition or otherwise," and while in transit within the U.S. and Canada. There is a $250 deductible. The annual premium for $15,000 of coverage is $350; for $45,000 the premium is $630; other amounts are available. The policy insures except against wear and tear, inherent vice, latent defect, insects, vermin, mysterious disappearance, loss or damage from fraudulent or criminal acts, theft from an unattended vehicle, and a few other events such as war. National Artists Equity Association, P.O. Box 28068, Central Station, Washington, D.C. 20038, 202-628-9633.

Huntington Block insures individual artists, but Mr. Block warns, "Unless a visual artist has an established market it is difficult for him or her to buy inventory insurance." (See the article "Fair Market Value.") The policy insures except against wear and tear, insects, vermin, mysterious disappearance, any dishonest act on the part of others to whom the property may be entrusted (except employees and carriers for hire), and a few other instances. The property is not covered on fairgrounds or at international expositions. They also have a business package policy available. Rates figured on a case-by-case basis. Huntington T. Block, 1120 20th St., N.W., Washington, D.C. 20036, 202-223-0673.

Connell Howe Insurors Inc. offers a Crafter Package Policy consisting of $1 million general liability, $1 million products and completed operations liability, $100,000 fire legal liability, $5,000 medical payments, and $5,000 contents coverage while set up in display. The coverage "is good for any number of locations you may show at during the year, even if you show in different states. . . . If the mall or fair needs to be added as additional insured, there is no extra charge for this endorsement." The annual premium is $500. There is a $250 deductible. Connell Howe Insurors Inc., 119 W. Pacific, Branson, MO 65616, 417-334-2000.

The Craftsman Protection Plan allows an artist to "cover all your crafts property with one blanket insurance certificate at an affordable price . . . without the bother of monthly inventory reporting or scheduling of individual works. The Plan covers unfinished and completed craft objects, raw materials, supplies, tools, and other property usual to your craft, as well as articles of others you are repairing." All risk; property covered in home/studio, on exhibit at fairs and similar events, and while in transit, in the U.S. and in Canada. Loss away from studio

covered at 50 percent of total protection amount, max. $12,500. Exclusions include property unattended in auto and mysterious disappearance (burglary is covered but proof of break-in is required). $25,000 coverage is subject to a $100 deductible. $250 deductible for more than that. Insurance costs about 1 percent of coverage amount per year, i.e. $471.75 to $548.25 for $50,000 worth of coverage. Craftsman Protection Plan, P.O. Box 2510, Rockville, MD 20852-0510, 301-816-0045, 800-638-2610.

NOTE: Insurance on artwork being exhibited should cost 1 to 2 percent of the work's retail value per year when offered by a reputable insurance company. We have heard of vanity galleries that "offer" their artists insurance at up to two percent of the value per month—at that rate you've bought back your own artwork (at wholesale) in two years! A reputable gallery will either insure your artwork while on the gallery's premises as part of its overhead, or it will offer you insurance at cost.

Taxes and the Artist

Carolyn Blakeslee

For tax purposes, artists are owners of small businesses operated as Sole Proprietorships, unless the artist has incorporated or formed a legally binding business partnership. This article will address the needs of Sole Proprietors.

Schedule C is used by Sole Proprietors to report business-related income and expenses. The gross income is listed first. All business-related income is listed: sales of artwork, grant moneys, teaching income if the teaching was done on an independent contractor basis, etc. Expenses are listed next and subtracted from the gross income. The remaining amount is called your net income, also known as your profit or loss. Social Security taxes are paid based on this amount (if it is positive), and this amount is entered on Form 1040, where a few other items may be deducted before the income tax is figured.

In order to qualify as a business (as opposed to a hobby), you must be able to demonstrate—if asked (audited)—that you actively pursue income from your endeavor. The IRS's rule of thumb is that your business should produce income 3 out of 5 years—you may show a net loss 2 out of 5 years. But the three-out-of-five rule is only a guideline: you could theoretically take losses for a longer period or ratio of time if you can show the IRS business cards, evidence of

gallery representation, and/or other concrete evidence pointing to your intention to make money. However, if you exceed the rule-of-thumb, you are more likely to trigger an audit. Audits are passed by those who have filed honestly but they are not for the faint of heart.

Anyway, many artists have questions as to what expenses are tax deductible. Even after the 1986 tax reform, the following costs of doing business are deductible on an artist's Schedule C. (And thanks to the Technical Corrections Act, artists no longer must capitalize these expenses; they may be deducted in the year in which incurred.)

• Advertising expenses. Examples: Direct mailings, including costs of buying a list, printing, postage, cost of mailing envelopes, etc. Ads placed or aired: TV, radio, magazine, newspaper, Yellow Pages, etc. Public relations campaigns including costs of consulting fees, printing or copying of releases, postage, cost of envelopes, etc. Business cards. Show invitations and the mailing thereof. The production, duplication, and mailing of your promotional videotape giving a brief tour of your studio and an overview of you and your work.

• Bank service charges if a separate business account is kept. I highly recommend that you maintain a separate business account; for one thing, expenses are easier to keep track of during the year. I also recommend keeping daily, weekly, monthly, and annual books; it is easier to record income and expenses day-by-day than at the end of the year.

• Capital expenditures. A capital expenditure is the purchase of a relatively permanent fixture; for example, tubes of paint are considered "Supplies," but a car or computer is a capital expenditure. Easels and drawing tables could be considered capital expenditures, or you might wish to categorize such expenses under "Miscellaneous" under a self-created category called "Furniture" or "Studio Fixtures." Anyway, if you spend less than $10,000 on one item which you use in business (i.e. a lithographic press, or a video camera), you may deduct the cost on your Schedule C. If you buy an item (e.g., a computer) that you use *to some extent* in your business, you may deduct *that percentage* of the item's cost on your Schedule C. For example, you spent $2,500 on a computer that you and your kids use for games, personal correspondence, and writing school term papers. You also use it to maintain your mailing list, typeset your show invitations, and inventory your artwork and slides. You use the computer around 50 percent of the time for personal uses, and 50 percent of the time in

running your business. You may deduct 50 percent of the computer's cost. However, if you sell the computer, you will have to "recapture" the income from the amount you deducted in a previous year or years. (Also see "Depreciation.")

• Car and truck mileage expenses (this amount varies each year; when this article was written the allowance was 24¢ per mile travelled in business-related trips, up to 15,000 miles, then 11¢ per mile thereafter; check for current rates), OR a percentage of all auto-related expenses. If you use your car 25 percent for business, then you may deduct 25 percent of all auto-related expenses, including gas, insurance, repairs, payments, maintenance, etc., OR 24¢ per mile travelled in business-related activities. I have found that the per-mile deduction is simpler, and costs actually work out to be exactly the same, no matter what car I drive—paid for or not, gas guzzler or gas miser, luxury or economy car. No matter which method you elect to take, a travel log must be kept that includes date, distance travelled, and the reason for each business-related trip. Start a diary— this can be fun. (Also see "Depreciation," as part or all of the automobile's depreciation can be deducted for business purposes.)

• Commissions. If you receive money for a sale and then pay a commission to a dealer or an art league later, then that commission is deductible against your income. However, if your dealer receives money and pays you your share after withholding his/her share, then the commission is money you've never handled and thus it is not an expense; you would report only your share of that sale as income.

• Courses and seminars. Courses such as framing and slide photography workshops are legitimate deductible business expenses designed to save you money in the long run. It is likely that courses teaching art techniques are deductible too, within reason; however, it would be difficult to justify a full-time or even a half-time load of college courses as a deductible business expense. It is also likely the IRS would not look kindly on your deducting the cost of that Caribbean workshop—after all, much of your intent in signing up for that particular activity was to take a vacation.

• Depreciation. Used on capital items costing more than $10,000. The item's cost is "capitalized" for the life of the item; in other words, a percentage of the cost of the item is deducted each year for a certain number of years. The IRS determines the life of the item and the percentages allowed each year. However, if you sell the item, you will be required to recapture that income from

the amount you deducted in a previous year. (Also see "Capital expenditures," "Car and truck expenses," and "Office in the home expenses"—yes, if you deduct for a percentage of your home's expenses you will have to recapture that in the event of a future sale, although you can sidestep that requirement if you do not claim a deduction for an office in the home during the year of the home's sale.)

• Dues and publications. Membership fees; magazines and newsletters to which you subscribe in order to further your art business, ditto for books.

• Employee benefit plans. Not applicable for *your* benefits. You may deduct 25 percent of the cost of your health insurance on Schedule C, but *this* line item applies to the costs of benefits you would give to your apprentices or employees, such as health insurance or retirement. Contributions to your IRA and/or KEOGH account(s) may be deducted on Form 1040. IRAs and KEOGHs are wonderful savings plans for the self-employed, as well as good tax shelters and good retirement plans, but the contributions you make to your IRA/KEOGH plans cannot be deducted on your Schedule C—in other words, you have to pay Social Security taxes on the contributions, but not federal or state or local taxes. Still one of the best investments around and you should be contributing $2,000 (or more is allowable in some cases) to your IRA and/or KEOGH every year.

• Freight. Examples include shipping completed commissioned works to clients, or shipping entries to juried shows. However, shipping that painting to your mother-in-law in time for Christmas is not deductible unless she bought it.

• Insurance. Insurance on artwork, studio insurance, 25 percent of your health insurance if you are not covered by your spouse's plan or another plan. (For auto insurance: See "Car and Truck Expenses.")

• Interest. The interest on your business indebtedness is deductible on your Schedule C. If you buy your printing press on an installment plan, for example, the interest is deductible. If you buy supplies with your credit card, then the card's interest applicable to the business expenses is deductible on Schedule C. Auto loan interest is considered consumer loan interest and is not deductible *unless* you use your auto in your business; then, the appropriate percentage of the auto loan is deductible with your other auto expenses (See "Car and Truck Expenses"). Your mortgage interest is deductible on Schedule A; your first mortgage is generally 100 percent deductible, and the interest on up to $100,000 of your home equity loan is also deductible (up to $1 million in total

home indebtedness). Credit card and other consumer installment loan interest is no longer deductible at all.

• Legal and professional expenses. The fees of accountants, lawyers, conservators, arts advisors, and other professionals are usually deductible within this category, as long as the fees apply strictly to the operation of your business.

• Office or studio in the home. If you use a portion of your home—say a bedroom or part of the family room—you may deduct some expenses. The deductible amount depends on the amount of square footage; for example, if your house is 2,000 square feet and your studio is 100 square feet, or a 10-by-10-feet bedroom, you may deduct 5 percent ($1/20$) of your home expenses. However, the room or area must be used *solely* in the running of the business—if there is even a guest bed there the IRS would rule against your taking that deduction. Also, if you show a net loss, your office-in-the-home expenses are the last to be considered and they may not be a factor in bringing your bottom line below $0; you will have to defer the deduction to the next year. If you take depreciation or in some other way take deductions against the capital in your home, then you will have to recapture it in the event of a future sale, and this could result in paying capital gains taxes. Other office expenses would include stationery, staplers, envelopes, etc., as well as almost-capital expenditures such as your typewriter and file cabinet.

• Repairs (to business property). Fixing your camera, slide projector, or adjustable easel seat would be deductible here.

• Studio rental. This is a fairly straightforward business expense with none of the complications of the office or studio in the home.

• Taxes. Only taxes on real and personal property used in business are deductible here, along with payroll and FICA taxes you paid for your employees. Normal federal, state, personal property, and local (business) taxes are claimed on Schedule A. Sales tax is no longer deductible except as a part of the total expense of any supplies bought which are otherwise deductible on your Schedule C.

• Travel, meals, and entertainment. Only 80 percent of your expenses incurred in entertaining customers and business associates is deductible, as well as 80 percent of any expenses associated with strictly-business travel and meals. The IRS figures that after all, you would be paying for food and shelter anyway.

• Utilities and phone. If you use part of your home as your studio, you may deduct a percentage of your home expenses (see "Office or studio in the

home"). That same percentage is divided into the total amount you spend on electricity and heating, and deducted here; however, you may not deduct your residential phone expenses even if you use it largely for business—you must install a separate business line. If you rent a studio, and utilities and/or phone are separate charges, they are deducted in this category too.

• Wages paid to others. Salaries to models, apprentices, secretaries, studio assistants/helpers, etc., are deductible here. You can even pay relatives, if the pay is a reasonable and fair amount, and deduct the expense. The IRS is wary of a dependent's allowance being deducted as salary/work wages, so the work must really have been done.

• Other/miscellaneous. Art supplies. Waste removal if unusual. Framing/ matting. Construction of sculpture pedestals. Foundry expenses. Photographic developing fees. Slide documentation. Construction of display panels. Entry/acceptance fees. Postage. P.O. box rental. In short, everything directly applicable to running your art business, but difficult to categorize into the above relatively neat divisions.

Once I received notice that I was to be audited. I was scared to death. I bought every magazine I could find that featured an article on the subject. The first thing I found out was that one could postpone an assigned audit simply by writing back, "The time is not convenient." Soon another audit appointment would arrive, and one is perfectly within one's legal rights to request a rescheduling (delay) several times. This gives you time to do your homework—to find out things such as the WORST thing to do is to take your receipts in a jumbled shoe box. Rather, have everything arranged perfectly; the more considerate you are, the more considerate the IRS will probably be of you, as long as your case is truly legitimate. Anyway, after three months or so I had done enough research to feel confident as to how to present my case, so I called the IRS and scheduled the audit. I arrived a few minutes early, couldn't find the office right away, and was finally directed to the proper floor (my auditor's entire division had moved). Heart pounding, I opened the door and was greeted with plants and freshly baked brownies! Not my image of the IRS. My auditor was friendly even to the point of being supportive. I came away "clean," and the IRS-imposed course in tax accounting turned out to be one of the best experiences of my life.

The moral of the story is, it behooves you to learn about taxes *before,* God forbid, you are audited. The more you know about the art of filing, the less likely

it is that you will be audited, and the more likely it is that you will be a wise steward of your money.

Check with your accountant before leaping blindly into any new ways of filling in your tax return. And be sure your accountant is OK too—if you do not have an accountant with whom you are happy, get a recommendation from someone whose financial situation you respect.

The "red flag" that triggered my audit might have been my sudden use of an accountant; I had prepared my own returns in the past. When I was informed of the audit, I could not find the accountant—after almost three months of placing phone calls to his "office," he never returned any calls, and I had to go to the audit entirely on my own! Who knows? Maybe the "red flag" was using an accountant whose reputation was in question already, rather than any questions the IRS had with my return, had I filed it on my own.

Many happy returns.

Artist/Dealer Contracts
Carolyn Blakeslee

To have a contract or not to have a contract? That is a question still asked with trepidation by many artists. A contract is not necessary if nothing goes wrong, i.e., differs from your verbal agreement and undiscussed expectations. But how often does an event occur that exactly meets your expectations?

My views on this have changed. I used to think that trust was a stronger bond than a written contract, but I have learned that a good, complete written contract generates trust. A contract provides a structure in which a relationship can grow, without the burden of wondering what-happens-if.

If you are in *any* kind of business relationship, if *any* aspect of your partnership goes awry, or if *anything* unexpected happens and is dealt with in a way that one or both partners feels is not OK, then the relationship—at the very least—is in trouble. Folk proverbs bear this out: "Expect the unexpected," "Hope for the best but prepare for the worst," "Life is what happens to you while you're planning other things."

A contract does not mean that you are a suspicious person. It means that you are a wise businessperson. The necessity of having a detailed contract does not imply that you think the gallery director is a less than trustworthy person. A

good contract will protect him/her too. A gallery director shouldn't want to fool around with ugly feelings and court cases any more than you do.

The "what-ifs" should be discussed before the relationship is locked into place—before signing anything *and* before leaving any artwork at the gallery. The agreed-upon resolutions should be written into the contract. Don't fall for a ready-made contract that the gallery director has on hand. Although it might be tempting to feel that it is better than nothing, if you have *any* questions, negotiate. Finally, let a lawyer review it—that's one of many things the Volunteer Lawyers for the Arts organization was set up to do. (For the name, address, and phone number of the chapter nearest you, contact the national VLA office at 1 East 53rd St., 6th Fl., New York, NY 10022, 212-319-2787.)

Here are some issues that can arise in a relationship between an artist and a gallery.

- *How long is the agreement to be in effect?* Trial period? specified period? open ended?
- *How can the relationship be terminated?* In writing? by either party? time period of notice?
- *Who owns the art?* No kidding. I was horrified to hear of a case where an artist left several works on consignment, the gallery director eventually claimed the artist gave them to her as a birthday gift, the artist hauled her into court, and he had no contract to back up his claim. The gallery director kept the works.
- *When will the artist get paid upon sale of work?* This is important to agree upon. Installment sale terms should also be spelled out—will the artist get paid bit by bit, as the gallery gets paid, or at the onset of the sale?
- *Will the artist be told who bought his/her work?* It is good to know who one's collectors are so one can add them to one's resumé and mailing list.
- *What happens if the artist sells an artwork out of the studio while in a relationship with a gallery?* It depends. If someone visits the studio as a direct result of contact with the gallery, then the gallery is probably entitled to a commission. However, since you are the one who makes the sale, the gallery is probably entitled to a smaller commission than if it had taken place on gallery premises. On the other hand, if you are

regularly selling work out of your studio and the gallery has made no efforts on your behalf, then you might want to look for another gallery, and your gallery might not be entitled to any commission. These details should be agreed upon and spelled out if possible.

- *Is representation exclusive?* Exclusivity is a common request. Unfortunately, it doesn't do anyone much good. Exclusivity came from the days when the Leo Castellis of the world could pay artists a monthly stipend against the sale of future work and could virtually guarantee an artist a substantial following and income in the future. Let's face it, most gallery directors are not Leo Castellis. Could it be that the hotter your work is—i.e. the more galleries in which it is seen—the more collectible/ salable your work will be? If the gallery director really wants exclusivity, agree to area (say, a 25-mile radius) exclusivity only, and negotiate for a trial period. Giving the gallery exclusivity during a one-person show, and for a brief period before the show and a few months afterward, also is not unreasonable.

- *Who is responsible for what expenses?* A commission of 50 percent, and even more, is not uncommon these days. I know, galleries incur expenses, but so do artists. The 50 percent commission really should cover an awful lot. Be wary of a gallery asking for a 50 percent commission—on the art you have already spent so much time and money working on—which then asks you also to pay for show invitations, advertising, postage, insurance, and so on. You might as well rent your own space, put on your own show, and keep 100 percent.

- *What happens if the artist dies?* The standard "This agreement, made by and between . . . and his/her heirs . . . " should take care of that.

- *What happens if the gallery goes out of business?* "In the event of ceasing operations," when may the artist pick up his work, and how is s/he to be notified?, etc. The clause specifying your ownership of the artwork will also help to back up your claim in the event of this scenario.

- *What happens if the gallery burns down?* OK, you have insurance, and the gallery has insurance, but what exactly does that mean? Will the insurance pay you the full retail price of your destroyed work, or the retail value minus 50 percent per piece, or the preceding less a $500 deductible, or just the cost of materials?

- *What are the details of your promised exhibition?* When will your show take place? How long will it be up?
- *Who sets the prices?* The gallery director knows what his/her market will bear. However, you know what your work is worth to you. Also, when you do raise your prices, don't lower them later, because there will certainly be someone out there in your public who will feel ripped off because s/he could have gotten your work at a lower price.
- *Who absorbs the discount if any is given?* I can see both sides of this one. At the most, though, agree to splitting it. Make sure that you are notified of a proposed discount in writing and that you agree to it in writing.
- *Who pays sales and income taxes?* The gallery should collect and forward sales taxes because the gallery is conducting the sale and collecting the associated moneys. The artist, as a self-employed person, should be responsible for paying his income taxes. The artist is not "employed" by the gallery because they have entered into a mutual contractual agreement. Conversely, the gallery is not employed by the artist.

These are just a few issues which can cause tremendous uproar for both artist and dealer. Better to sort things out before problems even arise. For more information consult the articles "Advantages of Written Contracts" and "How to Negotiate Contracts."

PART 3

Presentation

Manhassset Garden, 1990, Folded India ink drawing, 20"x16"x3",
Gail Eisner, Royal Oak, Michigan

Portfolios

Tools of Communication

Carolyn Blakeslee

Components of Your Portfolio

You have chosen to communicate with people, and to make a living, by producing visual art. The work speaks for itself. Or does it?

Written and other materials made to supplement visual art can serve several purposes: they can enrich the viewer's understanding of the work, deepen the viewer's appreciation of the artist, generate publicity, and facilitate sales. These materials come in the following forms: business card, resumé, bio, artist's statement, slide information sheet, audiotapes, videotapes, articles and reviews by others, and writings by you.

Business Card

You probably don't take your portfolio with you. So, at the very least, have a business card made. You might consider a business card that presents, in color, one of your artworks on the front, and your name and contact information on the back.

When you meet someone you would like to follow up with, exchange cards—within the next few days, call to set up an appointment to show your portfolio.

Resumé

Your resumé is the next most basic of your presentation tools. A resumé is a business document that tells, in a brief space and a dry format, what you have done with the last several years of your life. It gives the viewer an idea of how

educated you are, how experienced you are, where you have shown, and how you have been recognized. If your resumé is well-crafted and attractive, it also gives a positive impression of your creativity and your competence in other areas of your life. It serves a social function as well: it makes the viewer of your portfolio more comfortable. Besides introducing him/her to your background, it gives him a place to put his hands (other than into pockets); it gives the viewer a focal point when it is time to break eye contact; and it makes him feel more secure about investing time and money in you and your work.

Bio

A bio is a shortened prose version of your resumé. Your resumé has, at the top, your name and address; then a chronological list of solo shows; then a list of selected group exhibitions; selected collections; and so on. Your bio abandons the list format and consists of a paragraph to a page, written in the third-person, highlighting the events of which you are most proud. These may include solo shows, prestigious group shows, awards, commissions, major collections, and personal information about your home, studio, family, and travel facets of your life that have made an impression on you and your work.

Bios are especially useful for those writing about you: reporters, catalogers, gallery directors, publicists. Although writers enjoy writing, they find it helpful, especially when on deadline, to have information already in capsule form, rather than having to winnow their own prose from your resumé. So, feel free to juice it up a bit; the challenge will be to make it readable and interesting and catchy, while still conveying strong information in a reporterly fashion. Avoid self-accolade; your press clippings should communicate to people that you are The Greatest Show on Earth, not your bio. However, you may annotate, in a neutral way, your major accomplishments and landmarks here.

Artist's Statement

How many times have you worked something out by writing—in your journal, on a scratchpad, in your sketchbook? Writing your Artist's Statement can be an "Aha" as well as a joyful experience, and it can end up being a component of your business plan.

But self-knowledge is only a fringe benefit of the Artist's Statement. The purpose of writing one is to allow the viewer in—to increase his understanding

and appreciation of what you are doing and why. Imagine yourself back in your art history class. It is 8 a.m., and you would rather be in bed. Slides are being shown and discussed. The artwork *is* beautiful, though, and you start to wake up. As the lecturer explains the intricacies of light and shadow, thematic material, cultural factors of the time, the difficulties of the technique used, you hear little murmurs of "Oh!" and "Hmm," and you ask questions.

Your Artist's Statement is your opportunity to conduct a mini-art history class about yourself and your work. It might not be 8 a.m., but perhaps the viewer has a boatload of business things to take care of (or would rather be sailing). Your statement is a way to catch his interest and attention.

A statement might include information about your technique, your approach to working, your philosophy as it is expressed in your art, and major life experiences which have influenced your art.

Avoid criticspeak. Straightforward, honest writing is always refreshing, especially to someone whose business involves having to read criticspeak every day. Also avoid a patronizing tone, or on the other hand, overfamiliarity. Do not succumb to self-accolade; you are explaining *what* you do, why, where, when, how. Although the W's may involve some mighty personal and heartfelt information, it is nevertheless real information from the horse's mouth—not opinion— about why you work the way you do. Finally, avoid self-deprecation. For example, a common line in statements is, "I am attempting to . . . " Never say you are *trying* to do something, say you are *doing* it.

Probably the most successful approach is writing your statement like a combination of a good letter and a short story, written to a person whom you do not yet know but feel that you would like to be best friends with. You will be exposing your soul and mind to him to some extent, but you will be doing so in an organized fashion with your most accomplished and polished face showing.

Slide Information Sheet

Sure, everyone has a slide sheet. You just number your slides, and slip in a sheet numbered to correspond to the slides, giving the title, medium, size, etc.

But there is much more you can do with a slide information sheet. Beneath the caption information, you can write a sentence or a paragraph about how the work came about. In effect, you can make your slide information sheet into a series of mini-artist statements about each individual piece.

Audiotape

Perhaps you are gifted in music, and one of your pipe-dreams is to have your music played while your artwork is on display. Maybe you were interviewed on the radio. If you have audio that is well done and is important to you, include it in your portfolio.

Videotape

I would not be surprised to see videotapes become a standard part of the artist's portfolio. In just a very few minutes, a video can give the viewer a tour of your studio, a moving-picture idea of what you are like, and present a bunch of your artworks too—both in your studio and installed elsewhere, on location. That's not even taking into consideration the creative possibilities of your video presentation.

Your video can do double duty, too: many local cable TV stations are looking for fillers, arts pieces, and human/community interest pieces, and your video could fill any of the three slots if it is well produced.

Articles and Reviews By Others

Press clippings about you are where opinions get to show. Even ads and one-line gallery listings are fine. The purpose of this component of your presentation package is to let the viewer know that you are quite capable of getting publicity, and that your name is already in fact becoming known.

Articles and Other Writings By You

If writing is a part of your output, feature some of your writing in your portfolio in whatever way strikes you as being right. For example, if you are a poet, allow your poems to have a presence in your portfolio. Or, if you have published articles, tuck tear sheets into your portfolio.

Your presentation tools can serve to help present your artwork in the best light. Like selecting the proper frame or pedestal, your presentation package serves to give the viewer a context in which to see your work, or new facets of it. Thus, your presentation tools can truly assist you in generating sales, publicity, and understanding. And putting together a smashing portfolio can be just as rewarding as completing an artwork. Approached in a creative, dynamic way, it becomes an art form—an artist's book if you will—of its own.

How to Make and Use a
Portable Portfolio Book
Carolyn Blakeslee

This article is a continuation of the article "Tools of Communication." As I wrote then, "You probably don't take your portfolio with you." Well, why not?

In this article we will show you what to do with your tools now that you are in a mindset of producing or organizing them.

Uses of the Portfolio Book

- You will be able to do spur-of-the-moment presentations when caught away from home. People feel free to give photo presentations of their kids, so why shouldn't you feel free also to show your artwork? Your portfolio book can be placed into your tote-bag, large pocketbook, or briefcase and brought out when necessary.
- You can take your portable book with you when traveling much more easily than you can take original artwork.
- Many dealers do not like to visit artists' studios—there is too much pressure on everyone. The portable portfolio book will enable you to present much of your work at an appointment with a gallery director.
- When you have your show, the gallery director might wish to place your portfolio book on the reception desk or on a sculpture pedestal. The book can deepen the gallery visitor's understanding and interest in you and your work, and it can actually help the dealer sell it.

Components of the Book

Your portable portfolio will contain the following items: resumé; bio; artist's statement; slides, 4"x5" transparencies, B/W photos, and color photos; slide and transparency information sheet (your photos should have caption information affixed to the backs); price list (*retail* prices); and tearsheets of articles and reviews by others, as well as ads; and show invitations or catalogs. You might also wish to include other materials, such as a photograph or two of yourself and your studio.

Most artists find that a three-ring binder is quite practical for holding their portfolio materials. Others prefer to get a fancier version thereof, such as a

binder which can be zipped all the way around. The latter product will protect your stuff better, but the first is certainly sufficient. Of course, it never hurts to take a different approach—as an artist, you could do almost anything with it, such as create a piece of "book art" that happens to have your resumé and what-not in it. You could work with a different notebook size or format, even making a miniature. Or, you could make a special box and place everything into it—you get the idea. But for this article I will assume you are working with a standard-sized notebook.

You will need several holders and dividers for your materials:

- Clear protector pages, with a sheet of black paper, should be used in your "opaque" sections. Protector pages will keep your resumé, bio, statement, price list, and slide information sheet clean. The advantage to using black paper in your opaque sections is that you can put printed sheets or photographic prints into the protector page on both sides, and it looks neater—the backs of the other pages or photos won't be seen peeking around the edges of the one being viewed. These pages are also nice for presenting your color 5"x7" or 8"x10" photographic prints; black backgrounds tend to make the colors "pop" more than white backgrounds do.

- Clear plastic protector pages *without* black paper, or black transparency holders, may be used to protect your 4"x5" transparencies.

- Clear slide sheets, generally sporting twenty slots, house one's slides.

- If you don't feel like putting your reviews and other tearsheets into clear protector pages, you might consider "pocket" pages for holding them. Many such materials can be placed into the pockets inside the covers of notebooks, too, although I prefer to put my business cards and brochures into those.

- Dividers. Dividers are optional, of course, but it can't hurt to include them if you find that your portfolio book has become bulky. Also, dividers can serve to call attention to some major facet of your resumé; for example, if you have several photographs of artworks that were installed as a result of commissions, you should feature those in a separate section, called "Commissioned Artworks" or something like that. The photo will be of the artwork in its site, and the location may be given as you wish, i.e. the specific address, or just the city. Anyway,

dividers can be as simple as tabbed notebook dividers, or as elaborate as something you make yourself. Rub-on letters, in a variety of wonderful typefaces and styles, are available at graphic arts supply stores—that kind of detail can give your dividers a typeset quality.

Organization

Most portfolio books I have seen open with the resumé, followed by the bio, statement, then just about any mixture of the visual presentation materials, and finally the reviews and catalogs. But with this project, as with any other, you may do anything you want. Perhaps you will start off with a photo of one of your works, perhaps you will use photo pages as dividers—no matter how you organize it, have fun.

When you are finished, get some feedback. Go first to loved ones who are honest but not "brutally" honest, then to people you know less well, and then make your appointments with the people you want to carry your work.

Finally, don't leave home without it.

Rethinking Presentation Packages

Caroll Michels

A few years ago I began keeping track of the number of presentation packages my clients annually send to galleries, art consultants, and curators. I learned that *generally* it is taking fifty exposures of the *same body of work* to generate *one* positive response.

This means that on the average, fifty people must see slides, photographs, or other visual materials of the same work in order to either receive an invitation to exhibit, or spur interest in establishing a consignment relationship, sale, or commission opportunity. Although artists have sent fewer than fifty packages and received good feedback (in one case three packages led to the sale of three paintings), such experiences are by far the exception rather than the rule.

The good news is that because most artists only send between twelve and fifteen packages per year, this number of mailings does not even begin to approach an effective market penetration level to justify any sense of defeat or rejection.

The bad news is that preparing fifty packages that contain traditional presentation materials—including cover letter, slides, resumé, artist statement,

press clippings, and a self-addressed stamped envelope—can be unwieldy, costly, and time-consuming.

Artists spend an average of $12 to $25 on a typical presentation. The high cost factor, coupled with much wasted time waiting for packages to be returned by uninterested parties or tracing lost materials, makes it apparent that *there has to be a better way.*

In the summer of 1989, one of my clients decided to publish a brochure in conjunction with an open studio event planned for the following October. She had considered using a brochure for a long time, but was troubled by its negative connotations—unfortunately, some people sneer at brochures as a marketing tool, another one of those groundless taboos that have crept into art world protocol.

With the guidance of a graphic designer, she designed a six-page, 7½"x9" brochure that included three four-color reproductions of her work, a one-page biographical narrative listing exhibition credits, collections, educational background, name, address and phone number, and a two-page essay about her work.

One thousand brochures were printed, one-third of which were used to accompany an invitation to her open studio. They were sent to New York area galleries, private dealers, art consultants, curators, friends, and people who had previously expressed interest in or purchased her work. In the months following the open studio she sent brochures to gallery and private dealers, art consultants, and curators nationwide with a cover letter offering to send a set of slides if they found her work of interest.

I asked the artist to keep track of the response generated from the brochure for a 12-month period ending September 30, 1990. Following are the results:

- Brochures were sent to 329 art consultants, private dealers and galleries. She received forty-eight responses.
- Out of forty-eight responses, twelve people requested slides. Seven people retained the slides for future consideration.
- She developed consignment relationships with galleries in New Jersey, Connecticut, and Alabama, and two galleries in California.
- She was invited to have a one-person exhibition at an alternative space in New York City.

- She sold two paintings at the open studio event, another painting through the art dealer in New Jersey, and another piece at the one-person show.
- In addition, she sent several copies of the brochure to dealers and art consultants with whom she had previously worked, resulting in the sale of two additional paintings and a corporate commission.

Translating the results into dollars and cents, in the fiscal year ending December 31, 1989 the artist earned $4,143 from the sale of work; between January 1 and September 30, 1990 her sales totalled $15,750.

The cost of the brochure, including printing, layout, and design for 1,000 copies and envelopes, was $2,392. The artist spent another $533 for the design and printing of a letterhead for cover letters, making the total cost of the project $2,925. She sent the brochures first class at 45¢ each. Thus, the final cost of each package was $3.38.

Apart from budgetary considerations and achieving the highly unlikely feat of being able to send 329 slide packages a year, if my client had continued to use the traditional presentation, which was costing her $25 per package, she would have spent $8,225!

In addition to drastic cost savings, there are other important benefits of using a brochure versus a slide package:

- A brochure allows artists to reproduce work in a larger format compared to a tiny slide image. The slide viewing system was designed for the convenience of dealers, consultants, and curators, and is in no way in the best interest of artists.
- The use of a brochure also solves the problem of dependency on having materials returned for re-circulation. Often several months pass waiting for material to be returned, creating false hope that you have won someone's interest, when in reality the package is accumulating dust, the victim of a forgetful or disorganized dealer.
- Brochures are easier to handle and quicker to assemble. It is more likely that you will follow up on more leads or contacts and maintain a momentum for developing large mailings when time involvement is minimized. And brochures can serve a double purpose as a sales tool for dealers and consultants.

Additional information and guidelines about developing brochures is featured in the article "An Introduction to Direct Mail." The article discusses direct

mail campaigns, developing a brochure with other artists, minimizing expenses, and target marketing.

When considering brochures as a viable option to slide packages, be prepared for negative criticism from peers as well as others in the art world who suffer from petty jealousies or lack of understanding of basic marketing skills. Many artists as well as dealers fear making a move outside of the archaic and illogical rules of art world etiquette. But there are also many people in the art world who are looking for fresh, imaginative, and effective ways to find new audiences.

PART 4

Relationships

My Father's Stroke II, #2, 1990, Ink, wax, charcoal, prisma, conté on paper,
40"x26", David Dodge Lewis, Farmville, Virginia

Galleries

For the Artist Seeking
Gallery Representation
(excerpted from the book Washington Art: A Guide
to Galleries, Art Consultants, and Museums)
Lorraine Arden, Carolyn Blakeslee, and Drew Steis

Before you Approach a Gallery

The foundation of being a successful artist is respecting your own work. When you are producing consistent work that you really like, in a direction you are excited about, then you are ready to share it with the public.

Art dealers are people too; they like it when an applicant artist is genuinely interested in showing at that particular gallery—when an artist comes in with some knowledge about their philosophies and show approaches—as opposed to just getting a gallery, any gallery. Attending shows regularly will bring many benefits: the local art scene will become your own knowledge and not just hearsay. You will see for yourself the quality of work represented, the quality of the galleries' presentations, the extent of the galleries' advertising, and the sort of press coverage they generate. You will meet important people.

Build a list of galleries with which you are interested in exhibiting. Put these galleries on your personal mailing list and send them invitations to any shows in which you are participating. Add collectors, curators, and critics to your list too; these people will become familiar with your name and with your work. Add other artists you respect to your list as you meet them—you never know when a referral might result.

While you do your research, prepare your slides and portfolio.

Your Portfolio

Make sure your slides are truly representative of your work. The color saturation should be perfect, slide images should be squarely composed with no interfering background, and the slide labels and accompanying slide identification sheet should be neatly typed. A professional slide photographer will be able to assist you. Without fail, project your slides yourself and view them before you send them out to anyone.

Treat yourself to a neatly prepared portfolio book. Since the dealer is him/herself a professional salesperson, presenting your work clearly and neatly will help you. A good portfolio also speaks volumes about your professionalism over and above the quality of your work. A good portfolio book includes a current resumé, an artist's statement, press materials—even ads—showing that you are able to generate press, photographs of some of your artworks, and slides.

If you are calling the gallery for an appointment to show your portfolio, offer to bring a couple of actual pieces if they are portable enough. If you are sending them slides and a resumé, always enclose a self-addressed stamped envelope (SASE). These considerations are appreciated. And, SASEs make it more likely that you will get your slides back.

It is possible that you will be turned down several times before you contract with a gallery. Although it could be painful, *do not give up;* if your work is solid and presented well there is a dealer for you. Most dealers are always looking for new work even though they are often booked up to two years in advance.

Business Arrangements

Our questions to the galleries about their business arrangements elicited fairly uniform responses, so we are covering those matters here generally, rather than dealing with each individual gallery's policies. What follows are some usual policies. Terms vary, of course, from gallery to gallery.

Most gallery directors prefer a written agreement between the gallery and the artist. Specific policies should be addressed at contract time. Many of the galleries openly said that their agreements and terms vary from artist to artist—for example, sometimes exclusive area representation is arranged, other times it is not a requirement. When asked whether an artist owes the gallery a commission from work sold from the artist's studio, many gallery directors answered, "It depends."

Few professional art dealers are out to deliberately take advantage of their artists and clients. Granted, they all intend to make money, but if they acquire a reputation for not paying artists in a timely manner or not at all, or for dealing with clients unfairly or dishonestly, they hopefully will not be in business for long. Nonetheless, before you even approach a gallery, you should check with the grapevine and other sources to get a feel for the gallery's reputation. Find out if lawsuits have been filed against the gallery. Call the Chamber of Commerce, the Better Business Bureau, and the art dealer's association to see if any complaints have been lodged. Ask a few artists what they think of the gallery. If you trust your instincts and back it up with solid research of this kind, and take care of contractual arrangements in an objective and up-front way, your association with your dealer will hopefully be happy, long, and mutually productive and profitable.

Commissions run about 50 percent, give or take. The cost of mounting an exhibition really is very high. Starting with rent, staff salary, spackling and painting after each show, and moving on through printed matter, advertising and promotion, and receptions, the gallery business is not for the faint-hearted. Overhead can run thousands of dollars per show. Sometimes when discounts are agreed upon the discount comes out of the commission, sometimes not. Sometimes the gallery pays for the advertising, the framing, the receptions, the mailings, etc.—and sometimes not. If a gallery is taking a 50 percent commission, it surely should earn it! Make sure terms are understood. If they are not mutually agreeable and clear, no one will be happy.

If you have never set your prices before, a good gallery director can help you with that. (Also see the article "Pricing: It's All a State of Mind.")

Work is almost always insured while at a reputable gallery.

Usually the artist is responsible for some or all of the framing, and for transporting the work to and from the show. The gallery almost always foots the bill for a fairly nice opening reception for your show.

Galleries send out news releases announcing shows, and invitations to their list. It behooves the artist to send out releases too. Send out invitations to your list.

Most Washington, D.C. area galleries list in *galleries* magazine, the monthly publication giving current show information, as well as other magazines and newspapers. But display ads including a black-and-white photo start at

just $40. Even color ads are not out of reach. However, lead time is as much as four months before publication, so have your advertising plan prepared well ahead of time. Usually the gallery is willing to pay for some or all advertising. Make sure the ad image(s) and copy are mutually agreeable.

Usually the gallery will pay for the printing of several hundred show announcements. The gallery pays for postage to their mailing list, and the artist is usually responsible for postage to his/her list. Sometimes a catalog can assist in the selling of your work, but fancy catalogs are not usually produced for a first show. If the gallery director is proposing that you print a catalog, be wary of the costs; send out requests for at least a dozen estimates. Weigh all such expenses against your likelihood of profiting from the show or from the association itself.

Summary: The Long Run

Ideally the relationship between artist and dealer will develop and grow. As together you establish the salability and reputation of your work, the gallery should bear more costs. Gallery staff will prove themselves to you as they make sales and pay you promptly. You will prove yourself to them at the same time: do not call every day to see if anything has sold—besides being a pest, you might be interrupting a sale!

A good art dealer is concerned about short-run sales, yet will be interested in representing you for many years. S/he should be able to assist you in obtaining placement in galleries in other cities, in museum collections, and in corporate and public collections. You are in a business partnership together. S/he is not your boss, nor is s/he your employee. But one cannot exist without the other. Respect your relationship with your dealers and your buyers, and love the contribution to the arts that only you can make.

Making National Gallery/ Representation Connections
Caroll Michels

The 1988/89 edition of the *Art in America Annual Guide to Galleries, Museums and Artists* lists 3,358 galleries, alternative spaces, museums, university galleries, private dealers, corporate art consultants, and print dealers in

towns and cities throughout the United States, from Anniston, Alabama to Thermopolis, Wyoming.

Six hundred and eight of the *Annual*'s listings are located in New York City's borough of Manhattan, 129 in Chicago, 95 in Los Angeles, 37 in Atlanta, 35 in Dallas, and 14 in Kansas City.

Although New York is considered by many to be the art capital of the world (along with the erroneous assumption that New York artists are more talented than artists elsewhere), the main reason New York is deserving of its title is due to the large number of exhibition opportunities that are packed into the small island of Manhattan, and the vast range of disciplines and styles exhibited.

However, viewed in its entirety, the art world offers hundreds of thousands of exhibition and marketing possibilities throughout the United States. These resources are consistently overlooked and neglected by the majority of artists.

Provincial attitudes and artificial barriers about the art market restrict artists from career development. Many artists believe that their market is limited to their city of residence, or that some sort of universal censorship is imposed, illogically concluding that there is no market *anywhere* for their work if they are unable to generate exhibition opportunities or find a receptive audience in their own home town. Additionally, many artists are blocked from making national connections by pondering trivial details and the logistics of transporting work to other cities, and of working with out-of-town dealers and agents.

But it is important to keep in mind, regardless of the varied philosophic or altruistic reasons dealers give to explain their involvement with art, the bottom line is money. If someone believes *money can be made from your work,* geographic considerations become inconsequential.

Additionally, curators are under pressure to put contemporary art into a historical context, discover "new movements," and develop exhibitions of thematic content. Curators cannot rely solely on regional artists to accomplish their goals, and if they are aggressively pursuing a reputation in the art world, they are on a constant quest to discover artists who will reinforce and support a particular point of view.

The most effective way to find suitable out-of-town galleries is to travel. (Depending on your tax status in the eyes of the IRS, travel for the purpose of making contacts with galleries, agents, museums, etc. may be considered a

business expense and may be tax deductible.) The *Art in America Annual* can be a helpful preliminary tool in locating exhibition resources. On a state-by-state, city-by-city basis, it lists the names, addresses, and phone numbers of gallery dealers, alternative spaces and museums, and describes the type of art and/or medium of interest, as well as the names of artists represented or exhibited. Use the *Annual* for pre-travel research to compile a list of galleries corresponding to the various descriptions that apply to your work (e.g., works on paper, sculpture, photography, painting, etc.).

Other publications offer more detailed information about marketing and exhibition resources on a regional basis. (See "Resources," below.)

Visit each gallery on your list to ascertain whether *it* is right for *you*. Consider this to be an exploratory exercise, not the time to present your work. Deciding whether the gallery is "right" means paying attention to big and little details: initial impressions; the work exhibited; quality of exhibition design; light and space considerations; and envisioning your work in a particular gallery.

In addition, know the gallery's price range. A gallery should offer you pricing breadth. Pricing can become a major issue for artists exhibiting both in large and small cities. Dealers in small cities easily hoodwink artists into lowering prices to fit into a framework of what they believe the local market will bear. However, regional pricing is immoral and impractical because it penalizes your market in large cities and patronizes your market elsewhere. Regional pricing also supports elite notions that people in small cities or rural areas are incapable of "valuing" art.

Eliminate from your list those galleries that fall short of your standards.

Next, concentrate on the ones that have made an impression. Try to set up an appointment, mentioning that you are from out-of-town. New York galleries are notorious for being inaccessible to unreferred artists. Galleries in smaller cities are generally more availing. (Refer to the *Art in America Annual* for the name of a gallery's contact.) But if you are unable to make an appointment, drop off or mail a presentation package.

If you are unable to visit galleries in person, you can get an idea of the type of work out-of-town galleries exhibit by scanning art periodicals, studying gallery display ads, and reading articles and reviews that are accompanied by photographs.

If you are unfamiliar with a gallery's reputation, before committing to a consignment and/or exhibition arrangement, contact artists who are already involved with the gallery for feedback. (The names of gallery artists are listed in the *Art in America Annual.*)

Negotiating with out-of-town dealers can be as simple as sending a contract that outlines your requirements, and, if necessary, being willing to compromise over certain issues. It can be as complicated as persuading a dealer to use a contract! A good contract should cover a wide range of issues. Unfortunately, many of the contracts issued by dealers are narrow in scope and do not take into account the very realistic scenarios that can and do develop in an artist/gallery relationship. (See the article "Artist/Dealer Contracts.") However, there is an abundance of resources available that provide legal guidelines and sample contracts. For example, Dynamic Documents offers detailed generic contracts that address important issues in a gallery consignment and/or exhibition relationship (available from Dynamic Documents, c/o Elizabeth Crounse, Lake Shore Drive, R.R.D. 4, Lake Carmel, NY 10512). Similar sample contracts are provided in *The Artist's Survival Manual* by Toby Judith Klayman and Cobbett Steinberg, Charles Scribner's Sons; and *Legal Guide for the Visual Artist* by Tad Crawford.

National contacts can also be made by participating in out-of-town museum, alternative space, and Percent-for-Art slide registries, and contacting corporate art consultants, university galleries, and museums.

Developing markets beyond your home city offers many rewards. Extending your horizons beyond the United States should also be investigated. (See the article "Making International Connections.")

Resources

Access: A Guide to the Visual Arts in Washington State. Profiles 161 commercial galleries, 49 college and university galleries, 49 nonprofit exhibition spaces, 28 alternative commercial spaces, 18 museums, art schools and programs, art organizations and services. A chapter outlining Washington State's artist/dealer consignment law. $7.95.

An Artist's Guide to New England Galleries: An Insider's Resource Book. Lists over 200 resources that exhibit contemporary artwork in New England. The Artists Foundation, 617-227-2787.

Art in America Annual Guide to Galleries, Museums and Artists. The 1992/93 edition lists nearly four thousand galleries, museums, alternative and university spaces, throughout the United States. $15 (includes shipping). *Art in America,* 542 Pacific Ave., Marion, OH 43306, 800-347-6969, 614-382-3322.

Artist's Guide to Philadelphia. Profiles the art scene in the greater Philadelphia area (includes Bucks County, Allentown, Bethlehem). Fifty-six commercial galleries, seventeen alternative spaces and public businesses that show art, eight co-op galleries, twenty-six university galleries, fifteen community galleries, eleven museums and municipal galleries. Submission requirements, usual commission and contractual arrangements, etc. $11.

Artists' Gallery Guide for Chicago and the Illinois Region. Lists 253 commercial galleries, alternative spaces, cooperative galleries, college and university galleries, and museum spaces in Illinois and adjoining areas (St. Louis, Milwaukee, Indiana). Includes a copy of Illinois's consignment law. $16.

NAAO Directory. Lists organizations (300+) that are members of the Nat'l Assn. of Artists' Organizations. Fairly detailed descriptions of their spaces and programs including policies, budget info, mission statements, facilities, disciplines served, other programs and services. $25 (includes shipping). National Assn. of Artists' Organizations, 918 F St., N.W., Washington, DC 20004, 202-347-6350.

Washington Art: A Guide to Galleries, Art Consultants, and Museums. Profiles 158 commercial galleries, 58 art centers and alternative spaces, 23 corporate art consultants, and 23 museums in the Washington, D.C. metropolitan area. (EDITOR'S NOTE: This book was prepared by *Art Calendar* in 1987 and published in 1988, thus it is out of date. The book is still available for $5, but we recommend that you call your target galleries first to make sure they are still in business and/or at the same location.)

Going National/ International

Making International Connections
Caroll Michels

I recently met with an American artist who regularly exhibits at museums and commercial galleries in West Germany and Italy. She sells enough work in Europe to enable her to have two studios: one outside of Rome, and another in New York City.

She described how well she is treated; that in Europe the occupation of artist is cherished and highly respected, but her main problem is that she is without New York gallery representation.

"Are European dealers and museums putting pressure on you for New York representation?" I asked. The answer was no; this was her idea. Although she provided a lengthy monologue in response to my questioning why she needs a New York gallery, in essence the real issue was *validation*. She had bought the myth that New York gallery representation equals universal validation.

As she had been out of the country for several months I climbed onto my soapbox and gave her an overview of New York galleries. I told her that over the last 12 months, it has become increasingly difficult to differentiate between "vanity galleries" and what are considered "mainstream" galleries, because of the incredible amounts of exhibition-related costs galleries demand artists to absorb—in addition to requiring artists to *give* their dealer a piece of artwork if no work is sold during an exhibition. Most artists are acquiescing to the demands!

I descended from my soapbox. When the artist recuperated from shock she realized how fortunate she was to have cultivated European contacts that did not look to New York for validation of her talents.

For many logical reasons, I have always advocated developing markets outside of your hometown. With the increasing New York gallery greed factor,

which—like other sordid business practices of the past—will eventually trickle down to galleries in other regions, it is becoming even more important for artists to diversify markets.

In the article "Making National Gallery/Representation Connections" I pointed out that "provincial attitudes and artificial barriers about the art market restrict artists from career development. Many artists believe that their market is limited to their city of residence, or that some sort of universal censorship is imposed, illogically concluding that there is no market *anywhere* for their work if they are unable to generate exhibition opportunities or find a receptive audience in their home town." Also, many artists are hesitant to explore international connections because they worry over the logistics of transporting work to other countries. Geographic considerations are inconsequential. If someone is interested in your work, transportation costs and responsibilities can always be negotiated and worked out fairly. Keep in mind that you always have the *choice* as to whether in the long run it is worth the time, and sometimes money, to transport your work to foreign countries.

If you are intrigued with the idea of exhibiting and selling work abroad, but don't know how to make the contacts or get started, following are various resources that are available. Unfortunately, one comprehensive reference book does not exist that lists the names of all international galleries, museums, private dealers, corporate consultants, and alternative spaces, but several individual references are available.

The *Art Guide* series published by A & Black, London, provides good background information for contacting galleries, museums, alternative spaces, organizations, members of the press, etc., in selected international cities. Updated on a regular basis, the books are distributed in the United States by the Talman Company, 150 Fifth Avenue, New York, NY 10011, 212-620-3182. A catalog can be ordered from the distributor. The series includes the following books.

- The *Amsterdam Art Guide* ($9.95), edited by Christian Reinewald, covers Amsterdam and outlying cities and lists commercial galleries, art museums, and print galleries. The names and addresses of critics and art periodicals are also included.
- The *Berlin Arts Guide* ($19.95), edited by Irene Blumenfeld, includes museums, commercial galleries, and photography and craft galleries in Berlin.

- The *Australian Arts Guide* (3rd edition, $16.95), edited by Roslyn Kean, lists galleries, museums, photography and video resources, and art service organizations in Sydney, Melbourne, Adelaide, Perth, Brisbane, Canberra, Darwin, and Hobart.
- The *London Art and Artists Guide* (5th edition, $12.95), edited by Heather Waddell, includes over 600 galleries and alternative spaces, 100 museums, and art competitions.
- The *Paris Arts Guide* (3rd edition, $12.95), edited by Fiona Dunlap, includes information on galleries, museums, print studios, and arts organizations.
- The *Madrid Arts Guide* ($13.95), edited by Claudia Oliveira Cezar, lists galleries and museums.
- The *Glasgow Arts Guide* ($13.95), edited by Alice Bain, lists galleries, museums, studios, and arts publications.
- *The Artists Directory: A Handbook to the Contemporary British Art World* (3rd edition, $18.95), edited by Heather Waddell and Richard Layzell, is particularly comprehensive in covering information on contemporary British galleries, exhibition advice, public art program resources, awards and competitions, and arts organizations.

Many other resources are available:

The annual July/August edition of *Art & Auction* magazine, *The International Directory for Collectors*, lists the names, addresses, and telephone numbers of galleries on a country-by-country, city-by-city basis. It is annotated to indicate those galleries which show contemporary art and feature international artists. *Art & Auction*'s address is 250 West 57th St., New York, NY 10107.

The International Directory of Corporate Art Collections, published by ARTnews, contains information on one thousand corporate art collections including Japanese and European corporations. The *ARTnews* address is 48 W. 38th St., New York, NY 10018.

Although *Art Diary* and *Photo Diary*, published by Giancarlo Politi Distribution (P.O. Box 36, 06032 Borgo Trevi PG, Italy) is annually published, and lists the names, addresses and phone numbers of artists, critics, galleries, museums, cultural centers, and art periodicals in twenty-seven foreign countries, the entries are in fact not updated on a regular basis. You might need to refer to a second source to obtain correct mailing addresses.

Of course, the most effective way to make international contacts is to travel. By scanning periodicals that review and/or advertise international galleries, you can get an idea of the type of work certain galleries exhibit. International periodicals can be found in bookstores and libraries that have an extensive art section. The names of various foreign art periodicals are listed in *Art Diary*, *Photo Diary*, and the Art Guide publications mentioned earlier in this article. They include, for example, *Flash Art* (Italy), *Art* (Germany), *Canal* (France), and *Artscribe* (Great Britain).

In addition, the names of museum directors and curators in foreign cities can be obtained by contacting cultural attachés of embassies and consulates of countries that are of interest. Although an attaché might not have the names readily available, you can request that research be performed.

After compiling a list of museums and galleries, send each contact person a package of visual material and a resumé with a cover letter stating that you are planning a trip to their city, and would like to set up an appointment if they find your work of interest.

If you receive positive response, make the trip a reality! With confirmation of interest in writing, depending on your tax status, international travel for the purpose of making contacts with galleries, agents, museums, etc. might be considered a business expense and might be tax deductible.

More detailed guidelines for selecting and working with galleries in foreign cities are similar to those mentioned in the article already cited, "Making National Gallery/Representation Connections."

Developing international markets offers many benefits—not only increasing earnings and exposure, but providing realistic possibilities of traveling to and residing in other parts of the world. A list of benefits could go on and on, but for all practical purposes, with the way things are heading in the U.S. gallery system, international markets might be the only *palatable* option left to American artists by the end of this decade.

Sending Art Beyond the Pale: Problems with Interstate Sales

Peter H. Karlen, Attorney-at-Law

Most artists are familiar with horror stories about works of art shipped out of state. These works, solicited by out-of-state galleries and institutions that run competitions, have been known to disappear or be destroyed.

The problem is, these horror stories are being told with more frequency. For instance, contemplate the following three which wended their way to this writer's law offices. (Details of these tales of woe have been changed slightly to protect the innocent.)

Horror Story No. 1: A California artist sends paintings to a Miami gallery on consignment. Shortly thereafter the gallery files bankruptcy proceedings, and the artist's paintings are seized by the trustee in bankruptcy. The artist pleads unsuccessfully for the return of the works and has to hire a Miami attorney who does next to nothing for her. The trustee gives the artist two choices, however. The artist may purchase her own paintings or may "split" the paintings with the bankruptcy estate. The artist chooses to split the paintings with the trustee.

Horror Story No. 2: A California artist sends paintings to a Chicago gallery that wants to make prints from the paintings. The gallery promises to pay for reproduction rights. The paintings are sent by the gallery to the printer to make the reproductions, and the gallery defaults not only on payment to the artist, but also on the printer's bill. The printer demands payment from the gallery, and the gallery allegedly pledges the artist's paintings as security for payment of the printer's bill. The printer withholds the paintings despite demands by the artist because the gallery continues to refuse to pay the printer's bill. When the artist threatens to sue, the printer files a lawsuit in Chicago against the artist to determine title to paintings, and the artist must defend suit in Chicago. Again, the artist is given two choices: he can purchase his own paintings from the printer at auction, or pay the printer's bill. The artist decides to sue.

Horror Story No. 3: A California artist sends works to a Chicago gallery for purposes of examination after solicitation by the gallery. The cost of materials for said artworks runs into thousands of dollars. Despite proper packing in crates, the works arrive at the gallery completely destroyed, as if they had been dropped from an airplane. The gallery had promised the artist that the works would be insured, and the artist relied upon such insurance coverage. No insurance policy is in effect, and because the gallery was "not at fault," it won't pay. The artist lets the matter drop.

Frightened? Well, who could blame you?

Sending one's work out of the state is a risky business. It is easy to be tempted by promises of solo exhibitions and juried competitions at prestigious galleries or institutions thousands of miles away.

Furthermore, in order to advance one's career, chances must be taken. After all, the business of art is now conducted at national and international levels, and it is difficult to earn a reputation and a living by limiting oneself to hometown patronage.

Advice for the wary is straightforward. Check the out-of-state gallery's reputation for honesty and financial integrity within its bailiwick, especially if it does not have a verifiable reputation on a national or regional level. The investigation should be fairly thorough: telephone calls should be placed to local artists and arts administrators who can vouch for the integrity of the organization.

Having conducted the investigation, it would be worthwhile next to discover what laws will govern the intended transaction.

In the first place, the governing law will probably be the law of the state in which the gallery or other institution is located. A number of states have statutes which regulate artist-dealer relations, e.g., California, New York, Connecticut, Massachusetts, New Mexico, Texas, and Wisconsin.

Under some of these statutes, artworks on consignment are immune to the claims of the dealer's creditors. Thus, both Horror Stories No. 1 and No. 2 might have been different if the incidents had occurred in states having such laws; however, because the Chicago story did not involve a consignment and the Miami controversy involved federal bankruptcy law, there would still have been complications for both artists.

The statutes which protect against creditors' claims amend the provisions of the Uniform Commercial Code, in effect throughout the United States, that would otherwise protect a gallery's creditors who have acquired security interests in art from the gallery. Without these statutes, under the Uniform Commercial Code the consignor (the artist) has to file a statement with the appropriate state official (e.g. the secretary of state) indicating that s/he holds title, in order to vitiate later claims by bona fide creditors.

Horror Story No. 3, about the destroyed work, might be affected by those provisions of artist-dealer laws which make a dealer strictly liable for damage or loss of works placed on consignment. Naturally, such statutes might only apply to works within the dealer's control, and works being shipped by the artist to the dealer might not be covered. Nor is it clear whether return trips are covered.

Now that moral rights are in effect throughout the United States via the federal law, the Visual Artists' Rights Act of 1990 (see the article "The Visual

Artists' Rights Act of 1990"), the artist-victim of Horror Story No. 3 may have a moral rights remedy. Under the federal legislation, the artist may make a claim for any intentional or grossly negligent destruction of his work of art. However, it might be difficult to prove any liability on the part of the gallery for "gross negligence" or otherwise, and the action would probably have to be brought directly against the shipper. Of course, in such cases it is even difficult to prove "gross negligence" by the shipper since the shipper disclaims any knowledge of how the art was destroyed and there are usually no eyewitnesses coming forward to testify for the artist.

The artist also has recourse to other statutes. For instance, copyright laws give the artist the exclusive right to distribute his or her work publicly by sale, lease, lending, or otherwise.

The only exception to this exclusive right is given to those persons who are deemed *owners* of the works of art. Thus, one who purchases a work from an artist may resell it without violating the artist's exclusive right of public distribution as a copyright owner. In bankruptcy proceedings, the trick is to assert that the trustee or the dealer's creditor who intends to resell the work will be infringing the artist's copyright if a resale takes place. Therefore, it is imperative to register one's copyright in the work before the sale takes place and then sue for copyright infringement. This tactic may not succeed, however, if the court rules that the creditor or bankruptcy trustee is an owner under the law of the local jurisdiction or according to the copyright law.

The best method of protection, nevertheless, is to insist upon written contracts, which have legal effects. A good contract, whether formally drafted or in the form of exchanged letters, should indicate who will be responsible for insurance, damage, and loss. It should also provide for immediate return of the works before any bankruptcy proceedings are instituted or before the gallery is sold. Clearly, where no artist's protection law is in force in the jurisdiction where the gallery is located, it is best to ensure that the works and the proceeds derived from them be deemed *trust* property belonging to the artist.

Some further precautions have to be taken with regard to insurance. Obviously, the best method is to insure the works oneself for shipment to and from the gallery. However, if the gallery promises to maintain or purchase insurance which covers shipments, ask to see a copy of the gallery's insurance policy and certificate of insurance. Ensure by contract that the policy will be

maintained, and ask to be given a power-of-attorney to collect the proceeds if the gallery fails to make a claim.

Most importantly, if you can get a written agreement, try to include a provision which says that the law governing the agreement will be the law of your home state—if its laws are more advantageous to you—and that the courts in your home state will have jurisdiction to rule on cases involving you and the gallery or other institution. If you do not have the provision concerning jurisdiction, when there is a dispute you might have to seek relief where the gallery or other institution is located and might have to hire an attorney, sight unseen, in another state. Sometimes clauses that ostensibly establish jurisdiction in a particular state might be legally ineffective, so it is best to include a recital that the gallery or other institution is conducting business in your state, because this admitted conduct might justify jurisdiction in your home state.

If for any reason a dispute arises as a result of theft or destruction of your work taking place out of state, try to settle it with a minimum of expense. On the other hand, don't let others take advantage of you so that you are forced to "split" your works or "split the difference."

Where litigation is unavoidable, sue first, and sue in your home state if there is any reasonable basis for jurisdiction, i.e., the prospective defendant does business in the state or otherwise has substantial contacts with the state such as land ownership or part-time residence in the state. Conversely, if you do wind up litigating in another state and you have had few contacts with that state, try to challenge the jurisdiction of the courts of that state.

Your main problem with out-of-state litigation will be selecting an attorney. Don't randomly choose an attorney from a telephone directory or on the basis of friends' recommendations. For instance, in one of the Horror Stories mentioned above, the artist attempted to hire an out-of-state attorney. The first person selected after a lengthy canvass of friends had been dead for a number of years and thus was not able to help the artist with his legal affairs in Chicago! The second choice, also based upon a friend's recommendation, asked for a very substantial retainer. The third choice examined the merits of the case for a long time and then declined to take the case so that the artist's interests were compromised by procrastination.

It is best to try local art-law organizations for referrals. Most large cities have such organizations which are usually called "Volunteer Lawyers for the

Arts" or "Lawyers for the Creative Arts" or some similar name. When asking for a referral, don't automatically accept a recommendation from the first person who answers the phone because s/he might not be familiar with the competence of attorneys. Ask to speak to an officer of the organization; tell him/her about your case; then make a request for someone who has special knowledge in the area of law involved and who is competent and experienced. Better yet, have your local attorney do these things and have him/her investigate the background and reputation of the attorney who is referred.

Be firm and even tough when you feel that an injustice has been done. But be resilient, and don't aggravate yourself about an incident over which you might have little control.

Two of the above Horror Story victims did get aggravated. One became ill because of the injustice she believed she had suffered. Another became preoccupied with his misfortune and talked about it for months, but did nothing.

The last one was upset for awhile, but not too upset. He resolved to fight back and hired attorneys in his home state and in the state in which the wrong took place. Fortunately, he recovered some money and is on the way to recovering his property.

Market Research: Show Closings
Carolyn Blakeslee

Everyone knows that attending gallery openings is a good career habit. For one thing, openings give artists a chance to network. At openings, artists can usually meet VIPs—fellow artists, collectors, critics, gallery directors, curators. At the opening you also gleaned a great deal of information: you saw what So-and-So is producing now, and what his/her prices are now. You saw which works generated the most interest, which works attracted, which works repulsed. You probably overheard comments, some of which made you think, some of which made you chuckle. Just seeing *who* was there was a reflection of the artist, the show, and the gallery.

Ongoing post-opening market research is another important tool. Simply stated: What is getting attention? What is selling, where, for how much, and to whom?

One aspect of post-opening research involves what you probably do anyway: reading the reviews. How much attention has the show generated now that

the opening is over? Is there any way to tell how much attendance the post-opening publicity is likely to generate?

Visiting a show near its take-down time is another valuable, and often overlooked, follow-up study. Which pieces have the red dots? Did the entire show sell out, did nothing sell, did just a few pieces sell?

The following are several factors which you can use to analyze the reasons for a show's financial success:

- Popularity and reputation of the artist
- Pre-opening promotion
- Advertising
- Quality of the show itself
- Apparent VIP absence or attendance at opening
- Demographics of the folks at the opening: age, sex, marital status (if apparent), degree of affluence (if apparent), occupations—anything you can pick up about the crowd; break it down into percentages if you can
- Tone of reviews
- Popularity and reputation of gallery
- General state of the economy, nationally and locally
- Time of year

It is unlikely that you will be able to find out just who bought individual pieces, not that you would want to ask. It is also unlikely you will be able to discover the actual selling prices, but you can be quite sure they sold for close to if not at the asking prices, so you can get selling prices from the catalog, price sheet, or show labels.

Paying attention to what is selling where, and why, will give you lots of useful information in a short period of time. You don't necessarily need to nudge your work into a different direction, although that may be a possibility; for example, you might decide to "supplement" your deepest truest work which might not be selling as well as you wish. You might gain insight into your pricing. You might want to check into the possibility of representation at a different gallery, or you might decide that for several reasons—and be sure to identify them—your entire city is experiencing a slow spell and thus you might wish to wait it out, or to seek representation in a different area. Perhaps you will go out on a limb and open your own gallery.

Whatever the results—a new body of work, important business decisions, or just knowing more about the scene—researching your market can only help your cause. Nothing gives confidence, and results, like knowledge and preparedness.

Alternatives to Galleries

Primavera, 1991, Bronze bas relief, 48"x24"x2", Angela Treat Lyon, Santa Fe, New Mexico

Other Venues

How to Organize an Artists' Cooperative Enterprise (Based on a Model in Germantown, Tennessee)

Patricia Thompson

Germantown, Tennessee has few art galleries, and artists in the area did not have adequate representation locally. Some of the galleries are excellent, but were not able to properly represent all the qualified local artists. In order to exhibit on an ongoing basis, we needed an alternative. Some of us were loosely organized into an artists' gallery—a very casual group which made decisions in an often haphazard fashion. While I felt the concept was valid, I did not always enjoy the lack of organization. I kept thinking that we could be more profitable if we were well organized and selected our members wisely.

In December of 1985, I founded and organized our Artists' Co-op. The co-op has been successful since opening and every month we do better. We are always open to new ideas and methods that will make the group more successful. Our program is arranged to benefit both the individual artist and the co-op.

Several factors contributed to the initial smoothness of our cooperative venture. I have a background in administration and was familiar with real estate. I personally knew each artist invited to join us, or had a recommendation for them from someone I knew. The dedication of everyone in the group made painting and cleaning our newly acquired space and other tasks go quickly and efficiently. Today, two years later, the members of the co-op are still saying this was the best thing that ever happened to us.

Securing a Location

We selected a space in a very attractive shopping mall, located in an affluent part of town. I approached the mall, explained the nature of our co-op and

pointed out the benefits of having a gallery in the mall. I said the artists would be working in the space and having shows, which might bring a new clientele to the mall. The owners of the mall were pleased to lease space to us.

We worked out a short-term lease agreement. Under the circumstances, we felt it was important not to become financially responsible for a year's lease when the co-op was in its infancy. We obtained a thirty-day lease with automatic renewals; either party was obligated to give thirty days' notification if the space was to be vacated.

It is important to read the lease agreement very carefully. Be aware of which party is responsible for the maintenance and repair of the space, both interior and exterior, and who will handle problems that might arise with the heating or cooling system, toilet facilities, or other mechanical areas within the space. While many leasing agents have standard contracts, most items can be negotiated in or out of a contract.

Once you have agreed on your lease, you must contact the utility companies. Usually a larger than normal deposit is required for a new business. We elected not to get a telephone because the deposit required was very high; we decided we would rather work on art when we were in the gallery and not take care of personal business.

When you open a space or gallery in a business district, you will have to receive approval of the sign you place above your business entrance. If you select a mall location, as we did, you will need to submit a design to the mall management for approval and make any changes necessary. Our sign uses our co-op logo, which we also use on our business cards and stationery. It is now recognizable and is associated with the co-op.

Co-op Membership

Careful selection of artists is the single most important item to deal with. Quality of work, as well as personality, should be considered. Members will have to share in the decision-making and the work of running a co-op together. Everyone has to do their share. A mutual respect of each other's art is also essential. When browsers come into the gallery, the member on duty has to refrain from pushing his own work over that of other members. Scheduling staffing and cleaning is often harder than you might think, but we have been very successful in doing this because of the compatibility within the group.

Setting up a front end contract with each artist is important. When new artists sign contracts with us, they are also given a membership list and a list of general sales guidelines to follow. We have set a limit of twenty-four members at any one time. We keep a waiting list of artists wanting to join the co-op.

Each of the twenty-four original artists who joined the co-op paid a $50 fee (non-refundable) to cover start-up expenses and ongoing maintenance. Each new artist that joins our co-op is also required to make this payment. When we were just beginning, our initial deposit of $1,200 was enough money to get started. To meet our monthly expenses, each artist is assessed an equal percentage of the expenses as a monthly fee. We try to keep a little extra for emergencies. It is not our intention for the co-op to make money. The main purpose of the co-op is for artists to have a place to exhibit and sell artwork.

If an artist has an illness, or cannot fulfill his commitment to the gallery for a short period of time, a guest artist can be invited to fill his co-op position for up to six months. We invite potential co-op artists to attend a monthly meeting as a form of introduction. As a guest artist they are not assessed the $50 donation or the full dues. If a co-op member is to be gone longer than six months, he must resign and a permanent replacement is found.

All permanent members must pay their dues at the monthly meeting. If an artist falls behind in his dues, he risks dismissal.

Incorporation

We chose to incorporate to avoid putting each member of the co-op at personal financial risk. If an accident or injury occurs on the co-op premises or the business incurs debts that cannot be repaid, it can present a legal nightmare without incorporation. Incorporation means the business can be sued for all of its assets, but the artists who run the business are not personally liable. We work without debts by paying as we go. If we can't afford it, we don't buy it.

When you are ready to incorporate, it is important to find an attorney who specializes in incorporation. Don't be afraid to shop around and inquire about the fees. As a small business, a complicated incorporation is not needed. A standard incorporation application is sufficient. If the business is going to be nonprofit, this can be handled at the same time. After filing, it may take six weeks or longer for the paperwork to be completed.

Co-op Structure

We established a board of five to handle the major business decisions, such as insurance, mall representation, lease, and other financial matters. We also appointed a director to handle the day-to-day problems and general guidelines. Other artists in the co-op are assigned certain jobs, such as secretary, treasurer, supply person, publicity person, and monthly scheduler. These positions are all without pay.

We have a monthly meeting, usually lasting an hour, in which we discuss necessary business, set up open houses and bring up new ideas. We rotate our artwork in the gallery once a month and require members to use 30 percent of their space for new work or work that has not been shown in the gallery in the last four months. All members have equal spaces. Each month we rotate three spaces forward; this way each member has a chance to be in all of the gallery spaces. This rotation also provides a fresh look to the gallery each month.

Scheduling

Our gallery is staffed exclusively by the twenty-four artists whose work is displayed, and we are all volunteers. Having twenty-four members works perfectly for filling a 3-month work period. Each person signs a schedule for 3 months and works every other week. Of course, a lot of trading goes on, but each member is responsible for their days and handles the trades. Two members work together at the same time, so one person is always on duty during lunch or when a customer is being helped. With the 3-month schedule, two members clean the co-op at one time. We straighten up and take the trash out each day and the co-op is cleaned once a week.

Sales

We do not charge a commission on artwork sold. We feel each artist should share expenses equally, whether they sell a lot or a little. Each piece of artwork in the gallery is listed on a 3"x5" file card and placed in an inventory box. On the front of the card we list the pertinent information about the piece and on the back is purchaser information, to be filled in when sold.

We have a layaway payment plan, gift certificates, and a loan policy that allows a customer to take home a painting on approval. The customer leaves a check for the amount of the artwork, signs an agreement to return the artwork

undamaged and has a chance to live with the piece for a while without purchase. The check is not deposited until the customer returns or purchases the painting.

Bookkeeping

We keep a daily log in which we sign in and out, note sales, customer needs and general information. In it, we also keep a record of monthly sales and expenses. A copy of the artist's agreement and general sales guidelines are kept in the book. The minutes of our monthly meetings are kept in a separate book. Each artist reads the daily log kept on the days they work.

Public Relations

We have an open house every 4 months—in April, August, and December. Approximately 2 months before an open house, two members are assigned responsibilities for the show, including invitation, publicity, refreshments, and gallery preparation. When the invitations are printed, they are addressed by all co-op members on the days they work.

We have a guest book in the center of the gallery. When an interested customer comes into the co-op, we ask them to sign the guest book. These customers regularly receive invitations to our open houses. When someone purchases something from a co-op member, we make a file card on them and type a label. We do this on an ongoing basis; now, when we have an open house, all we have to do is photocopy our labels for the mailing.

The first year of operation we tried many different types of advertisement: mailers, fliers, ads in local magazines, newspapers, and open houses. We discussed these methods at our meetings, so each member would become familiar with advertising procedures and costs.

One year we cooperated with the mall to co-host a children's art show. The show brought a lot of new customers to our gallery and to the mall. It was so successful that the mall wanted to do it the following year; although it was extra work, it was well worth the effort for the marvelous publicity it generated for the co-op.

We spend time listening to our customers. They tell us all kinds of things, like how they like the gallery, what kind of art they want, etc. This has helped us to be more responsive to the art-receptive community in our area.

We also contacted our local newspapers and invited them to visit the co-op, with the hope they would write an article about our gallery. Three newspapers did.

An Introduction to Art Fairs and Festivals
Carolyn Fiene

Art shows are perhaps the most fun way to sell the works you create. This is where you get to deal directly with a lot of different people, both customers and other artists. Strong friendships often develop; you will look forward to specific shows knowing that former relationships will be rekindled. And such fun you will have watching the parade of customers—to say nothing of the thrill of having the customers gather round almost begging to buy from you!

Summers, holidays, and special civic events are prime times for art fairs and festivals. Seasons when others are buying are the times you can be selling. Summer tourists are thrilled to take home artwork from their vacationland. And special festivals bring out more of the locals too.

This sounds great, but how do I get into an art show, you ask? When you see a show in progress, stop and ask one of the artists how they got into the show. They'll be delighted to direct you to the person in charge. And if you spend a little time talking with the artists they will probably be able to tell you about other fairs and festivals that are coming up. They will even evaluate them for you, telling you what shows were really fantastic for them in the past—which ones had the most customers with money to spend. Art supply stores are another good source of information regarding art fairs. Many suppliers even sponsor fairs in order to help promote their own merchandise. Shopping malls often have periodic art shows. Call the mall manager and ask about possible fairs. There are special art and craft newspapers and magazines that list shows. These are usually regional, so again, talk to other artists and ask them about such publications for your area. It might be worthwhile to subscribe to one or more. Your local newspaper probably lists art shows under their coming events,

too. Contact your local Chamber of Commerce. They know what special civic events or festivals are coming up in your area. They will also be able to tell you who is in charge of the event. Whether an art show is planned for an event or not, call the person in charge. You might spur them on to include an art show in their schedule of events.

There is always a fee for participation in an art fair—at least I have never found one that is free. The more established shows, with the most public popularity, will be the most expensive. However, even though the cost of entry might be high, you are more likely to have more sales and end up making more money. Shows range in price from a few dollars a day up to several hundred. This fee covers the rental of your space and pays for the advertising done by the promoter/sponsor. Some shows also charge a percentage of your gross sales.

Many shows are limited as to the type of art to be sold. They often divide the show into categories and limit each category. This is for your benefit, as adding variety and interest to the show increases sales. It is a good idea to have smaller works available. Card prints, even miniatures on magnets, can bring in sufficient money to cover the cost of entry. Be sure to have a supply of business cards on hand; mere interest at a show could be a sale in the future.

Art shows are excellent places to test public reaction to your creations. Keep your ears open. Listen to the comments of the customers. I have picked up a lot of useful information just by eavesdropping on the people who stop to look.

Art fairs and festivals are exciting places to show and sell. I have been in fairs from New York to California. There have been big ones with thousands of people passing through, and small ones with fewer than a hundred customers. But I've always had a good time and have found them financially beneficial. It's so much fun—I do hope you will try it.

A Note from the Editor: Many years ago I spent several summers setting up on boardwalks during college breaks. I did charcoal portrait drawings. I had a great deal of fun, got the deep dark tan I wanted at the time, and met lots of talented and interesting people. Plus, I made a living (it certainly beat any other part-time jobs I took in the cold months)—and I am certain that anyone going into the fair and festival market with more seriousness than I had at the time could do very well, especially now that the major craft shows have become such hoi polloi places to be.

Anyway, here are a few other things to keep in mind.

- *You will probably be required to collect and remit sales tax on some occasions. The show sponsor's prospectus will tell you whether you are responsible for that, or whether tax will come out of any commission percentage you pay them.*

- *Once you get your feet wet trying your local circuit, you might decide to enter the fairs and festivals market more seriously. If you decide to go on the road, be prepared to invest in display equipment and a vehicle large enough to carry your artwork, travelling belongings, and display set-up.*

- *Speaking of display equipment, whether you go on the road or stay in your area, you might wish to be prepared for inclement weather: a tent set-up and/or tarpaulins should take care of protecting your display from a summer thunderstorm—or from the sun.*

- *A variety of security systems might be in order. There are transportable systems which will protect your charge slips and other items if you take them into a hotel room. There are vehicle security systems which will sound an alarm if someone tries to break into your van. There are security systems directly connectible to your local police department that will help to protect the integrity of your gallery or studio while you are away.*

How to Build a Wholesale Business
(or, How to Avoid Doing Shows
for the Rest of Your Life)
Karen Gamow

The following is an article on how we turned our fine crafts business into a stable, $150,000 per year enterprise in just a few years. I'm happy to share this information—the fruits of our labors were hard won, and my husband and I feel that it would be a shame not to help others who are where we were five years ago. With some hard work, the right approach, and consistent energy, anyone can do the same thing—it's definitely worth it. The artist will need to supply the hard work and the consistent energy. But here is an approach that we have proved will work.

My husband's brother had been a professional nature photographer for years, but was dependent on craft festivals to make ends meet. Shows are fun,

and they serve an important purpose. But they can become a grind, especially as the income is very irregular.

Five years ago, the three of us decided to work together and started a wholesale craft business. This year, we'll do $150,000 in gross sales with five full-time employees. My brother-in-law now makes more in royalties from our efforts than he ever did from his shows, and we have a thriving business.

The product we make and market is called Whispers from Nature Photography—it is original photography in miniature size. We chose to specialize in working with retail stores in tourist areas. Why? Because then we could send a solid, tested product to a shop, and be able to send that same product for years without making modifications. The tourists would be different each year, so there was less need to come up with something new all the time. Of course, stores always love new things, and that avenue is always available. Marketing through tourist shops, however, at least takes some of the pressure off having to create and produce new items. Tourist stores also generally have a much higher volume of traffic and therefore higher sales.

Our goal was to set up a business that could start quickly *and* run itself as soon as we were in a certain number of stores. We didn't want to be dependent on finding new accounts each year.

If you're just starting out and/or aren't sure whether your product will sell well in stores, I strongly suggest test-marketing and market research. We began our test-marketing and research at craft shows. We found a consistent pattern: over the course of the twenty shows per year we did, certain photographs *always* outsold others, no matter what time of year or what type of clientele. Look for buying patterns such as the average age of your customer, sex, and apparent income bracket. From those factors, think of the kinds of stores those customers probably frequent. Or, ask them straight-out. Visit those stores, and watch for similar kinds of patterns. Once you find a product that works consistently for you, then you're ready to approach a store's buyer with confidence; you will know that if s/he takes your work, it will move quickly off the shelves.

Once you have done your homework, you are ready to develop your presentation and information packets for potential buyers. Here are some ideas that have worked well for us.

- Create a display rack for your product—something small and beautiful to meet the needs of stores with limited space. Try to keep your costs as low

as possible—$10-15 is ideal. Go into a variety of retail stores to see what display methods they use, and tailor such methods to suit your product.

- Develop a fact sheet about your product that tells why it sells, how it is best displayed, and the costs and terms of getting started with an initial order.

- If your display costs more than a few dollars, charge the store for it, but do something to offset the cost to the store, such as offering free merchandise, so that it's no money out of the store's pocket and very little out of yours. For example, if your display costs $15, and each item you produce retails for $5, offer three free items with the first order to offset the cost of the rack.

- Go out in person and speak with store owners. Gather their advice on how to make your product more marketable, and how best to display it. After all, if you can't sell your work to them, the public will never see it.

- Take a few sales trips. Once we spent 4 weeks in New England selling to store owners in person, and we learned a tremendous amount about our customers. We found that we could drop in and show our product as long as we were professional and very brief in our presentation, and sensitive to the store owner's other responsibilities. Our sales pitch took less than a minute, and people made decisions quickly.

- Learn all the objections to your product, be able to overcome them quickly and with confidence, and be prepared to offer a money-back guarantee if you think the store is worth it, to prove your confidence in your work.

- If you don't have time to hit the road, that's no problem. Sales trips are a great way to meet people and to learn, but in fact it is more cost- and time-effective to solicit stores by mail. This is how we built our business so quickly, and it's the key to our current success. Frankly, the reason we didn't solicit stores by mail in the first place is that there were no mailing lists that met our particular needs.

- Buy a good mailing list. There are many list brokers in the United States who sell store names in almost any category you can imagine— museum shops, shell and nautical shops, country craft stores, etc. What we discovered was that there were no good lists of quality stores

in tourist areas—over a 5-year period we ended up creating a list ourselves. The stores on our list turned out to be a gold mine for us.

- To each of the hundreds of stores on our list, we sent a personal cover letter, a fact sheet, and a photo of our display, along with a sample or two of our photographs. (Don't worry if you can't squeeze a sample into an envelope—a good photograph of your product is all you need.)

- Be aware of timing. The best tourist stores buy very early in the year. It is important that they be contacted in January or February. (Many tourist stores are buying for their summer tourist season at that time, as they get little Christmas traffic. Who does Christmas shopping at Disneyland?) The smaller the shop, the later you can get away with contacting them—but by April, most of the stores you'd love to be in are bought up for the year. This timing schedule works well: it gives you something to do during the slow months after Christmas, and—since tourist shops are busy all summer—it balances out your Christmas season. Finally, non-tourist shops generally buy in January and July.

- Here's the piece of advice that too few craftspeople I know take. If you do, I can guarantee that your business will skyrocket, given that your product is marketable to begin with. Take all those store leads that you sent letters to, and CALL THEM within three days after they should have received the packet in the mail. When you call, your close rate will jump from 2-5 percent, to much higher. A full 25 percent of the people we personally call purchase our product. And 90 percent of them reorder. Why? Not only because our product works, but because we call our stores, even for reorders. Lack of follow-up is the single most common reason for poor sales by wholesale craft people.

Always be open to fine-tuning your idea of who your market is. You can't market your stuff to everyone. It can take a year or more to draw any conclusions, but it's time well spent. We were surprised to discover, for example, that Whispers from Nature photographs do well in shops with wood or pottery, and poorly in places with glass or baskets.

If you're excited about getting started, then this article has been worthwhile. Starting this business and watching it work has been one of the most enjoyable projects I've ever undertaken. Good luck to you, and happy wholesaling.

For a free packet on how to get new store accounts by mail, send Whispers from Nature a self-addressed stamped envelope. The packet will include how to write a good solicitation letter, what to say when you make your first call, and a simple system for keeping track of your follow-up calls. Write Whispers from Nature Photography, 14618 Tyler Foote Road, Nevada City, CA 95959, or call (916) 292-3727. You may also get free details on their mailing list of 800 country gift stores and 350 nautical/shell theme gift shops all in tourist areas around the United States.

had to be currently working in the greater Washington metropolitan area, which takes in parts of Virginia and Maryland; they had to be recognized by their peers; and their work had to be appropriate to an office environment."

Having established the rules, Mr. Fowler turned to professionals for help during the next phase.

"We had two art consultants, Susan Agger and Terry Lubar, and they went out and identified a number of artists that they thought met our criteria. Then my wife and I went out to visit studios, visit the artists. We selected those artists we wanted to include and we identified the works that were available at the time and seemed to fit."

Terry Lubar, owner of Arts&Design, a Washington, D.C. based arts and interior design consulting firm, said the job of identifying Washington artists took quite a bit of research. "We spent several months visiting galleries, shows, exhibitions, and talking to artists before we compiled a slide show of fifty artists. From these, thirty were chosen and because they were what we like to call 'emerging artists of quality' we knew their art would be somewhere in the range of $2,000 to $6,000 each."

During the 1988-89 period, forty-one works were purchased from twenty-nine local artists. Media included oil, acrylic, watercolor, and other works on paper including charcoal, crayon, pencil, ink, as well as polychrome, enamel, wall sculpture, mixed media, clay, and photography.

Washington artists represented include: Ed Ahlstrom, Allen D. Carter, Peter Charles, William Christenberry, Y. David Chung, Peter Costas, Patrick M. Craig, Joan Danziger, Georgia Deal, Roger Essley, Susan Paul Firestone, Fred Folsom, Patricia Tobacco Forrester, Carol Brown Goldberg, Tom Green, Martha Jackson-Jarvis, Jacob Kainen, Susan M. Klebanoff, Susie Krasnican, Edith Kuhnle, Leslie Kuter, Mark Alan Leithauser, W. C. Richardson, Robin Rose, Eric Rudd, Sherry Zvares Sanabria, Andrea Way, William Willis, and Yuriko Yamaguchi.

Today the collection hangs on office walls and in public spaces on four floors of the Peat Marwick headquarters at 2001 M Street N.W. in Washington. Recently the pieces were rotated for the first time, changing the locations of the major pieces for a fresh look. A new catalog of the collection is being prepared. Individual and small group tours are permitted with advance telephone reservation.

Corporate art collections are not a new idea. Abbott Laboratories in Chicago started its collection in 1930 and now owns 252 works of art. The

Curators

Interview with
F. David Fowler, Corporate Curator
Drew Steis

"Decoration or collection?"

This was the question for F. David Fowler in 1988 when KPMG Peat Marwick moved to larger offices in downtown Washington, D.C.

Mr. Fowler, as managing partner of the international accounting and management services firm, said deciding whether to buy decorative art as opposed to establishing a corporate art collection was not difficult.

"We had a very practical reason for starting the collection," Mr. Fowler said. "We wanted to have artwork that was consistent with the quality of the new facility but first, many questions had to be answered.

"The easy thing to do would be to go out and identify works that at a minimum cost would fill up the walls just to have something on the walls. We have chosen to have what we think, and what others seem to think, is a quality collection instead of just filling up the walls."

In the process, Peat Marwick has established a first-rate corporate art collection dedicated to, and limited to, the works of living Washington-area visual artists.

"We see ourselves as a Washington organization although we are part of an international organization. So we thought, what better way to tie ourselves even closer to our community than to work with local artists to enhance our space? So it was a practical consideration of having space we needed to enhance, and it gave us the opportunity to work with local artists."

Once the decision was made, David Fowler established the collection with the same attention to detail that has made Peat Marwick famous.

"We spent a lot of time talking about the idea and we consulted many people before we set up the criteria. To be included in the collection, the artists

Anheuser-Busch collection in St. Louis, Missouri goes back to the late 1890s. Corporate collections can be general in nature, or specific to local artists or to a style or period of art. There are at least three other Peat Marwick corporate art collections at offices in Philadelphia; Chicago; and Orlando, Florida. A good resource is the *ARTnews International Directory of Corporate Art Collections,* which lists hundreds of collections with contact names and addresses. It was published by *ARTnews* & International Art Alliance, Inc. (See the article "Making International Connections" for contact information.)

David Fowler is no stranger to the arts. "Wherever we have been, my wife and I have been very involved in the visual and performing arts." He has been active on the boards of the Mississippi Museum of Art in Jackson, and in Washington, D.C. the Cultural Alliance, National Symphony, Washington Opera, and the National Capital Children's Museum. He currently serves on the board of directors of the Corcoran Gallery of Art.

What advice does David Fowler have for artists who would like to have their art included in a corporate collection?

"It is so difficult. The key to being included in a corporate collection is no different from being in an outstanding private collection: you have to be known, have a good gallery. I get invitations to every gallery opening in town, every exhibition and show, but it is tough. I wish we could do more with local artists but the budgetary constraints limit us."

David Fowler says the Peat Marwick Art Collection is by no means closed. "We still have bare walls. But we have taken the position not to buy works of lesser quality simply to fill those walls. We want to fill those walls with works that we think are consistent with the rest of the works."

Mr. Fowler says that while no formal budget or acquisition plan has been decided on for 1990, "We will be making some acquisitions this year but probably not a lot. I would guess probably fewer than ten pieces—or something in that range.

"Some of the artists we identified initially did not have works available at that time that fit our needs. We will probably go back and make selections from those artists, and I am sure we will look for other artists as well.

"I wanted some time for the original collection to settle in. I do need to establish a plan to add to it because there are so many wonderful artists and we still have walls that cry out for them."

The Benefits of
Working with Art Advisors

Brenda Harris

Are art advisors a viable choice in building visibility and your resumé as well as in developing a support base of appreciative buyers?

As an artist, you are faced with an increasing number of choices about how and with whom you develop your career. An unregulated and highly political art industry complicates your decision-making even further.

However, there is no regulation that states you must choose only one means of promoting your work and developing your career.

Available to you today are a growing number of galleries, publishers, art agents, and representatives, as well as consultants who specialize in advising either artists or collectors. For this reason it is extremely important that you learn to ask good questions in order to determine which marketing mix (price, promotion, distribution, and art product) is best suited to your short-term and long-term goals. This article will focus on art advisors as a point of promotion and distribution.

There seems to be quite a lot of controversy and incorrect use of the terms "consultant" and "advisor" in the art industry. Often the two terms are used interchangeably. The power of reasoning, the knowledge of common business practice, and the help of Mr. Webster can help us to arrive at a definition. According to *Webster's*, a "consultant" is one who consults or gives professional advice or services to another. An "advisor" is one who gives information or notice. "Advice" is defined as a recommendation regarding a decision or course of conduct and "implies real or pretended knowledge or experience, often professional or technical, on the part of the one who advises." To counsel "often stresses the fruit of wisdom or deliberation and may presuppose a weightier occasion, or more authority."

In these definitions, one of the sources of today's confusion in the art world is uncovered. Our culture has created a modern-day monster called "consulting," which often is used by those who might have good intentions, but who are not fully qualified or trained to advise or consult. Many of these individuals are unaware of the meaning or responsibilities associated with being an art consultant or advisor. These professional designations are often

inappropriately used by gallery or artist sales representatives to indicate expertise and imply that the information is provided in the client's best interest. In reality, it is the product with the greatest profit potential, not artistic quality, that might be promoted.

An art advisor is paid by an individual or organization to provide, without bias or conflict of interest, art information and related services. The Association of Professional Art Advisors best defines an art advisor as a professional who is "qualified to provide professional guidance to collectors on the selection, placement, installation, and maintenance of art. The professional art advisor has an understanding of art history, art administration, the art market, educational concepts, contemporary business practices, public relations, and communications." The professional art advisor is trained to counsel and oversee all aspects of an art program.

It is reported that more than half of the businesses purchasing art today use the services of in-house or independent art advisors. As a result, a growing number of artists will approach or be approached by art advisors and consultants in the 1990s.

There are some guidelines that will help you determine if you are working with a professional art advisor.

First, art advisors do not maintain permanent inventories of art. This is beneficial for artists since their work is not tied up for extended periods of time. The work is generally consigned for a short time for presentation and approval purposes, thus making the work available to prospective buyers through several distribution outlets (art registries, galleries, other advisors) in wider geographic areas. This is especially attractive to artists who do not yet have the promotional support of a nationally recognized gallery.

Second, whereas a dealer is committed to specific artists and profits from the sale of their work, the art advisor is paid *by the client* to make recommendations and does not have any profit interest in the sale of a specific work. The art advisor is free to concentrate on the aesthetic quality and suitability for a specific collection.

Third, as with other concerned and qualified art professionals, art advisors take great care to develop equitable contractual agreements between the client and the artist for commissioned work, to protect both you and the client. Do not be afraid to inquire about this process or request documentation. The best

art professionals do not want to see either the buyer or the artist shortchanged. A successful commission or placement is one in which both the buyer's and the artist's needs are met.

When making decisions about the mix of art professionals (dealer, agent, representative, advisor, etc.) who will help develop your career, it is reasonable to ask for credentials and seek information about the art professional's involvement and reputation in promoting the cause of art. Ask about the degree of involvement the art professional will have on a project or special commission. What steps will the art professional take to ensure a successful project for everyone concerned? It is your career, your art, and your future.

Artists are finding that working directly with art advisors has opened new doors in geographic areas not covered by their dealers. Many art advisors work to generate publicity for and promote the cause of artists as well as promote recognition for a client's collection. Artists can benefit from the art advisor's important ties to the media, galleries, other art advisors, museum professionals, and individual and corporate collectors.

The choices concerning how you develop your career and who you work with are up to you. Each art professional establishes individual business ethics, practices, and contacts. Choosing the right mix of professionals can contribute to your future success. But, remember, your success may be determined by the quality of the questions you ask.

Marketing Out-of-This-World Art:
Interview with Angela Manno, Artist/Curator
Drew Steis

How did a batik artist end up with a one-woman, four-year travelling art exhibit sponsored by the Association of Space Explorers?

And how did the same artist find herself organizing a major show on space art now in search of a gallery and curator?

Even the artist admits it is strange. But Angela Manno says it really wasn't a giant step to go from dyed fabric to deep space.

Her new art form—transferring photos and other images of earth and deep space provided by the National Aeronautic and Space Administration (NASA) onto fabric—has proved to be more than artistically and financially rewarding.

Ms. Manno put together an invitational show about space art in conjunction with the 1992 celebration of International Space Year.

"We selected ten artists whose work we know," she explained. "The theme was 'Space Exploration and the Changing Self-Image of Mankind.' This show was sponsored by the Association of Space Explorers, an exclusive club of 145 men and women who have orbited the earth at least once."

Proceeds of the show were divided among the association, the artists, and the gallery space, Ms. Manno explained. "It was a fund-raiser for the Association of Space Explorers, a group founded in 1985 after three years of planning with the purpose of bringing together people who have travelled in space, and to encourage the exploration and use of space exclusively for the benefit of all."

Space art, Ms. Manno says, dates from the 1940s and should not be confused with the "little green men" school of science fiction illustrative art.

"Chesley Bonesdell in the early 1940s did remarkable paintings of Saturn well before there was any imagery of the planet. He was able to depict the landscape from several different perspectives with almost 100 percent accuracy but that has only been proved relatively recently. His paintings were published in *Life* magazine in the 1940s."

The journey from batik to beyond the stars began for Ms. Manno when she became fascinated with photos of the earth taken from space by NASA. She had studied art at the San Francisco Art Institute and batik with Jyotirindra Roy, the well-known Indian artist.

Ms. Manno has blended the two arts into what she calls "an unconventional medium." She first takes NASA photographs of the earth and transfers them to heat-sensitive photocopy paper. Then she transfers them to batiked fabric and fixes the image with heat so "the ink goes right into the fabric." The results she describes as surrealist.

"The astronaut Rusty Schweickart, an association member, saw my work and asked me to set up a one-woman show for the association's annual meeting which in 1987 was to be held in Mexico City. Xerox Corporation gave me a grant that allowed the thirteen pieces in the show, 'Conscious Evolution: The World Is One,' to also travel around the United States for four years."

That show is still together and Ms. Manno says she would like to see it stay together and find a permanent home in some public space. She refused to sell

the pieces individually but says she has received a number of both public and private commissions from people who have seen the show.

Angela Manno has been supporting herself with her art for the last five years. "I was invited by NASA to be their guest at the launch of Discovery at the Kennedy Space Center in 1988. My impression of the launch is now part of the Center's public art collection." Her work is also owned by corporate and more than sixty private collectors.

The space art show was her idea. "I have an affinity with the Association of Space Explorers because in my work I have been inspired by the photographs of earth from space and how that gives testimony to the Earth as a whole system. It makes us all rethink how we are all interrelated. 1992 was a time when a lot of people will be focusing more on the external and commercial possibilities of space exploration. But there is also a very important human, spiritual, cosmological, dimension that needs to be heard. When you see the Earth as this image everywhere—it is really a profound symbol and has a very deep psychological effect on people. I wanted to increase that kind of awareness through a show of this kind."

The show featured works by both U.S. and Soviet space explorers and artists. The lineup included Alan Bean, an Apollo 12 astronaut who walked on the moon; Alexei Leonov, the first man to walk in space; Robert McCall, a well-known space artist; Andrei Sokolov, the Soviet painter whose works have flown in space aboard a Soviet spacecraft; and Pat Carr Musick, a U.S. artist.

Juried Shows

Juried Competitions:
Don't Give Up
Carolyn Blakeslee

One artist expressed confusion that one of her paintings had won an award at one juried show but had been rejected from the next two she entered.

Another artist entered his first juried show at a nearby art center and his work was not selected. He quietly picked up his rejected works and wondered if he should give up. He disliked the work the juror had chosen, too.

A third artist, supposedly an experienced photographer, entered a local juried show and was accepted, but did not win the photography award. He disagreed with the juror's selection of the winner and removed his photographs the day after the opening.

Entering a juried show can bring up some powerful emotions. The very language associated with the process is loaded: "submit" your work, "jury" results, "hanging" days. All the same, most artists enter juried shows sooner or later and throughout their careers. The ground rules, and the rationales and decisions of jurors, may seem arbitrary or disputable, but they are understandable.

It is true that jurors are subjective. Each person responds to art subjectively, bringing to it his/her own opinions, preferences, memories, schooling, associations, and experiences. Jurors' decisions are based partly on personal response; otherwise they could not be honest about which pieces gave them a gut reaction. That reaction is an emotion or thought which, whether positive or negative, the juror finds strong and relevant enough to make a piece attractive in the context of the show.

This is the first thing many jurors look for—the gut reaction, whether the piece makes a strong impression as a whole. Many jurors, faced with the knowledge that they must choose 45 pieces from 300 entries, sit through the slide

show and reject some pieces very quickly, reserving perhaps half for a closer look on later go-rounds.

For other jurors, a piece's strength or weakness might become apparent only after taking a piercing look at it. For one juror—Cora Rupp, executive director of the Art League in Alexandria, VA—strength begins with consistency within the piece. Recently, while jurying a show, she stood before one painting and admired the beauty and mystery of the brush- and color-work in the middle of the canvas; she was drawn into the cool piney quality of the gesturally painted grotto. But the field of wildflowers in the foreground seemed like a different painting—as she said, "This is a discount-store fabric design, it is not the same painting, yet it is on the same canvas."

Even when an artwork is consistently executed, it may or may not fit into the theme of the show. One cannot predict a juror's decisions. The artist may feel that his/her work fits beautifully, complementing the theme with a new approach. But the juror may feel that it reads differently. For example, an abstract expressionist painting of a woman was viewed more as a feminist piece than as a portrait in a show about portraiture. In another show about recreation and the out-of-doors, a painting of a child playing, a photo-realist close-up, was read as a portrait and not as a painting of recreational activity.

Richard Andrews, former director of the Visual Arts Program at the National Endowment for the Arts, reported to us in 1985 that on the average at least half of the applicants for the artist fellowships are rejected immediately because of poor slide quality. Out-of-focus images, poor color, and interfering background matter—the easel, or the grass and trees in the front lawn—are the usual culprits. So, when entering a competition that will be judged from slides, make sure your slides are excellent.

View the slides yourself, projected, before sending them to anyone. I cannot emphasize this enough. I have a horror story of my own. I had several slides made of my work; I placed them upon a light table, and they looked fine. A month or so later I took the slides to a critique evening and was appalled to see that the silver tape had been applied sloppily; the crooked lines in the tape which had been too small to catch on the light table were loomingly large on the screen. The color saturation was incorrect. The surfaces of my paintings glared due to improper placement of the lights during the photo session.

Quality of presentation is another critical factor in jurors' decisions. Paintings that are accepted during the slide viewing are sometimes rejected upon arrival because the frames have been carelessly slapped on. Many other pieces are rejected on the basis of matting. From a recent show entitled "Jazz," one otherwise attractive piece was rejected because of the mat's dark color. Light, neutral mats are the industry standard.

But who is to say whether a dark mat is incorrect for a particular piece? Who is to say that the artist's judgment is incorrect? Of course only the artist can answer aesthetic questions, but if the goal is to participate in the "game" then certain guidelines of presentation can generally be counted on:

- Hire a professional photographer of art to produce your slides, or take an in-depth workshop on producing your own.
- Whether you take the slides yourself or hire a professional, project them and view them yourself before sending them *anywhere*.
- Always order a show prospectus before entering. When ordering a prospectus, enclose a self-addressed stamped envelope (SASE).
- Send in your entry on time, using the entry form that they have devised, rather than sending in entries "cold," and adhere to all other instructions in the prospectus. This may make their filing and organization easier, or it could be a throwback to the "follow directions" days—it does not matter. It's the way it's done. Include a SASE for the return of your slides.
- Never use "bracket" frames. They can cut people handling your artwork.
- Make sure your frames are well-made and carefully put together. Get your work professionally framed, or buy molding at a home improvement store or at a do-it-yourself framer's and construct a good quality frame. You merely have to cut your miters carefully, making sure that the painting's stretchers have not warped, and that the stretchers form perfect 90° angles. Learning to measure carefully and cut miters takes five minutes; perhaps the people at the lumber store would be willing to show you how, or even cut the miters for you there. Your measurements must be accurate within $\frac{1}{32}$"—this is not difficult. Wood-fill putty will make up the difference.
- If you mat your work, use light, neutral-colored mats.

- Accept the juror's decisions. Do not remove your pieces from the show before you are supposed to. And do not give up if your work has not yet been accepted. If you are persistent and follow the rules, it will be.

Even when protocol is followed to the letter, though, one can never be certain of the outcome. Alex, an artist, paints consistently. His work has the strength and quality he wishes to convey. He has produced excellent slides for his well-presented portfolio. He has entered a local show, after discovering that the work he has been doing dovetails with the show's theme, and after hearing that the juror's past choices were of paintings stylistically similar to his. He submits two slides of his paintings of friends riding horses—this is another nature show where artworks depicting recreational activities are encouraged in the prospectus. His work is rejected and he finds out later that the juror's ex-wife loved horses and the juror is bitter about them!

Given the basic faith in one's own work, an artist usually needs only to continue to enter shows before s/he finds acceptance. The trick is to be well-prepared, well-presented, and professional.

Interview with Beth Surdut, Artist
Drew Steis

Beth Surdut never planned to become a successful artist when she grew up. Although she knew she had artistic talent, she "didn't take it seriously. It was just something I did, like you do anything else."

But she is a successful artist. For the past eight years she has made her living entirely from her art: the design and fabrication of architectural ("stained") glass. She went to college, but the only visual art class she feels she "really would have missed out on" if she had not taken it was an Albers color theory course. She launched her art career several months after impulsively taking an adult education class in stained glass. Then, not out of dissatisfaction with her first medium but after another adult education course, she began to carve a new career for herself in a second medium: painting silk scarves and clothing.

In the early days she had also tried her hand at sumi-e painting, framing, furniture refinishing, and even construction work. All were reasonably successful, both artistically and financially. But all were stepping stones and Ms. Surdut is

now beginning to establish yet another new career in textile design. In fact, she already sells yards of her painted silk to designers who make pillows.

"We're taught that we can only do one thing well in our life, and we're just supposed to do that—tunnel vision. And I don't think that's true. Most people can do a lot more than one thing well." She is quickly figuring out additional ways to market her work, marketing being yet another thing she does well.

Her secret to success is pavement pounding, survival, and luck.

"I'd like to say that my talent is the obvious reason but I don't think talent really has much to do with it," Surdut says. "I could be the most talented person in the world but if nobody ever saw my work—if a tree falls in the forest, who hears it, does it make a sound?"

Ms. Surdut's architectural glass work can be seen worldwide, from a palace in Saudi Arabia to a hotel in Key West, Florida, as well as in homes in the McLean/Great Falls area of Virginia. Her dramatic silk scarves are draped around the necks of women across the U.S. She brings to her media a sense of color and light that has attracted an international following.

At her studio she explained how she built that following and what she wants to accomplish in the future. She is intense about her art but practical and not the least self-conscious about her successes. What might sound like bragging from another is taken as simple fact when she speaks.

"I am at my most comfortable when I am showing my portfolio. I know when I go to show somebody my work I am going to show them something that is great stuff. They don't have to like it because not everybody is going to like my work. Everybody has different tastes. But I know I'm very good at what I do and I think that comes across," Surdut says.

"I haven't entered many juried shows—my glass work is difficult to transport and to light correctly. I don't have any artistically 'political' contacts, but I've plugged along with people who I think are actually going to spend money on my work. One of my windows is in the same room with a Gene Davis and a Sam Gilliam. I don't know that I would get into a juried show with those two artists, but I know that the person who decided to buy those two artists' work also decided to buy mine.

"Ooh's and aah's don't pay the rent, they don't get me out of a cold house and to Jamaica. I think a little avarice and greed is a good idea. We're not living in a society where the king is going to pay for us to live by doing court commissions."

Ever on the lookout for a sale or commission, she carries a small stock of scarves in her car, and she is never without her business card, a postcard-size reproduction of one of her pieces with her name and telephone number on the back.

Surdut's journey to being a full-time artist is worth closer examination. While Beth Surdut's road to success is not for everyone, she offers good common-sense advice.

After college she started working in an art gallery where she learned framing and glass cutting. "When I was a teenager a man told me that women couldn't cut glass, that women couldn't chop frames. They weren't capable. So for years I thought that cutting glass was a mysterious, difficult thing to do. But when I got this job after college the man who hired me showed me the ropes. I realized that cutting glass was a piece of cake, when it came to window glass."

A chance meeting at a dinner party took her away from the gallery business and into furniture refinishing. "I met a man who owned an early-American antiques shop. He did all his own restoration work and he had had a couple of people come in, but he was extraordinarily meticulous and he wasn't happy with anybody. I said, 'Well, I'm not doing anything, I'll give it a shot,' and I was meticulous enough to suit him." Ms. Surdut worked with the antiques dealer before branching out on her own, refinishing museum-quality antiques for a number of dealers and private individuals in the Washington, D.C. area.

"Then one day I was thumbing through a catalog for Montgomery County (Maryland) night courses and there was a $10 class in stained glass and I thought, 'Gee, that would be fun.'"

Soon after she finished the course in stained glass, Ms. Surdut left the furniture refinishing business. "I wanted to live a long and healthy life. The fumes and chemicals and walnut stains on my fingers convinced me—I just couldn't see myself in 20 years still refinishing furniture. I decided that my interest in glass was growing and that if I was really going to be good at this, I had to do it full time or as close to full time as my finances would allow. I was 25, and I said to myself, I'll give this business five years."

With only four completed glass pieces to her credit, she approached one of her former clients from her refinishing business.

"She paid me $1,000 for that first window. She was very trusting. It becomes very personal. I'm making something that not only costs a lot of money, but they're going to have to look at every day. So I try to come up with

something that is absolutely beautiful. Not clever, not cute, but beautiful. I can't promise that ten years from now they can turn around and sell it for more. I had just four photographs of stained glass to show her, and the piece she commissioned was by far the biggest piece I had ever done. I'm still just as pleased with it now as I was eight years ago."

Getting the second commission set Ms. Surdut's approach to marketing that has helped her ever since.

"I am a pavement pounder. I went to anybody who would look at my work, from architects to builders to designers to private individuals. I must have made fifty phone calls to one particular builder for some etched glass work because he had built four Victorian houses and I knew that my glass would look great in them. I kept calling and he was always out of the country or in the bathroom but never available to talk to me." Eventually she reached him and he bought two sets of etched glass doors.

Another builder made the Saudi connection for her. "He sent me to a design firm in Georgetown that was handling a palace in Saudi Arabia. I showed them my portfolio and was asked to bid on providing twenty-four panels."

Beth Surdut won the contract even though her bid was the highest— $2,000 higher than the next highest bid, and twice as high as the lowest bid. "I got the job because I was better," she says matter-of-factly. "They had never seen any copper foil work before, they had only seen lead solder."

The 3-month project turned into a 5-month "aggravation" with delays and changes being ordered while Surdut and her team of six were forced to sit idle as decisions on new dimensions were made in the Middle East. "They called me halfway through the project on a Sunday morning at 7:30 from Saudi Arabia and told me to make everything smaller. You don't just make glass smaller. I lost my cool and said, '*Are you nuts!?*'"

Her commission to design a panel for a Key West hotel came through a wine distributor who "was visiting a friend of mine. When he saw my portfolio he said 'I really don't know anything about selling art but I go to a lot of hotels,' and within two weeks he got me a commission."

The transition from glass to silk came easily. "I saw a scarf at the Baltimore fair and I thought, 'There's no reason why I can't do that,' so I took a course and painted a dress. It was all free-hand. I paid $7 a yard for 4 yards of silk, plus the dyes. I traded private glass lessons to a student who sewed it all together. And

when I wore it out in public, I had complete strangers coming up to me and pawing my dress saying 'Where did you get that?' So I thought, 'Aha, there's a market for this.'"

She started producing scarves because "I didn't have to sew or involve any other people. I buy the scarves from China where they are hand-rolled and -sewn. They're 100 percent silk *habotai,* which is what most people call China silk. I stretch them out taut, on a stretcher, almost like a painting. I draw out the design, then paint with a sumi-e brush. The dyes are liquid, made in France, and steam-fixed. The scarves have to be rolled up in papers and steamed in a crab pot for an hour so the colors set and intensify."

The silk scarves led to Ms. Surdut's decision to join a co-op gallery. She had been contacted by the Old Mill Gallery at Evan's Farm Inn in Mclean, Virginia, several times as they put together their annual fine crafts shows, but Surdut's pieces were very big and she didn't do crafts shows, and the Old Mill Gallery already had a member who was producing architectural glass work. But she was able to join the gallery immediately as a silk artist.

"When the *Washington Post* did an article on me, people were driving in from an hour away and camping out at the gallery before it opened just to buy scarves. I sold $900 worth of scarves at the gallery in two weeks." She chuckles at the irony of her glass work having become her "day job."

Beth Surdut is proud of what she has accomplished. "I think it is really important to be really proud of what you do. After pursuing the creativity, after pursuing perfection of technique, after being aware of the best quality materials, things that I consider to be obvious. The whole idea of the starving artist is a really negative one." She did say that there were times when she "just didn't know where the money would come from." But even in her worst months she managed to buy flowers every week. "After all, I could be in my grave if I waited until I had the money. Then I'd go out and rustle up another commission. What else can you do?"

The above interview was published in Art Calendar *almost ten years before this book was published. In the years that have transpired, Beth Surdut has lived and worked in Hawaii and other South Pacific island locations, has run her own gallery/boutique where she sells silk paintings and painted silk apparel, and is working with textile and fashion designers including Mary McFadden. Surdut makes her home in the Boston area.*

Publicity and Advertising

Untitled, 1990, Photograph, 10"x8", Bob Bennett, San Francisco, California

Outreach

Public Relations
Sharon Kennedy

You can't quite get over the emotional letdown now that your opening reception and exhibit are over. You were counting on those art critics and potential clients—all no-shows.

Hopefully this situation lives only as a daymare as you busily plan your to-be-successful show. You are not alone in this fear; unfortunately, for some artists this scenario exists as a memory of a real event.

The wise artist plans a strategy whereby s/he draws attention to him/herself and the artwork. The creative act of getting attention is called Public Relations (P.R.).

P.R., your total communication effort, is just one facet of your business plan. For the do-it-yourselfer, Joseph R. Mancuso (author of *How to Prepare and Present a Business Plan* and *How to Start, Finance, and Manage Your Own Small Business*) presents a complete picture. You could also pay a company like Arthur Andersen to develop a business plan for you. Your area Chamber of Commerce is a source to find out about other management consultants.

A good business plan incorporates the following components:
- Summary of your business
- History/track record
- Definition of your arts product/service
- Identification of your market
- Identification of your competition
- Pricing
- Promotion/public relations
- Financial projections
- Sources of start-up or expansion capital

You might want to consign business responsibilities to another person or to a business service. But even if you pay someone else to handle the business stuff, of which P.R. is a part, you should know the elements of an effective P.R. program.

To begin with, you must create and give priorities to the objectives of your P.R. Probably your P.R. program will encompass all of the following objectives:

- To establish an image. What is your image? Can you, or do you want to, project a better image?
- To build a recognized name before your patrons and the public. What do you want people to think of when they hear or read your name?
- To improve sales and increase earnings. What are your monetary goals?
- And—this is crucial—to continue to reinforce your name and your work to the media and the public.

Any contact you have with other people, positive or negative, is part of your P.R. This aspect of P.R. is sometimes known by the tired expression "networking." More aggressive networking becomes "active marketing" and is also affectionately called "pounding the pavement." Other artists you talk to might be able to recommend you to potential clients (referrals) or to a good gallery. Perhaps the gallery directors you greet at their openings will invite you to bring in your portfolio. And who knows what person you mention your skills to will commission you to produce a piece specifically for them? Maybe at an opening you will meet a major critic who might not have heard of you so soon. Talk about being at the right place at the right time! This is not magic; there is nothing like putting yourself into the right place constantly (and sooner or later the right time will arrive).

Somehow the "right" people must be made aware of you and your work if you are to fulfill your objectives. There might be a fine line between friendliness and pushiness, but the successful artists I know successfully integrate both attributes.

A second element of your P.R. package may be advertising. Advertising in the major newspapers and broadcast media is expensive—will the results justify the expense? Only you can answer that question. In the meantime, the smaller town newspapers and even cable TV may offer affordable rates.

Another advertising option is a direct mail campaign. For example, if you have a limited edition print of an aviation subject available, you might want to

rent the membership list of Aircraft Owners and Pilots Association, and send them brochures about your piece. (See the article "An Introduction to Direct Mail.")

It is crucial to target your audience, objectives, and creative selling idea before committing to advertising "copy" (verbiage). What do you have to offer? Who is most likely to buy it?

But there is nothing like FREE publicity. If you can get coverage in the papers and on the air without paying for it, then it is a reflection of your well-written, well-targeted news releases. Any exhibit you participate in will be "news" to one group of people or another, one newspaper or another: your local hometown paper, your college alumni paper, a trade journal or two, and the bigger metropolitan papers. News releases can be one of the most dramatically effective ways of getting attention for you and your work. By sending appropriately worded news releases to the appropriate media, you might receive a great deal of publicity free. No one could afford to buy advertising equivalent to the media attention received as a result of a good news release. (See the article "Getting Press: Writing and Targeting News Releases.")

An important skill to develop is awareness of what is newsworthy. Perhaps your exhibition dovetails with other newsworthy events. For example, the director of a Washington, D.C. gallery sponsors an annual juried show of art by and about women. She gets coverage for her gallery and artists during National Women's Week.

The media do not often discover you through the grapevine; there are a lot of grapes. Critics and talk-show hosts do not just wander into your exhibition and review you or invite you onto their talk show. They must be made aware of the event through your news releases. You should have a list of local and national media, complete with deadlines and contact people.

At the same time you are building media relationships, start building a network of patrons. Your list begins with friends and neighbors who may wish to purchase your work but will at least bring their warm bodies and their supportiveness to populate your openings. Next add community and business leaders, those who might be interested in your subject matter or style, and other people within your targeted community. At this level, your network might include membership in the Chamber of Commerce or rent mailing lists; a bulk mail permit will save you about 30 percent on the mailing of 200 or more pieces. Also, after

every gallery show make sure you receive a copy of the guest list and include these people in your next mailings.

Consider getting community visibility through renting a booth at your town festival, donating an artwork to a community fundraiser, or speaking at someone's meeting. Many civic and arts groups are always on the lookout for guest speakers. Your own community newspaper and cable TV station have an interest in the arts and local artists. They frequently allow greater free space for community residents, especially if the exhibit takes place in the community.

Recognition in the larger metropolitan media can be achieved by associating with the galleries, artist organizations, and alternative spaces that receive coverage. Even if you do not have gallery representation, you can enter juried shows that are likely to get reviewed. The title of the show can have a lot to do with it; an art critic will probably be less likely to pay attention to a show called "XYZ Art League's 3rd Annual" (unless it is juried by Leo Castelli or the curator of the Museum of Modern Art) than to a show called "Emerging Artists of Distinction."

Several times a year Washington, D.C. galleries form consortia to sponsor shows. Some of their media campaigns are built around "Gallery Walks," or shows dealing with "New Talent," but they create a newsworthy event, they continue to generate excitement about it, and they always get coverage. In this way an event or an artist undergoes a metamorphosis into something akin to a tradition or a legend.

A book that can help you further your media campaign is the *Media Fact Book* available from the United Way.

Business management training is available at reasonable rates through community colleges, art councils, and artist groups. Many area Lawyers for the Arts chapters offer workshops in business management, from income tax filing to gallery contracts. Communications conferences are sponsored by groups like the Public Relations Society of America. A number of organizations sponsor artist conferences. If you are interested in direct mail campaigns, your local post office will know where you can attend a bulk mail workshop.

Though the coordination of your business efforts may seem overwhelming, directing and expanding your P.R. will make the outcome of your exhibits less subject to the winds of luck and will vastly increase your chances of attaining your objectives.

Getting Press: Writing and
Targeting News Releases

Carolyn Blakeslee

A news release, also known as a press release if it is meant for print media only, is a statement prepared for and distributed to the news media. News releases are written by vice presidents of publicity for community organizations, by every P.R. firm, by every communications officer—in short, by every person or organization wishing to publicize his/her event or cause. It's a trade-off: the media gets its news, and you and your event obtain free publicity via press or airtime.

Sometimes an editor will print your story verbatim as you submitted it, and sometimes s/he will call you for further information. No matter which approach the editors take, you will get coverage in at least some of the media you contact if you send out professional-looking and -sounding news releases. You could even get an interview or a full-blown story if you play your cards right.

Almost every event is news to one entity or another. Do you use an unusual medium to produce your art, say, discarded Michelin tires? For that matter, do you work for Michelin and produce artwork at night? Then the Michelin corporate magazine and the other tire trade magazines should hear about your artwork and your shows. The editors of those magazines might feel that the story about your art will provide a human interest break to readers who are usually fed technical information.

Have you been in touch with your alma mater lately? with the old hometown paper? with the magazine you used to work for? with your local newspaper? Almost every profit-making and nonprofit organization produces a newsletter, magazine, or other printed matter. They are constantly in search of news and stories.

However, editors have a love/hate relationship with news releases. Their publications cannot exist without them, but there is always a mammoth-sized pile of releases to read through, and many, if not most, of the releases that come over editors' desks end up in the circular file. Why?

Let's use *Art Calendar* as an example. *Art Calendar* publishes listings of upcoming professional opportunities for visual artists. We do not publish listings of current shows, although we are glad to list a gallery show in the Classifieds. The press releases we receive on anything other than upcoming

enterable events usually get discarded. Don't get me wrong—we like to receive some of those releases. It is a great pleasure to see the names of *Art Calendar* subscribers on lists of winners, grantees, authors, etc., and occasionally an artist's news results in an interview. But it's amazing how many releases *Art Calendar* receives on plays, concerts, and dance performances—events that have nothing to do with our publication's content. The people sending out those releases simply haven't familiarized themselves with our publication or asked for guidelines.

The bigger the magazine/paper/TV/radio station, the more news releases the editors have to go through, and the less attention any release is likely to get, unless it is very well-targeted and tailored.

Troubleshooting

There are several reasons a news release will not make it into print or TV/radio/cable airtime:

- It was sloppy. Sloppiness and ugliness reflect on you and your event.
- It was poorly written, with grammatical and spelling errors.
- It failed to grab the attention of the editor, i.e., it was boring.
- It was imaginative all right, but unprofessionally so.
- It was not directed to the proper editor.
- It was not appropriate for the publication/TV/cable/radio station.
- The writer failed to discover that the medium to which s/he sent the release charges a fee for making such information available to the public.
- There was not enough room that day, week, or month to run the item.
- It arrived too close to, or past, deadline.
- The editor knows the person who wrote the release and doesn't like him/her. This is unlikely but possible. If this ever happens to you just keep sending news releases frequently and send duplicate releases to other appropriate editors on the staff. One person can't make or break you.
- The writer was rude, pushy, and/or has a bad reputation.
- The writer did not provide enough information and did not give contact ("For further information please contact . . . ") data so the editor could follow up.
- The event was just not judged to be newsworthy.

Tailoring and Targeting

How do you know which media your "news" is appropriate for? Such knowledge comes only through doing research and paying attention. For example, only by regularly reading the critics do you know what kinds of shows and which galleries they cover. In fact, you may choose to continue to send releases to all of them even if you know that some of them will never come—that is just another step in getting your name known out there.

The first task is to figure out exactly what is newsworthy about your event. For example, will proceeds of your art show benefit AIDS victims? Then you should be in touch with every single news medium in the area, including major and community magazines and newspapers, radio talk shows, and radio and TV newscasters. You should also be in touch with organizations concerned about AIDS and let them know what you are up to. They may be able to help you with publicity, emotional support, maybe even volunteers. If your show is about wildlife, contact regional wildlife organizations about your show. If your show is about portraiture, contact the society columns and society magazines.

Get a feel for what is newsworthy and the appropriate media to whom you should target your news. Is it newsworthy that your art league will be having Mr. X speak at your meeting, open to the public, next month? An item about the lecture will perhaps draw a one-line listing here and there. But it is doubtful that people will care unless it comes across in the news release that Mr. X is famous, or is a dynamic speaker whose program is worth the time and may, in fact, be worth a longer blurb or even an article.

You know that your event is newsworthy. With words on paper you must convince the editors to run your story—usually without even getting to speak to them.

Format and Flash

You are a visual artist; you can produce a release that both follows the rules of format and is visually appealing.

First, a news release must be neatly typed in a non-italic typeface and double-spaced, so the editor can read it quickly and edit it easily.

Your release should be typed, Xeroxed, or printed onto letterhead stationery. If you do not have letterhead, neatly type your name, address, and telephone number at the top.

At the left-hand top of your page just beneath your letterhead, you should have the current date; as in a letter, this is the date you are sending the release. Just below that date, you should type "FOR IMMEDIATE RELEASE" if you want the editor to print it any time from the minute s/he receives it. Or, if you would prefer that the news be printed later, type "FOR RELEASE [fill in the appropriate date]." In the top right-hand corner, directly across from the Release/Date information, type "For Further Information, Contact [fill in a name, address, and a telephone number reachable during the day]" so the editor can call that person for clarification or further information.

The following, centered, should appear at the bottom of each page except the last: "- more -." And at the very end of your release text (even if it is a one-page release) should appear: "- End -" or "- 30 -."

Be sure to tell Who, What, When, and Where, and how much and whom to call for reservations or information if applicable. Why's, How's, and histories may be necessary to your story or they may add interest and that last dash of flash. For example, if you have shown at the Museum of Modern Art or if your work is in so-and-so's major collection, that background information might be appropriate, even crucial, in your news release.

However, producing a professional news release requires walking a fine line between the flash and the fire. An editor who receives a beautifully packaged release full of self-adulation (i.e., "Artist X is an unrecognized genius who paints wonderful, swirling, surrealist canvases answering the cosmic questions. Through this show he seeks to find a financial sponsor who will rescue him from underappreciation on the part of the masses of blithering humanity.") probably will not run that item. It's OK to address spiritual or lofty approaches in your news releases, but please be real.

Spell correctly.

If you have any doubts about grammar or punctuation, *The Elements of Style* by William Strunk and E. B. White is an excellent manual to consult. An occasional error will not hurt, but a page full of glaring mistakes will jump into the wastebasket. Its writer does not appear to be professional and therefore his/her event probably isn't either.

So much for format and visual appeal. Now for style. Writing is learnable. Pay attention to newspaper and magazine writing. Each writer, and each journal, has an editorial thrust; each writer or journal generally covers a different kind of news.

Each also has a different style. As you produce your releases, you may decide to tailor them to appeal to the editorial tone of each journal to whom you will send your releases. One magazine will be urban and up-tempo; another publication will be society; another, folksy. When you send information to your community paper, make sure your news is of interest to members of the community.

Sending Photographs

The local papers are much more likely to run photographs of artworks because they are more interested in local artists than the larger papers are. But always send photographs anyway.

When you send a photograph, make sure it is a crisp, accurate reproduction of your work of art. A snapshot will not do, nor will interfering background. Newspaper editors prefer 5"x7" or 8"x10" black-and-white glossies. Make sure you include complete caption information, written lightly on a piece of paper affixed to the back so it will not bleed through. Slides are appropriate for large magazines and any other publications that regularly use color illustrations. Enclose a SASE and you will probably get your photos or slides back.

Conclusion

The worst press is no press.

Exhibition Planning: Using Invitations and Press Releases As an Extension of Your Creativity

Caroll Michels

Last year Braintree Associates of New Jersey, a company that uses Jungian symbolism in fund-raising, placed a small symbol of a broken egg on a direct mail solicitation to raise money for a charitable organization. As a result, their client received a 414 percent increase in contributions, although the broken egg was not mentioned in the fund-raising letter and, according to a follow-up poll, donors claimed not to have noticed it.

Each month I receive hundreds of exhibition announcements from artists nationwide. But the vast majority of communiqués contain neither a subliminal

nor a conscious message that, barring geographic limitations, would stimulate my interest in attending the show, or energize me enough to pick up the phone to request additional information.

This is not to suggest that symbols of broken eggs be incorporated into exhibition announcements, but the results of the Braintree campaign illustrate the importance of visual information in getting a message across.

The use of exhibition announcements as an extension of an artist's creativity and very special way of looking at the world is an all-too-often neglected aspect of exhibition planning.

For various reasons, artists, curators, and dealers and other exhibition sponsors are not analyzing the purpose of an announcement, the results it should achieve, or what it should communicate.

There is a direct correlation between announcement design and exhibition attendance. Well-executed announcements can stimulate interest in an exhibition, and the more people in attendance, the greater the chances of increasing sales and commission opportunities. Creative announcements can also generate press coverage and invitations for more exhibitions.

Generic invitations, those that omit visual information and merely list the name of the artist, exhibition title, location, hours, and dates, are frequently used for group exhibitions to diffuse the problem of selecting one piece of work to represent all of the exhibiting artists. A generic solution is also used because some artwork is not photogenic, and loses its power when reproduced in photographic form. But the most common reason generic announcements are used is to save money.

Granted, generic announcements are less expensive than four-color cards, but even four-color cards can be boring and are not necessarily the great panacea for creating a successful announcement. Keep in mind that a successful announcement does not need to be in color or contain a photograph of actual work.

For example, for an exhibition entitled "Reflections," organized as a memorial to artist Jane Greengold's father, a square of reflective paper was attached to a card accompanied by text describing "reflections" as a metaphor for her feelings and thoughts after her father's death.

For an exhibition entitled "Paintings at the Detective Office," artist Janet Ziff's announcement contained a drawing of a mask in which two actual sequins were attached.

Taking a more minimal approach, for the exhibition entitled "Lost Watches," artist Pietro Finelli's announcement only contained basic who/when/where information, but text was printed with silver ink on a thick piece of gray cardboard that felt sensual and pleasurable to read and touch.

In a group show that explored the concerns and reactions to different social, informational, and psychological situations through the combined use of words and images, the Organization of Independent Artists developed an announcement highlighting the exhibition title "A, E, Eye, O, U, and Sometimes Why," with a drawing of an eye placed next to the word "eye."

In each of the above examples, without using photographs of actual exhibition artwork or spending a lot of money, the invitations extended beyond satisfying the purpose of announcing the show. Each invitation also gave the recipient a sense of the artist, and was in itself an *invitation to respond to the artist's message* with intellect, humor, compassion, pleasure, or whatever emotions and sensations are evoked.

Lack of imagination in exhibition planning does not stop at the invitation. The average exhibition press release that I receive is usually destined for a file labeled "Yawn," otherwise known as the wastepaper basket.

For example, a typical lead paragraph reads as follows: "A group exhibition featuring the work of sixteen abstract artists opens at Brand X Gallery on June 1, 1990. The exhibition features paintings, drawings, and sculpture." Since the purpose of an exhibition press release is to spur interest in attending the show, the Brand X example hardly accomplishes this mission other than attracting the attention of sixteen artists' parents, relatives, and friends.

On the other hand, following are examples of press releases with strong lead paragraphs, exemplifying possibilities (although taking Tom Wolfe out of context—sorry, Tom) of the *painted word*:

- "Imagine dirigibles hovering over the World Trade Center, or a NASA space shuttle parked on your block. These events would never happen in real life unless, of course, they were a project of an ambitious sculptor. Even then, the construction would be very daring if not too costly; however, The Rotunda Gallery's new show, 'Sculptors' Drawings,' provides sculptors with the opportunity to indulge such fantasies."
- "For admirers of drawing who love to see the sweep of a line across a surface or a form emerging in space, Pratt's forthcoming exhibition

'Spirit Tracks: Big Abstract Drawings' offers . . . sixteen large abstract works that explore the richness of black and white in charcoal, ink, crayon, gouache, and acrylic."

- "So profound is a grain of sand that some people continue to see worlds within these particles of ancient rock. This experience applies to the recent wall reliefs by Lydia Afia, entitled 'Behind Glass: Windows of Fallen Light'. . . . "

In exhibition planning, announcements and press releases should be given as much tender loving care as curatorial decisions. Cutting corners might bring immediate relief in easing time and money pressures, but the consequences of short-term thinking can backfire. Boring publicity tools usually bring boring results.

Advertising

An Introduction to Direct Mail
Carolyn Blakeslee

How long have you been wanting to reach a larger audience? How often have you dreamed of having the time, resources, and inventory to justify a direct mail promotion, catalog, and/or national advertising of your artwork?

Like most artists, you would probably love to have a color brochure or catalog featuring your work. What has been keeping you from producing such a wonderful sales and documentation tool? The large investment of time and money necessary to design and accomplish such a project, of course. And the fact is, most people don't know where to begin.

Then there's the fear of success—the fear of stepping into risky new territory characterized by a higher professional level, more money, and ultimately more time to think about and do art.

This article sets forth a step-by-step action plan that you will be able to tailor to your own life- and art-style. This article will tell you how to identify your markets, produce a color brochure and/or catalog, accomplish a direct mail campaign (just one of the myriad ways to promote yourself), reach hundreds or thousands of people, and produce results both personal and financial—at a fraction of the cost you have been thinking it would involve.

If the thought of producing a brochure on your own is absolutely intimidating, then Step One is to join forces with several other artists, with the intention of producing a group brochure and support team so you can all share the costs and efforts involved. Even if the thought of going solo is not intimidating, this approach might be worth consideration.

Think about it: galleries and art consultants—portrait representatives, for instance—produce brochures of several different artists' works all the time. They had to start somewhere. You can, too. Think of this project as a co-op gallery by mail.

Perhaps the people with whom you want to associate work in styles and media similar to yours. Or you might feel that presenting a wide variety of work, linked by a thematic or other thread, will get the best results. That is a judgment call only you can make based on research and a dash of intuition.

Brochures and color postcards can be printed surprisingly inexpensively. All of us have seen ads flogging "100 color postcards for just $53" (stay away from these because they are photographic prints, not printed postcards) or "1,000 4"x6" color postcards for just $439." But with a little investigation, you can find firms willing and able to produce, for example 25,000 9"x12" *high quality* brochures, printed front and back on glossy paper, with typesetting, design, and layout included, up to eight full-color images, and folded into a standard three-leaf brochure format, for $3,000 or less. Yes, $3,000 is much more than $439, but the per-unit cost is crucial here: 1,000 postcards at $439 cost 44¢ each; 25,000 brochures at $3,000 cost just 12¢ each, and you've got much more ad and image area in the $3,000 project. So, while the $3,000 project is seven times more expensive than the $439 project, the $3,000 project yields almost *twenty-five times the results* at less than four times the cost, with probably three times the "bang for the buck" in terms of ad and image area and impact.

Ask several printers—at least forty—for samples and estimates. Believe it or not, only about half of them will respond. But after receiving a couple of weeks' worth of replies, you might find yourself laughing at the incredible variations in price—and you will be *very* happy you took the time to send off for as many estimates as possible.

Here are the economics. The above-outlined 25,000 brochures at $3,000 come out to 12¢ each. A bulk mail permit, available to anyone at any post office, will cost a one-time administrative fee ($75 as of this writing) plus a per-year charge (at this time $75), totalling $150 to get set up. It will then cost 19.8¢ to mail each brochure. If you mail all 25,000, then the total mailing tab will be $4,950 plus the permit fees. (So far our subtotal is $8,100: $3,000 plus $150 plus $4,950.)

Next, you will need to compile or rent quality lists of people to whom you will be sending your brochure: this is your "target audience." More information on targeting them comes later in this article. Lists are available from mailing list brokers (in the Yellow Pages) as well as from most subscription publications. A "quality" list, usually meaning highly specialized and up-to-date, will run around $75 per thousand names and addresses, sometimes considerably more or less,

and will come printed on stick-on labels if you want and pre-sorted in zip code order. This zip code ordering is crucial for third class bulk mailings; your post office will give you details and instructions on how to prepare your mailing. So, your list of 25,000 will cost around $1,875.

So far your tab for printing, labels, and mailing is around $9,975. Yes, it's a lot of money. I can hear you screaming, "We might as well take a full-page ad in *ARTnews!*"

Let's look into that for a minute. Here's the truth about ads in magazines. That magazine might be seen by the reader once, in a hurry, when s/he gets the mail—if s/he has the time to leaf through it at all. Perhaps the reader will see your ad again when s/he grabs a bit more time to read the magazine more carefully, and a third time if s/he is a real art nut and wants to spend some quality time with the publication. Then it disappears. Into the trash if s/he is not sentimental, onto the cocktail table pile (where it might be seen by other people, that's the good news), or into the bookshelf if s/he saves back issues. Thus, your ad might be seen six times, twice, or not at all. And even if it *is* on the cocktail table, it will probably be replenished with the next issue. So your ad's shelf life has been a flash or two during one month.

Not to knock advertising—it is definitely worth considering when you have more experience in promoting yourself (or a good agent/gallery/representative network), and when your cash flow is steady and predictable enough to justify such large one-shot expenses. Steady, reliable cash flow is the result of *any* good marketing program, whether applied in the field of fine art or any other business. There is absolutely no reason you cannot establish a good cash flow, and make money, as an artist.

Back to the ten grand you have blanched over.

Suppose you and seven colleagues team up to produce and mail that brochure whose printing price includes eight full-color images. $9,975 divided by eight comes to $1,247 each—to reach 25,000 people directly, with a color brochure not buried in some other publication. $1,247 is a much more manageable up-front investment than $9,975. And it *is* an investment, not a gamble, if it is done with proper attention to detail. Besides easing the per-artist monetary outlay, forming a consortium could help to alleviate participants' fears and generate credibility and mutual support. You will also be able to divide the time-consuming responsibilities of getting estimates, proofreading, obtaining the postal

permit, doing market research, obtaining lists, applying labels, bundling and mailing, etc.

Here are the statistics on direct mail campaigns. If a brochure is clean, attractive, and well-written, AND is received by a reasonably carefully targeted group of people, the average rate of return is usually 2 percent. That might not sound like a whole lot, but read on.

You have identified the group of artists you would like to work with. You have all agreed to split the costs of the direct mail campaign. Now it is time to find out who your audience is. At this stage in the game they might be absolutely unknown to you, so some research might be necessary. Are they old-money? Are they yuppies?

Once you narrow down the field of prospective buyers (everyone), the goal is to *contact* a selected group (direct mail is just one way to contact them), nurture the establishment of your clientele, and develop relationships with individuals within your clientele until suddenly you find that many have become your friends and even passionate advocates—your "following." This is not dirty pool, this is fun, and you are doing them the favor of letting them know about your artwork.

To target your audience, you must first study yourself and your art. What kind of artwork—what art product (please do not feel yucko about that word, you *are* in business)—are you producing? Do you produce small-scale watercolors you would be willing to part with for $200 each? Do you do medium-sized portrait commissions in oils starting at $2,000? Do you have limited edition bronzes lined up in your studio waiting for corporate placements and bylines on your resumé?

Each artist will have the best results with a particular kind of art appreciator. For example, if you do representational oil paintings with nautical themes, it would be futile for you to promote your work to people who love experimental media or abstract work. By the way, I have also been asked, "Should I tailor my work to the market?" Not necessarily. There is no reason for you to do any kind of art except the work you want to do, because there almost surely is a market for it. It is only a matter of discovering that market and letting them know you are alive.

Let's continue with the nautical example. Suppose you and seven other artists you know produce nautical artworks. One of you does limited edition

hand-pulled prints. Another artist in your group does commissioned "portraits" of people's boats and/or the owners on it. Another does oil paintings of specific areas, like the Chesapeake Bay or the Florida Keys. Another does watercolor harbor scenes from a historical point of view. Another offers paintings of waterfowl. And so on.

Now for the market research part. To which 25,000 lucky people are you going to mail? You are not *selling your wares,* you are *helping people become aware of your service* and you are *helping them to obtain it.* What group is most likely to be assisted to discover and enjoy your product? For example, if you were cooped up in a law office 12 hours a day, wouldn't you love to have a large-scale painting of a sailing destination, complete with the proper mood and lighting, in your office?

One way of conducting market research is to go to the library and ask for a directory of trade associations. The purpose of trade associations is to assist their members to make their livings comfortably in their trades. If your trade is nautical art, perhaps there is a national association of nautical artists, or of nautical artists' organizations. Contact the appropriate organizations and see if they have data as to who is buying your kind of art. There will also be trade associations of marina owners and clubs of yacht owners.

Get as specific as you can. Where do the buyers of your kind of art live— do they live on the coasts, near large lakes, or are they wannabe's who live nowhere near water? Are they private individuals, or are they in charge of curating corporate collections? Do they buy from galleries, are they best approached by people who have made appointments to show their portfolios, or have they demonstrated response to *many* ways of presenting artwork available for sale? How much, on the average, do they spend on artwork? Are your prices too high? Are your prices too low (just as frequent a turn-off)?

Your research will yield a clear, concise mission statement that will save you time, money, and needless frustration. For example, a color image consultant's mission statement might be, "I provide color consulting services to professional women in the Chicago metropolitan area. My services give self-assurance to my clients, who are over thirty-five. They desire a polished self-assurance because they have frequent, responsible contact with their clients and colleagues." The color consultant's client profile, then, is "professional women over thirty-five in the Chicago metropolitan area."

Here is an entirely hypothetical description of your nautical artists' client profile. (Keep in mind that your secondary market could be wannabe's—people who *wish* they fit the description or who hold the description as a goal.)

The typical buyer of nautical art prefers medium-sized, representational, two-dimensional artwork with emotional appeal: dramatically stormy, sunny, etc. He (emphasis on "he") often displays art in his office partly because of the prestige it offers him in his workplace, but he likes to display art at home too. He takes an average of two weeks' vacation per year, usually to resorts on the water. Around forty-five, he is married. He and his wife hold upper-management jobs, and/or own their own business(es). Their joint income is about $150,000 and they live in an upper-middle-class suburban neighborhood outside a city that was built along a navigable waterway. They own a sailboat and a second home. He buys nautical art because he enjoys its prestige, beauty, and escape value, but he also hopes for its eventual appreciation in monetary value. He is wary of spending more than $1,000 on an emerging artist but will drop up to $5,000 on an "undiscovered" artwork that he feels is extraordinary. Normally, neither he nor his wife have the time or the inclination to visit galleries; however, they do so on vacations, and that is where they buy most of their art. He likes to read nautical publications, and would probably enjoy seeing a brochure that tastefully presents nautical art he has never seen before. He might not buy right away, but a year or two down the pike he might get around to it.

The shortened version of your client profile: "Professional men around the age of forty-five from two-income families who own sailboats and live in the suburbs of cities on waterways." Your mission statement: "I provide (x) service to (client profile). They desire and enjoy my service because (x)."

How do you find your client profile (target audience)? You talk to the trade association folks. You go to nautical art galleries' openings and people-watch. You go to art expos and observe who hangs out at which booths, and you take notes when someone buys work similar to yours. You talk to marina personnel—in short, everyone you can think of and have time to approach. If

you do portraits, what kinds of people buy portraits? Who buys large-scale interior tapestries? What kinds of people buy monumental large outdoor sculpture? *Who will be most likely to buy—and love—YOUR artwork?*

Where do you obtain lists of 25,000 good prospects?

You might contact marina directors by letter, telling each what you wish to do; ask to borrow or rent the marina's membership list, and enclose a copy of the brochure you plan to send out. You never know, they might even offer to publicize your group in their newsletter, or offer you a show.

You might also contact yachting magazines and rent their mailing lists.

Keep in mind that "testing" lists is a crucial direct-mail business practice. One list might perform very well, another very poorly. The only way you will find out is to try it. But if a list boasts 100,000 names, you'll be out a huge amount of money if the list performs poorly. Therefore, the industry standard is to order a quantity of names, usually 5,000, for "test" purposes. You will be required to provide a copy of your promotional material to the list owner and not deviate from what was approved. If the list performs well, you can then order the entire list and promote to the entire group.

At the same time you are testing your lists, you should be sending news releases to yacht and sport boating publications about your art consortium and the services you provide. Releases should include photographs of some of the artworks and/or artists, or a brochure with a clear notation that reproducible photos of artworks and artists are available upon request. Releases should also be sent to resorts known for their sailing facilities, and, of course, to the marina directors.

Most of the people to whom you send your brochure will throw it away. However, a large number might find your brochure so attractive that they cannot bring themselves to throw it out with the rest of the "junk mail." After all, the rest of the junk mail has "Zappo Mailgram" and "Open Immediately or Lose Out" and "Last Chance for This Special Offer" and all sorts of—well, junk—all over it. But your brochure is already "open;" there is no envelope or letter from the publisher to plow through. It is attractive and classy; you have spent the time refining your brochure until it met your highest standards. Your brochure won't get filed away with back issues of anything. The recipients might, however, put it on their cocktail tables, or into a pile to be gotten to later.

OK. Back to economics. Let's say your mailing generates an initially low response: only 1 percent of the recipients, or two hundred fifty, send in an

order. The orders are split fairly evenly among the eight of you. Two hundred fifty divided by eight equals 31.25. So, with a *low* response, each of you has sold 31.25 artworks! Suppose your average selling price is $400. You have each grossed $12,500. Subtract your $1,247 for the brochure, and money for framing and shipping. Also allow some time for personal thank-you notes. These people obviously love original artwork and they will almost certainly enjoy the personal connection with you. Anyway, $12,500 minus the brochure, framing, and shipping costs, will probably net each of you around $10,000. Not bad for an up-front promotional cost outlay of a bit over $1,000. You would have spent money on art supplies and made those paintings anyway, right?

And who knows how many of those 31.25 people will turn into repeat clients? Who knows how many sales or commissions will come your way because they will recommend you to their associates?

Now for advertising: *now* you can afford to reinvest some of your money into advertising; *now* you can afford to begin to establish your name in print and in the minds of the public.

There are, of course, alternatives to taking on seven quasi-partners. Twenty-five thousand high-quality postcards cost as little as $800. Postage for postcards is actually less than the bulk rate—19¢ each, versus 19.8¢ each—and they will be delivered first class. Using these numbers, your total investment will still come to $5,550. But suppose you are promoting, say, a signed offset print that sells for $75 not including frame—far less than the $400 example outlined above. If just 2 percent of your postcard recipients place an order, you still gross $37,500.

Another approach, with or without quasi-partners, is to print up a few or even several hundred black-and-white brochures and a brief proposal for an exhibit, and mail your proposals to marina directors in your region or even nationwide. The possibilities are endless: they could sponsor a month-long show of your group; they could sponsor a one-night installation of artwork for a special event they are holding; and so on.

I have used the marina and nautical theme only as an example of carrying a theme through. The same principles can be applied to floral, medical, and a myriad of other styles and subject matter.

By no means is a direct-mail campaign guaranteed. But it is very likely to produce good to excellent financial results if it is carefully planned and carried out.

Taking a personal risk—and that's what we're talking about here—is far better than chanting "What if." God did not intend that we be poor and unappreciated, nor that others be unable to see and thus share the fruits of our talents.

What Makes a Brochure Successful?

- **Visual beauty**

You are promoting a visual art experience. If your brochure is dowdy or amateurish, why would anyone want to buy your actual work?

- **Contact information**

If your brochure features several people, either agree in writing on who is responsible for being the contact, or print each person's information adjacent to his/her artwork.

- **The inclusion of copyright symbols**

Protect yourself. Include the copyright symbol (©), the year of the artwork's completion, and your name. This information shouldn't be intrusive but it can't hurt to include it in tiny type underneath each image along with the rest of the caption information.

- **Neatness and crispness**

There is no room for typographical or grammatical errors. If you are not skilled in editing, have a professional review it before sending it to the printer. Have the printer send you a proof—it's worth the extra time and money.

- **Clean, consistent design**

Good color saturation, contrast, and a fine line-screen are musts. (See the article "Buying Ad Space in Artists' Sourcebooks" for more discussion of line-screen and other printing terminology.) Blurry or coarse images are unacceptable. Often, color reproductions look classiest and most attractive set against a black background. Or, if you are aiming for a softer effect, a white background might be best. A compromise is to box in each image.

- **Attractive images**

Your brochure should feature the best examples of your work.

- **Simple, "at-a-glance" ad copy**

Perhaps you could include a brief description of the work pictured, and/or quotes about your work from a review, a respected arts professional, and/or current owners of your artwork. Perhaps you should include highlights of your career or life, including goals and projects in progress. Why should people

invest in you? Tell them! Also, sharing a select amount of personal data deepens the art experience for them. Seek the advice of a professional writer if need be.

- **A list of your services**

Do you accept commissions? Do you do portraits? Are there other kinds of work you produce besides that which is illustrated in the brochure?

- **Ease of ordering or commissioning work**

Give clear pricing information and terms, or a statement that prices and further information will be "gladly" furnished upon request. Words like "gladly" and "guarantee" mean a lot to someone who might never have heard of you. Similarly, make it easy for the recipient to request further information and/or a portfolio review if s/he is not convinced on the basis of your brochure. You can probably talk your bank into letting you offer credit card capability, and 800-numbers are inexpensive—these two factors could increase your orders by 50 percent or more.

- **Guarantee of satisfaction**

You can also be creative and offer other goodies besides a guarantee—for example, you can offer a trade-up option later on. Rentals or "on approval" plans can also work if handled carefully.

Buying Ad Space in Artists' Sourcebooks

Carolyn Blakeslee

There have always been "Sourcebooks." But a few new publishers have entered the book production business. There are now Encyclopedias, Directories, Catalogues, Surveys of Contemporary Art, Living Artists, Erotic Art, West Coast Artists, and so on. To pay to have your artwork published in a book: a way to generate sales and commissions, or a waste of money? a marketing dream, or a nightmare?

It depends. Advertising, if placed in a quality publication, is valuable for several reasons. Advertising can generate new clients and commissions, it gives you another tear sheet to place in your portfolio, it can be an important part of the process of producing name recognition, and it can bring on warm fuzzies like feelings of prestige and accomplishment.

If you are considering buying a plate in a book, you must first look at the prospectus/advertising materials you received from the publisher. Did you order

the information, or was the material unsolicited? Does it appear that your name was obtained from a mailing list? Did you receive duplicate packets? Duplicates might indicate that the publisher has bought several mailing lists; how does that "speak" to you? Is the material attractive and well-written? Is the print job professional? Or is the material amateurish—riddled with editorial, grammatical, graphic, typographic errors—and/or poorly produced? If their prospectus packet doesn't look good, it is safe to bet that the final book is unlikely to look any better. However, if their packet is *cheaply* produced but otherwise good, it is possible that funds are being saved for the production of the book itself.

Even if the packet completely meets your standards, it is time to ask the publisher some questions if they weren't addressed in the prospectus.

1. What about the printing process?
 a. What kind of paper will it be printed on? On good, glossy color litho paper (color reproduces more richly, and B/W has more contrast)?
 b. At what line-screen will plates be reproduced? All offset printing of picture images is done through color separations (color plates) and halftones (B/W plates). The smaller the line-screen number, the fewer lines per inch, and the coarser the image will appear. Newspaper photos and comics, for instance, are extremely coarse, and are printed through line-screens well below 100. Halftones and color separations, to look good, should be between 175 and 200 lines. If you are unfamiliar with line-screen terminology and differences, a visit to a print shop is a good idea. Most printers will be happy to show the results of printing with different line-screens/halftone negatives, and the differences in papers.
2. How many copies of the book will be printed? Weigh the numbers with the answers to the next groups of questions.
3. Will any copies of the book be sent out free of charge?
 a. If so, to what groups (i.e. curators, dealers, art consultants)?
 b. How many to *each* kind of group? If the publisher is targeting *your* market, even a relatively small press run (a few thousand) might do you some good. For example, if you are interested in contacting architects and interior designers, and the book will be sent to 5,000 of those people as well as 1,000 corporate buyers, buying a plate in

the book might be a good investment for you. If you had been meaning to send your materials out to art consultants around the country anyway, and the book will be sent to a few thousand art consultants, then it is probably a good investment.

4. If the book will *not* be sent free of charge to anyone, or to very many:
 a. Ask where the book will be available.
 b. Ask whether a direct-mail campaign will be carried out, and if so, how many brochures will be sent, to which groups of potential buyers. Figure that one to three out of every 100 will buy the book as a result of a direct-mail campaign. Further, realistically only a fraction of *those* people will be interested in your work.
 c. Ask how much advertising other than direct mail they intend to do, and in which publications the advertising will be placed, how often, and for how long. Also ask about how long and how forcefully a publicity campaign will be carried out.

5. How often does the book come out? The shelf life of a book is an important factor in your decision to buy ad space.

Now look at your own bottom line. What do you expect to get out of your investment? Does the book fulfill your needs?

If everything looks good so far, it's time to order a copy of a previous book they have produced. If you are thinking seriously of buying advertising, it is possible the publisher will mail you a book free of charge; but even if you have to buy it, it's better to pay $20-50 for a book than $500-2,000 for advertising sight unseen. If you receive the book and you wish you still had your $20-50, at least you won't feel like a chump for spending a lot more money on advertising in it. If they have not produced a book before, ask if there is a sample page available that has been printed on the paper to be used in the book.

When you receive the sample book or page, look through it. Is it so striking you can't put it down, or do you feel like putting it on your "pile" and going through it later? graphically and aesthetically OK? editorially, grammatically, typographically OK? Do they know to put vertical dimensions before horizontal before depth in the captions? Would you be proud to be in a similar book? If you were a recipient or purchaser of the book, do you think you would feel proud to display it prominently, would you feel confident about commissioning the artists therein, and would you look forward to receiving it every year or so?

If the book passes the tests so far, now it's time for the acid test. Write or phone some artists in the book whose work and/or location is similar to yours. As briefly as possible, ask them what their goals were and whether they were happy with the results of placing an ad in that particular publication.

One good annual book is *The Guild,* published by Kraus/Sikes, Inc., 228 State St., Madison, WI 53703, 608-256-1990. Available for around $50, it is a sourcebook of American artists, especially those working in craft media in architectural and corporate contexts. Each year, a review panel examines submissions and then advises the publisher as to the appropriateness of submissions for the current design market; the review panel has consisted of accomplished architects, interior designers, art directors, editors, and others. With a press run of twenty to thirty thousand, the book is mailed free to more than ten thousand members of the American Institute of Architects, the Institute of Business Designers, and the American Society of Interior Designers; it is also sold in bookstores. Artists pay $1,100-1,500 for a full-page display and also receive tear sheets for their own publicity purposes. If you are a fine artist who is thinking of advertising in another sourcebook, I recommend that you order a copy of *The Guild* to see how it ought to be done and then order the book you're thinking of advertising in to see how it compares.

Know the book and your goals before you buy the space.

Public Art

Two Women Holding Hands, 1992, Oils, 11"x 6¹/₂", Jessica Gandolf, Portland, Maine

Important
Contacts

Interview with Françoise Yohalem,
Public Art Consultant
Drew Steis

"I can tell if an an artist can do a large-scale project even if that artist has never done such a project before. I can tell from meeting with somebody, from going to their studio, how reliable, how responsible, how technically competent they are—and it is wonderful when I have the opportunity to give someone a chance." Giving artists a chance is a business for Françoise Yohalem, a Bethesda, Maryland-based art consultant specializing in art in architecture and Percent-for-Art projects.

"I act as a resource," Ms. Yohalem told *Art Calendar* in an interview. "I think this is important. I am not a representative and I am not a dealer. People are confused because there are some people out there who call themselves consultants but who really are artists' representatives and artists' agents and art dealers.

"The difference is as a consultant, I work for the client. I am hired by the client, paid by the client for the work that I do on a project whether it is an hourly fee or by the job. I do not take a commission on the artwork and that is where the big difference is."

Another big difference to Françoise Yohalem is the artist—where the artist is concerned she is very protective.

"An artist who gets involved with someone who calls himself a consultant should find out right away what this means. Is it someone who is taking a commission on the work—if so, how much is this going to be? Or is this someone who will not be taking a commission, but maybe will be passing on the commission to the client? It is important from the beginning to ask questions, to not be shy about asking questions. This is business, and artists as businesspeople have to know what the story is because artists can be too naive."

Ms. Yohalem knows the art business from both perspectives—as a trained artist and as a businesswoman. She came to the United States from her native France in the 1950s, working first for the French Embassy, and then earning a bachelor's degree in painting from American University and a master's degree in painting from the State University of New York at Albany. Her first job after college was as the assistant director of the University Art Gallery in Albany where "I found that I liked that more than painting." She returned to the Washington area in 1976 to take over the management of the Franz Bader Gallery. After five years, she set up her own business—and now she has good advice for artists in their dealings with dealers.

"I would like to warn people that when they approach a dealer, or when the dealer approaches them, they should try to find out everything about that dealer's reputation, and talk to other artists who have been represented by that dealer. Ask the dealer for the names of other artists whose work they have handled, who have had shows there—and then call those artists and find out what kind of experiences they have had. That is the best way. Talk to other artists—especially when it is a gallery director who wants money down first and promises all kinds of unrealistic things like a show in New York and a catalog. These galleries should be put out of business, but despite lawsuits against them there are still people who want to have shows in these places, who don't know what is going on."

There is a precise way Françoise Yohalem does business, and a formula that she finds successful.

"When a client approaches me—say it is someone who is looking for an outdoor sculpture for a plaza or a piece for a lobby—I will meet with the client and the architect to discuss the project and the style, site architecture, and the audience. These are all important to a public art project. After getting all this information, I will make a presentation of the work of maybe 40 artists from my slide registry. Sometimes I might have to reach out for someone else, but my slide registry has the works of 350 artists from around the country. From that presentation the client will select maybe three or four—which is sort of a typical number—and ask them all to make site-specific proposals with models."

Here, Ms. Yohalem pauses, as if to prepare for combat.

"And here I want to say to artists: Never make a model, never make a proposal, unless you are paid for it. This is very important. Artists are too often willing

to do a lot of work for nothing on the hopes that maybe something good will come out of it—and that is wrong. It gives the wrong impression to the client. It says that the artist is not professional, that the artist is pathetic and wants the job so badly that the artist is willing to do anything. I think the client respects the artist more if the artist says I expect to be paid for this." Ms. Yohalem says a standard design fee for a finalist in a design competition is usually $500 to cover the time.

Once a final artist is chosen for a project Françoise Yohalem still has work to do.

"I will usually get involved in the contract negotiations to be sure that everybody is happy and then I follow the fabrication and the installation. I feel very much needed at the installation because there are always problems—the lighting is never right."

There are a few other pitfalls along the way.

"I think it is important that an artist know what the budget is before he gets involved in a project. Sometimes a client will say 'Well let's bring an artist on and then let's see how much they think it is going to cost.' I think that is not right. I think the client should have an idea of what the budget will be ahead of time. Then they can ask the artist 'What can you do for this amount of money?'

"Then it is up to the artist to figure out on that kind of money, for instance he can do something in steel that will be in the correct scale. Then he has to get in touch with the fabricator, if he doesn't do his own fabrication, to find out how much it will cost to fabricate it, how much for transportation, how much for insurance.

"I usually require a fairly detailed kind of budget. I want to be sure the artist has thought of all these things that are involved and that there will be no surprises. I don't want to get involved with a project where the artist is not going to be making any money."

Françoise Yohalem knows where the money is and where it isn't.

"The Percent-for-Art Program says that if the state or a city builds or re-builds a public building, then one percent of the hard cost of the building would have to be spent on art. So if the library cost $5 million then one percent would be $50,000 and that would have to be spent on artwork.

"In the Washington area, Washington, D.C. has a one percent program that they implemented about two years ago but as far as I know they have been sitting on the money and they haven't really started advertising any of the projects except for one smaller project downtown. In Montgomery County, Maryland, there are

three very active programs: Art in Public Architecture, which puts art in facilities such as firehouses and libraries; Art in the Parks; and Art in the Schools. These programs have been struggling. They started with one percent and were cut down to one-half percent two years ago and now I am really worried that they may not make it. Rockville, Maryland, has a one percent program that is a very good program. I have been working with them for three years."

Ms. Yohalem is encouraged by the health of the Percent-for-Art programs nationwide.

"I think it is growing across the country, although there is some backlash—and there are some programs that have been in existence for a few years that are struggling to survive. There is a sense that public art programs are getting much more sophisticated, especially the ones the National Endowment for the Arts funds. The trend now is to get the artist involved at a very early stage and have the artist part of the team, the same as an architect or a landscape architect, and get them all working together to incorporate the design of the new building. I work with my clients to educate them and show them slides of what is happening around the country to make them realize what public art is all about."

And how can the artist—especially the first-time artist—get involved in public art projects?

"Well, this is always the trick. How do you get started and how do you get someone to trust you if you haven't done it before?"

Françoise Yohalem answers her own question by listing hard work, innovation, and good slides as the keys.

"If you are a muralist, it is sort of easy to paint a big wall in your house and then take slides. If you are a ceramic artist and you have dozens of small pieces, you might try a combination of bigger pieces using small elements to make a big wall kind of composition and take slides of that.

"Another way for someone who has never done any large-scale installations is to make models. Try to make up a situation where you pretend you have been commissioned to make a presentation and a maquette for a site-specific piece in front of a building, and just make a scale piece and then take slides of that.

"If people really want to find an opportunity they can make their own. Read a competition's call for entries, and pretend that you are a finalist, and try to make a model for a piece that would be specific to this particular site."

Ms. Yohalem urges artists to obtain the best photographic slides possible. "That is so extremely important. If their slides are yucky that's it, it's over."

And she is always looking for new artists. "I am happy to receive slides. If the work is really not appropriate, is not the kind I think I can use, then I will send it back with a letter. Send your best slides and a resumé. I have given opportunities to people who have never done anything large-scale before if I really like the work."

Françoise Yohalem can be reached at 10834 Antigua Terrace #203, North Bethesda, MD 20852.

Profile of the Brea, California Slide Registry

Drew Steis

Brea is a 12-square-mile city in northern Orange County, California, about 12 miles from Disneyland. It has 34,000 inhabitants and nearly 100 public works of art.

Not surprisingly, Brea, California, also has one of the oldest and most active Art in Public Places programs in the United States.

"We commission two works a month on average, or around twenty a year," explained Emily Sabin, Brea's Cultural Arts Manager.

Ms. Sabin oversees the Brea city gallery which holds six art shows per year in the Court House/Civic Center complex. She also is in charge of Brea's Slide Registry which she started in 1984.

"Our slide registry is open to artists from all over the world," she said. "But I have to tell you that our developers like local artists, so more than seventy percent of our Percent-for-Art projects have been by California artists.

"It is really a regional registry because developers do not like to spend their money on transportation. Although we have installed public works from artists living in Paris and Belgium this year, our developers like local artists unless they are able to incorporate transportation into their fee."

Emily Sabin explained that just the night before, two commissions had been given to two local artists. "Developers know that our slide registry exists, and when they want an artist they come to us and we determine what they are looking for in terms of style, material, and size. Then we show them the slides of artists whose work we think matches what they are looking for.

"One developer came to us, took six resumés away, and then interviewed only one artist who was given a $20,000 apartment building commission for a nonobjective, stainless-steel-and-stone pair of companion pieces four by eight feet in size.

"A second artist was given a $65,000 hotel commission for a travertine piece which incorporates a water feature."

Brea's love of outdoor works of art dates back to 1975 when "our city manager Wayne Wedin convinced some developers and our city council to use art in public places the way he had seen art being used in Europe. We have a real aggressive city council and our Percent-for-Art program grew from that. Fortunately we also have a strong tax base from a major regional shopping mall and a continuing building program."

Today Brea's slide registry is relatively small—numbering "about eighty artists. We have never actively solicited slides from artists, but we are always interested to see new artists' works if they meet our criteria," Ms. Sabin continued.

To be considered for inclusion in the slide registry, an artist must have completed at least one monumental or large-scale work, demonstrate that s/he understands engineering and fabrication on a large scale, have a body of work, have studied, exhibited, and have pieces in private and public collections.

"About sixty percent of our public art is abstract and forty percent is realistic," Ms. Sabin continued. "Office buildings tend to get abstract while apartment buildings and hospitals lean more toward realism."

Emily Sabin says "emerging artists rather than established well-known sculptors are getting the majority of the commissions because of price mainly." Of the eighty artists currently in the slide registry, ten have received commissions.

When asked if Brea would soon run out of public space for art, Ms. Sabin replied that it was not likely because of urban renewal. Among other things, the city is planning a major sculpture garden in the heart of the downtown.

"I don't know the final size yet but it is going to be acres and acres between the regional shopping center and the Civic Center. In the next two years I would think we would have about twenty commissions for works of art in the sculpture garden."

How to Participate in Slide Registries

1. Write to the sponsoring organization and request guidelines, an application, and other pertinent information about the registry and the

sponsoring agency. "Pertinent information" could include a brochure illustrating accepted artworks, a copy of the jurisdiction's Percent-for-Art legislation, and other helpful stuff.

2. Ask to be placed on the mailing list to receive Percent-for-Art and other announcements.

3. When you make your slides, pay attention to the slide registry's prospectus as well as other clues such as their illustrated brochure. You may wish to tailor your slides to feature your artworks only, your artworks installed, or a combination of both. If none of your artworks are actually installed in corporate or government locations, enlist a friend to lend his/her office space to you for slide-making in situ, or to talk the management into accepting one or more of your pieces on loan. The organizations administering public art projects prefer to see artists with experience. (For hints on getting experience, See the article "Interview with Françoise Yohalem, Public Art Consultant.")

4. When you send in your packet, be sure to include a self-addressed stamped envelope (SASE), whether the guidelines specify it or not.

5. From time to time, send the registry a batch of new slides, an updated resumé, and, if required, an updated application form. There are two reasons to send in new slides occasionally:

 a. New slides keep the registry up-to-date on your new experience and/or your new styles and available artwork. Your slides might be less likely to stagnate in an inactive file.

 b. Slides can wear out. Slides can fade or change color after as little as one hour of cumulative projection time. Even slides stored in the dark can fade after just six months.

6. Always view your slides, projected, before sending them anywhere.

Interview with David Breeden, Sculptor
Drew Steis

"I have to sculpt. It's inside me. I need to let it out."

David Breeden has turned his drive to create wondrous shapes out of various materials into a classic success story of how an artist can and should self-market.

Mr. Breeden has tried many ways to sell his art and by trial and error has found what works best for him. His experiences can be a model for all visual artists who want to make a living through art.

He has sold his works from the back of trucks, at street fairs, in alleys, at cocktail and dinner parties, by catalog and mail order, and in art galleries. He has written a book about his art which he sells to people who often then buy his work. He knows how to court the media and has had dozens of articles written about him and his work. For the last 18 years he has opened his home and studio to a weekly Wednesday night potluck supper where his sculpture studio and artworks are on view and for sale—he and his wife/business partner, Elizabeth, affectionately refer to this practice as "the longest running open house in history."

Selling sculpture through gallery dealers, he says, has been the least productive avenue over the years. "They would be happy if I limited my production to twenty-five to thirty pieces a year. But I can't," says Breeden, who has created more than three thousand sculptures in the last 10 years. "I don't think I have sold a piece a year at one gallery but I can sell dozens of pieces at a good weekend arts and crafts show.

"It's funny, one show can have a hundred thousand people attending and I'll hardly sell a thing. Another show will have just a couple of thousand people come and I'll do very well." It has taken time and effort, and he continues to test new show locations and seasons, but he has settled into a mix of shows that work for him now.

He still gets nervous before shows, though—for Breeden, there is an element of being onstage, as he enjoys meeting people and works very hard to communicate and sell. "I get there sometimes hours before the shows formally open, and I stay until the security guards tell us we have to leave." He also generates as much publicity as he can, inviting local TV and radio stations to come to film or interview him while he does demonstrations at the shows. That's good for him, and it's good for the show. "Besides, that way I get some work done at the same time."

He thinks as much in tons as in individual artworks. As we talked with him at his Biscuit Run Studio and home near Charlottesville, VA, he was loading five tons of sculpture onto three trucks for the four-day Long's Park Art & Craft Festival in Lancaster, Pennsylvania.

David Breeden prefers selling at fairs and festivals, where 50 percent of his sales are generated, and then selling to individuals from his studio, for another 45 percent. The reason is simple economics. Art gallery sales account only for the remaining five percent of his income. "A $6,500 piece of sculpture I can sell to an individual here or at a show when the same piece I might consign to a gallery for $3,200 and they might keep it for two years and then send it back unsold. That kind of piece might take me three days to execute and even at $500 a day plus $300 in materials I would only have $1,800 invested in it. Even though it might be priced at $6,500 I would rather sell it for $3,000 to someone rather than wait for a gallery to move it."

Mr. Breeden said the best way to deal with a gallery is to establish by contract a "hire/purchase" agreement whereby the gallery pays 10 percent down on delivery and 10 percent a month until the pieces are paid for. "But," he warns, "most galleries won't do it. They say, 'Well, we don't want your work as much as we thought we did.'"

At a recent arts and crafts show on the streets of Shadyside, a community within the Pittsburgh city limits, he sold $24,000 in sculptures in two days including one piece he delivered to Washington, D.C.

David Breeden has lived and studied in Brazil and Africa and began his artistic career with custom furniture and splatter paintings in 1961. He began sculpting exclusively about 12 years ago, first in wood then in metals. Then he gravitated to the native soapstone of Virginia. Typical of his marketing savvy, he now trades the Virginia soapstone he gets from a nearby quarry for California alabaster—he trades or gets materials free of charge whenever possible.

His style ranges from abstract to representational. He has created candelabras, soap dishes, fountains, and "once when I was really hard up I took all my sculptures and drilled holes and wired them then sold them to high-end furniture stores as original lamps. I needed the money and it was better than starving and better than going to work at something else."

His first large-scale sculpture sale, a 12-foot sculpture in soapstone, sold to the City of Charlottesville, VA, is yet another example of his marketing ingenuity. "I got the city to accept it, but I had to find someone to donate the money to buy it, and then I got the stone quarry to donate the stone," he explained. "There are tax advantages to doing it that way and I have had the tax laws researched to find out how to do it right."

Today, his large works are on public view throughout the country from Virginia to Florida to California at courthouses and other public buildings, on college and university campuses, at churches, schools, hospitals, and in private collections.

David Breeden one time met his match. "A woman came to the studio with her decorator and fell in love with a piece. She said she would take it, took out her checkbook, but when I said it was a little over $8,000 with tax she replied, 'Oh no, that won't do. I have nothing in my collection under $10,000.'"

He lost that sale but remains philosophical.

"If I do a show and sell $8,000, that gets me new clients for my work. Old purchasers of my work bring friends and they tell their friends."

Mr. Breeden also teaches, having between three and twelve assistants at any one time. "I sketch on and block out all the pieces myself—the concepts are mine—but I use students for the finishing and polishing and lifting. I don't lift anything heavier than fifty pounds now."

He used to winter in Ventura, California where he had an association with a gallery. Now he spends the winters in Jamaica, where he has several commissions for both public and private large-scale pieces in the works. "Percent-for-Art commissions are starting to come through for us now, too.

"I work every day. It is hard work but I have fun."

Elizabeth Breeden adds, "To make it in this business, you have to work every single day. He does the artwork and the selling, and I handle the business end. It really is a full-time job for both of us."

Stop by to see his work and to talk with a man who knows how to market his art.

Need to Know

Contracts for
Public Commissions

Peter H. Karlen, Attorney-at-Law

Even though government support for the arts at the state and federal levels has not increased much over the past few years and may actually have decreased, there seem to be more commissions for public artworks coming from local government agencies. This is a time when city and county governments recognize the need for monumental public artworks to become aesthetic symbols of the cultural development in their local jurisdictions.

For the artist who wins a competition or is otherwise chosen by an arts selection committee, the real problems begin after the selection is made. In virtually every jurisdiction, the contract for a public commission will not be legally binding until signed by an authorized agent of the governing body, whether this is the city council, board of port commissioners, or county board of supervisors. In other words, being selected is not the same as actually securing the commission.

What usually follows selection is submission of a contract by the government agency. The problem is that such contracts are often drafted by government attorneys who do not work on arts projects and who have little experience in drafting public-works contracts. These contracts are usually form contracts more suited to the erection of buildings, bridges, and sewage systems, than to the production of works of art.

The Basics

The artist must first negotiate the basic terms of the agreement concerning time for completion, description of the work, and compensation. If the government entity specifies a brief period of time for completion, it is best to

negotiate a longer period if possible. If not possible, it is best to provide for a grace period. After all, monumental works of art are not always completed on schedule because of delays in acquiring materials and support services.

The description of the work should conform to that in the original bid, if possible, and the artist should not attempt to change the work while in progress without the consent of the agency. For that matter, the agency should not try to exact promises that were not part of the original proposal, either.

With regard to compensation, the artist should be sure that the initial down payment will be sufficient to purchase the necessary labor and materials to start work. Furthermore, the artist should ensure that there is a constant flow of progress payments to keep the project—and him/herself—funded. Some agencies will ask the artist to defer the principal payment until the work is delivered. A counterproposal is to request that the agency make progress payments based upon the progress of completion or based upon necessary expenditures for materials and labor.

All payments should be made directly to the artist, but if the agency insists upon paying suppliers directly, the artist should have the right to be notified about all payments made to suppliers.

Licenses, Permits, Bonds, Insurance

Public entities are making increasing demands for security measures in order to protect themselves from liability. Many public entities are self-insured and do not want to tie up their own resources by exposing themselves to liabilities. Often the artist will be required to take out public liability insurance and will have to carry other types of insurance for employees, such as workmen's compensation insurance. Frankly, it is difficult for an artist to avoid carrying this insurance unless the agency has its own insurance policy and will let the artist pay the additional premium required in order to add the artist to the policy as an additional named insured.

Some public entities are even asking for performance and payment bonds from artists. The typical performance bond insures that if the work is not completed by the artist, the bond will cover the work's completion, and the typical payment bond insures that all of the artist's subcontractors and employees will be paid in full even if the artist defaults. If possible, artists should resist demands

for bonds. In the first place, these bonds are almost impossible for artists to get; second, they cost money; third, the agency can secure its position without resort to bonding.

One alternative to the performance bond is a system of progress payments whereby the agency withholds payment as soon as the artist defaults. The more progress payments, the more difficult it is for the artist to cause injury to the agency. The same alternative is also available for payment bonds. At the end of the project the agency can withhold a substantial amount of money until the artist provides proof of payment to all subcontractors and employees. Another alternative is to let the agency have a security interest in property owned by the artist. Perhaps the security interest could even be in the copyright of the work or of other works.

In some cases the agency may ask the artist to secure many or all of the necessary permits, including permits issued by the agency itself. The artist should balk at the suggestion. After all, the agency should be aware of all permits required and should pay for them, since it is in a much better position to acquire and pay for them. At the very least, the agency should tell the artist what permits are required, should let the artist apply for them, and then the agency should pay for them. Any number of permits or other similar legal requirements may be involved—for instance, those relating to building codes, zoning, utilities, and even environmental considerations.

In one case five or six years ago, an agency even required that the artist have a contractor's license. This requirement was patently absurd since artists do not usually have the time, money, or qualifications to get a state contractor's license. The best way around this requirement is an arrangement whereby all work that should be done by a licensed contractor is actually performed under the supervision of the licensed contractor. Thus, in the erection of a large sculpture, the licensed contractor can do the work on the foundation, leaving the artist to finish the sculpture itself. The licensed contractor may even erect the sculpture under the supervision of the artist.

Related to permits and licenses are approvals of structural integrity by third parties. In some cases, the agency may require the work to be examined and approved by a certified engineer. It will be difficult for the artist to resist this requirement. The artist should, however, insist that the engineer be a neutral third party whose services are paid for by the agency.

Terminations and Approvals

Agencies will attempt to retain rights of approval for each stage of production. Certainly once the complete proposal including sketches for the work is approved, the agency should retain no other approval rights over the aesthetics of the work, provided that the artist adheres to the original design. The agency can, however, maintain reasonable approval rights in relation to structural integrity and other related physical characteristics of the work. By reasonable approval rights, I mean rights that cannot be exercised arbitrarily and without reasonable justification. An agency should never be permitted to accept or reject at its own absolute discretion.

Agencies will always retain termination rights. Once again, arbitrary terminations for no cause or merely for the convenience of the agency should not be permitted. Termination rights should only be allowed for material breaches of the agreement by the artist, with provision for grace periods to allow the artist to cure defaults after receiving notice of the defaults from the agency. If the artist fails to prevent an unjustified termination, not only does s/he lose the commission, the publicity value of which is in addition to—even greatly in excess of—the stated compensation, but the artist is usually left with weeks or even months of potentially empty time, since that time had already been budgeted for the public commission.

Environmental Art

Peter H. Karlen, Attorney-at-Law

Environmental art opens new vistas for artists but also a host of new legal challenges. In fact, an environmental piece is often just as much the product of a lawyer as of an artist. We have only to recall the works of Christo to see that this is true, e.g., "Running Fence" in Sonoma County, California and "Valley Curtain" in Rifle, Colorado.

By environmental art, I mean pieces not only significantly changing the environment, but also affecting how we look at the environment. Thus, not every site-specific or landscape work is environmental art, although most landscape pieces are, depending upon their size and nature. Environmental art will also include space art and works on a grand scale, e.g., the French project to orbit light rings to glorify the Eiffel Tower.

Environmental Impact

Among the many legal challenges for the environmental artist are environmental laws. Many years ago, the Landmark Art Projects of Southern California, spearheaded by artist Joyce Cutler Shaw and University of San Diego law professor Herbert Lazerow, planned a visionary work called "Urban Mesa" which had been conceived by a group of six artists and landscape architects. Using land that would otherwise be devoted to a parking lot, the plan was to erect a large bluff of natural-looking material in the form of a mound of earth, naturally striated and planted with "original" Southern California flora, all in the middle of a center city urban area. You would think that bringing nature to a denatured environment would be an easy thing to do, cost being the only issue. However, like any building project, the piece required innumerable hearings and negotiations with city officials. After all, it represented rather an unusual addition to a center city area. The same would apply to Landmark's other visionary work, the "Museum of Seasonal Change," a large rectangular plot of urban San Diego land to be planted with uniform rows of deciduous trees.

Any large work, especially one significantly affecting the ecosystem/environment, may even require environmental-impact reports to satisfy state, federal, or local requirements. Larger works may also be subject to local zoning laws. If the local agency only allows structures having a certain height or other certain qualities and the work exceeds permissible limits, the artist must request a zoning exemption from the agency.

Copyrights and Moral Rights

There is no reason why a large work, albeit an environmental work, should not enjoy traditional rights allowed other works. Arguably, an environmental work in the form of a landscape work is a "sculptural work" protected by copyright, even though it may be inextricably part of the land. Thus, an artist can register the copyright in the work, using photographs of the work as deposits. Of course, the artist is usually not worried about the full-scale reproduction of the work but rather small-scale re-creations or photographic reproductions, perhaps preventable through enforcement of copyright.

The environmental artist should not only consider copyrighting the original work but also all drawings and sketches from which it was made. One has to admire how well-documented and organized the Christo drawings and sketches are.

Moral rights present another problem, particularly in maintaining the physical integrity of the work. If the work is separable from the land, moral rights, including the right to protect physical integrity, can be enforced regardless of size without conceptual difficulty. However, can the artist installing a landscape work prevent its alteration when to do so would tie up uses of the land for the full term of moral rights (e.g., the life of the artist plus 50 years)? This was the problem facing artist Mowry Baden when he sued the University of California for destroying a landscape work consisting of steel ramps melding into a ravine at the U.C. Irvine campus. There is a similar problem facing artist Gary Rieveschl with his large outdoor work installed in the City of Concord, CA.

Moral rights statutes for the most part allow exemptions for building owners. Under certain state statutes, if an artist installs a non-removable work in a building it may not enjoy moral rights protection unless secured by the artist in writing. The reason for this rule is that the building owner should have the right to alter or demolish the building without having to worry about the artist's work. For works installed after the effective date (June 1, 1991) of the Visual Artists' Rights Act of 1990, the federal law, certain moral rights do not apply if the artist and owner of the building execute a written instrument specifying that installation of the work may subject it to destruction, distortion, mutilation, or other modification by reason of its removal. With a landscape work, the landowner makes the same argument. To protect the artist's moral rights would mean the landowner would have to forego other uses of the land that would change the work. This is said to be too much of a burden. The point is, however, that the landowner never should have permitted the installation of the work or should have only permitted it after securing a written waiver of moral rights from the artist. After all, everyone is presumed to know the law, including landowners who commission landscape works. We should remember that the artist may have invested months or even years in creating the landscape work and can expect it to be "permanent." The artwork's value to society may be greater than the lost value of the land during the period in which moral rights are enforceable. In any case, new legislation will have to resolve this problem.

Liability

Every environmental work carries with it a risk of liability, i.e., risk of claims for property damage, personal injury, and wrongful death. The price tag

is either the possible lawsuit and judgment or else at least the insurance premium. Any large environmental work if erected in a downtown area could operate as an "attractive nuisance," for instance, by attracting children who could climb to the top and fall off.

The environmental artist, particularly the landscape artist, should therefore assess the liabilities and apportion the risk. One recourse is a comprehensive liability insurance policy, which may be prohibitively expensive. Perhaps the costs can be shared with the party commissioning the work, or the commissioning party can pay the costs entirely. A less suitable alternative is to ask the commissioning party to indemnify and hold the artist harmless from all claims, which obligation, of course, depends upon the creditworthiness of the party giving the indemnity. Risks can also be reduced through the use of proper signage and warnings as well as by the installation of guardrails and lighting, depending upon the work. Remember that the critical problem with many outdoor hazards is not with adults making claims but rather with children who unexpectedly put themselves in danger, in much the same way that an abandoned icebox is not a danger to an adult but rather only to a curious child.

Conclusion

Large works of art, especially landscape pieces, may have significant environmental impacts, whether installed in the country or the city. We must remember that the objections to Richard Serra's "Tilted Arc" in New York City were not only on aesthetic grounds but on practical grounds, including that the work blocked sunlight, allowed litter to accumulate, encouraged loitering, and otherwise made the urban environment surrounding it much worse than it already was.

Artists should never forget that the public has legitimate environmental concerns regarding large works of art. These concerns should never be ignored nor deemed merely the prattle of philistines.

Your Art In a Museum's Permanent Collection: Fact & Fallacy

Drew Steis

Wouldn't it be nice to put on your resumé that one of your pieces is part of the permanent collection of a major art museum?

All you have to do, you tell yourself, is ship off that canvas, photograph, print, or sculpture to your targeted art museum with a little note of donation. They might even buy it. But if not, you can always call it a permanent loan. The important thing is to get it to them, right?

Wrong!

It has been tried in so many ways that any curator worth his/her name is going to ship that piece right back to you, probably at your own expense.

The day when fame and a big tax deduction could be had just by giving a work of art to a nonprofit organization is now part of our distant past. First, an artist may not deduct anything other than the cost of the materials involved in creating a work of art. Second, reputable art institutions have rigid guidelines that must be followed before they will accept a donated work of art.

In Washington, D.C., the National Museum of Women in the Arts is a good example. Founded in 1987 by collectors Wilhelmina "Billie" Holladay and her husband, Wallace, the museum focuses on the works of women artists.

But when the museum project was first announced, the staff was overwhelmed with offers of literally thousands of works of art from contemporary women artists. The prestige of being part of a permanent museum collection just being established caused many to send unsolicited letters, slides, and even the actual works of art to the museum.

A policy was quickly established. (It is the standard policy of most of the major art museums in the U.S.) A written proposal containing the artist's resumé or biographical information, slides or photographs, and any relevant articles, reviews, or exhibition catalogues must be sent to the curatorial department. Do not send the actual work of art no matter how small. All photographs and slides must be labelled with the following information: name of artist, date including year completed, medium, dimensions, title, and the top of the slide "should be clearly marked with an arrow and the word 'top'."

The art is reviewed in the order in which it is received by the museum's Works of Art Committee, a secret group comprised of board members, staff, and art professionals. If materials are to be returned after review, a self-addressed, stamped envelope is required. If no return envelope is included, the materials become the property of the museum, which accepts no responsibility for lost materials.

Don't hold your breath. Today there is a 6-month backlog.

There is one other way to have your work recognized by the National Museum of Women in the Arts. The museum maintains a file on women artists of all periods and nationalities who have had at least one solo exhibition. To be considered for inclusion in the museum's Library and Research Center's Archives on Women Artists, contact Krystyna Wasserman, director of the Library and Research Center, 1250 New York Avenue, N.W., Washington, DC 20005.

At the Renwick Gallery, a division of the National Museum of American Art, which is a part of the Smithsonian Institution in Washington, D.C., there is also a curatorial committee which must vote on all arts and crafts before their acceptance to the permanent collection.

"Whether it is donated, we find it on the street, or we pay a significant price for it, it must pass the same criteria," said Judy Coady of the curatorial department.

Letters of inquiry which are accompanied by slides are always welcome and each will receive a personal response. The gallery is currently looking for examples of works in clay from the 1920s and 1930s, jewelry from the 1960s, and contemporary furniture, according to Ms. Coady.

"We are always interested in significant, important works from artists and master craftsmen but we will add the works of unrepresented senior artists to the collection before acquiring a piece from a middle level or emerging artist in the same medium."

Send query letters to Curatorial Department, Renwick Gallery, Pennsylvania Avenue and 17th Street N.W., Washington, DC 20560.

One word of caution. Never misrepresent which collection owns your art. Whether it is a private, corporate, or museum collection, be sure they actually do have your art before you put that on your resumé. One major Washington, D.C. art museum currently is faced with the embarrassing task of telling an artist that her work is not part of their permanent collection.

"She stated on her resumé that we held a piece, but when we asked her to tell us where the piece was, she was unable to," one nationally known curator said. "It is a no-no to claim that, and they always get caught."

Museum curators are interested in new works, so don't be shy about sending in your slides and resumé. Not everyone will be picked for inclusion in a major collection, but there is always a chance that your art fits their needs, so go ahead and make it available. Just be sure to follow the institution's guidelines.

PART 8

Ancillary Products and Activities

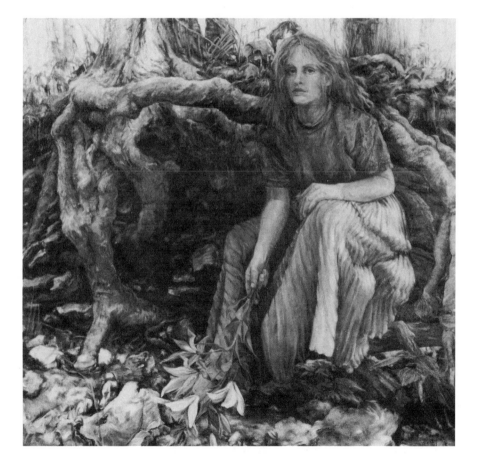

Failed Annunciation, 1991, Oils, 45"x48", Catherine Mills Royer, Indianapolis, Indiana

Essentials

Licensing Your Artwork
Carolyn Blakeslee

You have a design that would be appropriate for a coffee mug. You have just completed a painting that would be perfect for the cover of Annie Dillard's next book. You have made a photograph that would sell well as a poster. You have done a watercolor of a floral still life that would work as a sympathy card. You splashed some paint and you noticed that the resulting accidental design would look wonderful on a piece of stationery. You have an original furniture design that you have never seen in stores before—and you wouldn't mind seeing *yours* there. You're tired of your kids' stickers and just for fun designed a dozen of your own, because you knew yours would be better. You have a fabulous idea for a game that would involve the incredible mixing of creativity, color, and chance. You can see your new design on watches, or bedsheets, or gift wrap, or wallpaper, or clothing, or. . . .

These are just a few examples of ways you could license your artwork for controlled mass production and possibly make some very good money. According to *Licensing Art & Design*, a book by Caryn R. Leland, each year the licensing of visual art images generates over $5 billion in retail sales, and $75 to $100 million in royalty income for artists and designers.

The trick, of course, is in finding the appropriate licensee, and generating an appropriate contract or series of contracts.

How do you find a potential licensee? Pay attention to products at the stores you visit; keep track of those manufacturers and/or retailers who might be open to your line, design, or idea. Visit trade shows. Consult *Thomas's Registry of American Manufacturers*. Glom onto trade journals—your local library can get you started with how to find out who and where they are. For example, there is a magazine for toy buyers and manufacturers called *Playthings*. There is a directory

called *Who Makes It and Where* for stationery buyers and sellers, and magazines like *Women's Wear Daily* for the clothing industry and *Gifts & Decorative Accessories* for the gift and stationery market. *Decor* and *Art Business News* cover the offset print and poster industry. (See the article "Artist/Publisher Agreements.")

Prior to contacting a licensee, you might wish to perform a feasibility study of your own. In fact, having this information available at the time of your proposal might work to your advantage. Your study could include your observations about what the current market is bearing in terms of similar merchandise: trends, styles, colors, prices, etc., as well as your observations about a need or a niche that could be filled by your design or idea. During your study you might ask retailers whether they think a product such as [give a very general description of your idea or design] would sell. You might ask friends or even strangers whether they would buy such a product.

Once you identify a potential licensee, prior to submitting your idea/design, you are confronted with two contractual possibilities. One is a Nondisclosure Agreement, which you would submit; this would prohibit the company from using your idea/design. (See the article "The Protection of Ideas.") The other is a Submission (or Waiver) Form, given to you by the company. This absolves the company of responsibility of confidentiality in the materials/information you submit, and it puts the artist in a precarious position.

If the company representative won't sign your Nondisclosure Agreement, and you still feel you want to submit your design/idea, then create a paper trail. Document your idea/design. After the appointment is made, send a written confirmation of the upcoming meeting to discuss your idea (but write of the idea only broadly). Put your copyright notices (as well as trademark and patent notices, if applicable) on all of the documents, slides, and/or working drawings you submit. Take note of who is there and what their positions are. Send a letter documenting what took place at the meeting. If the company is interested, ask for or offer a written proposal.

When getting down to the nuts and bolts of your licensing agreement, you should present your contract first. The respect generated by your having a contract ready, with all your terms and requirements ironed out, is immeasurable. The licensee is free to come back with counteroffers, of course, but they are more likely to be reasonable. Licensing agreements involve some complicated law, though, and you are strongly advised to meet with a specialist attorney to

get your contract right before you even meet with a potential licensee to discuss the contract.

Here are just a few of the issues that should be very specifically addressed in a licensing agreement. For what purpose(s) are you licensing your design? There is a big difference between "ceramicware" and "a coffee mug." Obviously the first would be a much larger license. If you are granting exclusive rights, are you getting a larger royalty? Is the royalty nonrefundable? When are royalties due? based on what? Are you sure you have the right to grant the license? Is there a provision for you to be identified as the artist on the products? Is there a guaranteed minimum royalty? May the artist cancel the agreement if any of the terms of the contract are not met? Is quality control addressed?

Licensing Art & Design is a good source of more in-depth information on this subject. The book features two appendices: comparative average royalties of representative products (the average royalty for greeting cards and stationery ranges from 2 to 5 percent, while the royalty on commercial prints usually runs 10 to 15 percent), and a list of resources including several magazines, directories, and merchandise fairs featuring publishers and apparel and other manufacturers and retailers. The book also features a model Disclosure Agreement, and model Licensing Agreements which go into substantial detail.

The Protection of Ideas

Peter H. Karlen, Attorney-at-Law

An invasion of armies can be resisted, but not an idea whose time has come.
—Victor Hugo, *Histoire d'un Crime*, 1852

So you have an idea that will shake the world. Perhaps it is a sketch for a new television series that will enthrall the masses, or plans for a monumental sculpture that will become the eighth wonder of the world, or even a design for a better mousetrap. Since you may not have the resources to exploit the idea yourself, how can the idea be protected while communicating it to prospective collaborators and purchasers?

If you actually have a tangible work of authorship, that is, a creative work represented in tangible form, copyright protection may be available. However,

copyright protection is not available for ideas, no matter how they are described, explained, illustrated, or embodied in the tangible work. For instance, the author of a recipe book may have copyright protection for the literary content (i.e. the arrangement of words and numerals) of the recipes but cannot claim copyright for the ideas for recipes. No one can have a monopoly on a salad or cake, just the words describing it. Also, s/he who submits a script for a television series may have copyright protection for the text but not for the idea or concept of the series.

The same is true of patents. Patents protect nonobvious, novel, and original inventions in the form of machines, processes, manufactures, and compositions of matter. However, there is no patent protection for ideas alone; the patentable subject matter must be reduced to practice, and there must be a preferred embodiment of the invention. Without detailed drawings and specifications, and sometimes models, your patent application, even for the most marvelous device, will be rejected.

Protecting Ideas Alone

Except for a few scattered court decisions, there is no "property" in ideas. Thus, the originator of the idea generally forfeits the idea if it is disclosed to another person. In other words, ideas are as free as the wind; they cannot be grasped, held, or possessed. Once revealed, they are lost.

However, the idea may be protected indirectly because of the law's concern with preserving the sanctity of certain relationships. So when the originator can establish a particular relationship with the recipient of the idea, if there is a wrongful use of the idea, the idea is protected by arguing that the legal rules governing the relationship have been breached.

One type of legal relationship giving rise to protection is a contractual relationship. Before submitting an idea, try to get the recipient to agree to pay for its use and to maintain confidentiality. Preferably, this agreement should be in writing, though an oral agreement, which is harder to prove but often equally binding, may suffice. Naturally, recipients—especially large corporations that might buy, use, or develop your idea—usually decline to become parties to such agreements or, if they do agree, do so only on their own terms. The written contracts that they send you usually leave you with very little protection.

If you cannot get the recipient to agree openly and expressly to acceptable terms, there may still be contractual protection—sometimes a court will infer an

implied contract from the conduct of the parties and the circumstances of their transactions. For instance, a person who solicits your idea for examination will sometimes be deemed to have agreed to pay you the reasonable value for its use, even though no such promise was ever made. To find an implied-in-fact contract, it is best to have the recipient solicit the idea from you or, next best, to have the recipient voluntarily receive the idea. No implied contract to pay for the idea will be found when an idea is submitted to a recipient "cold" or against his or her wishes.

If a contractual relationship cannot be established, at least make the recipient aware that the disclosure is "in confidence," and get an acknowledgment of this fact. Should the confidence be breached, perhaps a court will give you relief by construing a contract implied in law, an artificial legal construction designed to prevent the unjust enrichment of one who breaches a confidence reposed in him or her. Such relief based upon unjust enrichment may also be proper if the idea is taken by wrongful means, e.g., by fraud, theft, invasion of privacy, etc.

Finally, certain preexisting relationships between the parties give rise to obligations concerning the use and disclosure of ideas. For example, the relationships between lawyer and client, between partners and, oftentimes, between employer and employee will be deemed confidential relationships. Within such a relationship, the recipient has a duty not to breach the trust placed in him/her when the idea is disclosed. The action is for breach of confidential relationship, so that lawyers, for example, are duty-bound not to use or disclose ideas communicated to them by clients.

Further Suggestions for Protection

You should remember that protection often depends on the degree of novelty, originality, and concreteness of the idea. By *novelty* one means that the idea has never been thought of before or is at least new to the trade, or perhaps only to the recipient. By *originality* we mean that the idea was not copied by the originator but was the product of his or her own imagination, though not necessarily novel. To the extent that the idea is properly delineated, described, developed, and articulated, it is *concrete*. Old, copied, or vague ideas are not the best subjects for legal protection.

Sometimes it is necessary to establish that one originated the idea at a certain time in order to negate claims by others that they first developed the idea. To establish priority, a copyright registration of a text or drawing embodying the

idea is sometimes recommended. Even though the registration only protects the text or drawing and not the idea, the deposit of a copy of the work at the Copyright Office is a matter of public record and establishes a date for your possession of the idea. Even the "poor man's copyright"—mailing a description of the idea in a self-addressed stamped and sealed envelope—which normally has no legal significance, may have the same effect. Otherwise, a notarized document containing a description of the idea will show the same date of possession.

The best advice is not to be too trusting, nor too suspicious, of others. Better yet, be a good judge of character regarding those to whom you entrust your ideas. When submitting valuable ideas, consult an attorney first. The concepts expressed in this article represent general guidelines but are not a guide to action in specific cases.

Artist/Publisher Agreements
Peter H. Karlen, Attorney-at-Law

During a career, an artist may deal with many galleries who will sell the artist's original works. However, artists usually do not deal with many publishers. Nonetheless, a good publishing arrangement can result in more sales, albeit in the form of reproductions, than a great number of gallery arrangements. Getting a publisher, therefore, can be a great boon.

On the other hand, publishers who are ready, willing, and able to publish your work are hard to find; finding all of the above in an *honest* publisher is even harder. Also, getting through the negotiations is difficult since a publishing arrangement involves many details. Here are some of the more important ones.

Scope of the Arrangement
The publisher who invests a lot of money in an artist typically wants an exclusive contract covering the largest territory for the longest period of time and in the most media of expression. The artist usually wants quite the opposite since most artists don't want to be tied up for long periods. An exclusive contract binding an artist to one publisher for many years can be very onerous if the publisher does not make good.

The artist has several strategies to negotiate a reasonable agreement. S/he can restrict the territory to a part of the U.S., or the entire U.S. without giving

away foreign territories, unless the publisher can show that it can meaningfully exploit foreign rights. If the artist is forced to grant exclusive rights, s/he should restrict the time period or insist upon minimum sales results, in the form of minimum royalties during the various accounting periods. The artist might insist upon a non-exclusive arrangement unless the publisher pays a fixed minimum sum of royalties for any particular accounting period. If possible, the artist should try to reserve for himself all media of expression not exploited by the publisher. Of course, some publishers, not even intending to publish in certain media, might want all media covered. For example, a publisher creating fine prints may not want the artist to independently put out the same works as posters.

Another arrangement favorable to artists bound by exclusive contracts involves options. Clearly an artist cannot sign his life away to a publisher for many years without ensuring publication of those works exclusively given to the publisher. The usual arrangement is that the publisher has the first pick of the artist's works or a right of first refusal, but if the publisher fails to publish the works it picks within a certain time period, the rights in those works revert to the artist.

Any contract involving exclusivity for a substantial period of time should be looked at by an attorney. The same holds true even for non-exclusive rights whenever the term is long, because the grant will stop the artist from signing exclusively with some other publisher during that term.

Materials and Framing

The usual understanding is that the publisher will choose the materials and framing for the works. However, because this choice is not only an economic but also an aesthetic one, the artist should insist upon some input. One solution is to allow that publisher to make the initial choice and then submit the same to the artist, and then allow the artist to make changes so long as the increase in costs is restricted, otherwise the artist has to pay the difference. A publisher who does not have a contract clause on this issue is inviting a disaster, namely, the artist refusing to sign multiples that have already been produced.

Approvals

The artist must retain a number of approval rights in order to protect his/her reputation. With fine prints, for example, the artist may want the right to

approve the initial chromalins from which reproductions are made, the prints coming off the press, and the advertising materials containing images of the work. By implication, this right is already reserved under moral rights statutes in effect throughout the U.S., wherein the artist is entitled to claim credit or to disclaim credit for "just and valid reason," or because the work has been mutilated, distorted, or modified. In short, the artist is already entitled to withhold his/her signature from an edition of fine prints if s/he can show a good reason. But this right should also be formalized in the publishing agreement. Artists must realize, of course, that publishers have heavy investments in printing limited editions, and the artist's right to withhold approval should be exercised very sparingly.

Free Prints

Artists should always insist upon a significant number of proofs, prints, or other specimens from an edition of their work. Moreover, these *gratis* copies should be free from restrictions and available for resale. This provides a considerable source of income for the artist.

Accounting, Books, and Records

Artists should insist upon regular accounting periods, preferably calendar-quarterly, with periodical statements of account to accompany payments. The publisher should be obligated to maintain complete and accurate books and records which the artist can inspect upon giving reasonable notice. Often the inspection clause will state that any serious discrepancies in favor of the publisher will be rectified at the publisher's expense, including the expense of the artist's audit.

The question of accounting and payment is most critical for the artist. Many publishers fudge their books and records; therefore, the books and records to which the artist should have access must include all contracts and documentation showing how many units have been produced by the publisher. Although production statistics do not accurately reflect what has been sold, they give a good approximation. After all, a publisher will not print 1,000 copies with the prospect of selling only 10.

Insurance and Other Expenses

All expenses of insurance, shipping, shows, and promotions should be sorted out in the agreement. Usually, the publisher pays for everything in

exchange for paying the artist a relatively small percentage royalty. If the artist expends money on travel or lodging in connection with shows or approvals, the artist should ask for reimbursement. Because a publishing contract involves a lot of communications via courier, mail, telephone, and travel, these items should be fully discussed in the agreement.

Dispute Resolution

Disputes between artists and publishers are not uncommon. Therefore, the artist who has fewer resources should usually opt for arbitration. The closer the site of arbitration, the better—preferably the artist's home town. If the publisher will not agree to arbitration, at least the site of the lawsuit should be specified in the artist's home state and home county, insofar as possible. Remember, the more detailed the contract, the fewer the disputes. Thus, an artist receiving a very long contract from a publisher should not discard it offhand as too much "legalese" but rather read it carefully and negotiate away unacceptable terms.

Termination

A very important part of the agreement is the termination clause. If the publisher goes bankrupt, becomes insolvent, fails to make or give one or more periodic payments or statements, fails to pay minimum royalties, or fails to print the requisite number of works, then the artist should be able to terminate the agreement. It is very difficult to terminate a long-term publishing agreement, so the termination clause must be clear as to how termination must be effected. One way is to insist that the grant of exclusive license is *conditioned upon* full performance of certain covenants, meaning that the failure to perform may result automatically in the termination of the license. In short, the publisher's promises should not only be *covenants* but also *conditions* of the granting of rights.

Another way to ensure faithful performance by the publisher is to insert a clause that "time is of the essence." Most publishers won't buy such a clause and will probably insist on its opposite, namely a *force majeure* clause, which allows for delays resulting from causes beyond the publisher's control, such as acts of God, including floods, fires, and natural disasters.

Conclusion

A publishing agreement is often a once-in-a-lifetime chance for an artist, but it can also be a source of untold aggravation. Artists burdened by exclusive agreements with dishonest publishers often have their livelihoods destroyed for years.

A good contract, thoroughly reviewed and negotiated, is one answer. More importantly, doing preliminary checks on the publisher's reputation, especially by contacting other artists, is a must. One way to check on a publisher is to examine the publisher's catalogs to find the publisher's current and previous artists. Then contact those artists and ask for references.

Talking Stock

Harold Simon

We are a nation—indeed, a world—obsessed with images. Wherever we turn, we see pictures; the ubiquity of photography is beyond question. Concomitant with our increased need for pictures on brochures, walls, and buses is the endless expansion of picture making. Our insatiable hunger for the photographic image is fed by an ever-growing cadre of suppliers. In 1986, approximately 13 billion exposures were made in the U.S. alone. Art photographers, photojournalists, commercial photographers—all contribute, but there never seems to be enough.

As the demand for images increases, so do the prices many photographers can command. It is not uncommon for an advertising photograph, assigned to a commercial photographer, to cost up to $10,000, and, occasionally, several times that.

Not every budget can afford this, and, at the same time, many photographers, themselves addicted to the production of more and more images, are discovering that they have quite a number of pictures, unsold, in their files. To put together the "wants" of the photo user, with the "have-availables" of the photo producer, we turn to the stock photography industry.

What Is Stock Photography?

The American Society of Magazine Photographers, in its *Stock Photography Handbook,* defines a stock photograph as "one that already exists and is available for licensing by the copyright owner or an authorized agent."

The photographer, who is usually the holder of the copyright, sells, directly or through an agency, the use of the image for a limited period of time or for a limited purpose. Stock images are generic in that they are not created for the specific uses to which the buyers will eventually put them, but can serve in a number of similar, or occasionally widely divergent, ways.

Until recently, most stock images were created for purposes other than being stock; they were pictures taken on a trip, out-takes of an advertising assignment, or unused images of a documentary assignment. At one time, most of a stock agency's files were full of such images. Stock photographers, in fact, were looked down upon as less than professional. Stock was considered a secondary market where pictures not good enough for their primary markets were consigned.

The economics of the picture market being what they are, this attitude has changed considerably. Today, more and more photographers shoot primarily for the stock market. Some produce images caught serendipitously. Others self-assign to get the pictures they want.

In the book *Satterwhite on Color and Design,* the noted commercial photographer Al Satterwhite describes a slow period during which he gave himself a stock photography assignment. He rented two beach houses in Bermuda, hired models, flew them and assistants down for a week, and spent six long days, and $28,000, shooting generic images he knew would be salable. The final yield was seven thousand chromes out of three hundred rolls of film. It took a year to recoup his expenses, but he estimates that he continues to make $8,000 to $12,000 a year profit on that session.

Producing Stock

Being a stock photographer means being able to produce technically excellent images and to respond to the needs of the market. The best photographers shoot what they want, and what they want happens to coincide with what the market is looking for.

In stock photography, the primary emphasis is on content. The advertising buyer is looking for a photograph that will create the proper mood to sell a product or service, and the editorial buyer is looking for an image that accurately describes a situation he or she wants to illustrate. The successful (measured in sales) stock photographer must wed artistic creativity and/or social awareness with market needs.

In addition to being able to produce for the needs of the market, a good stock photographer has to produce in volume. Since the stock market works with generic images, (e.g., children playing in a wooded area, young adults in a mall, etc.), the more images one has, the greater are the chances of having a buyer choose one. Some stock segments, such as travel, demand extremely high volume. It is not uncommon for travel photographers to submit five hundred, one thousand, even ten thousand chromes per year to their agencies.

Work that is more specialized—medical images, undersea zoological images, etc.—is usually produced in significantly fewer numbers. Many stock agencies are willing to accept as few as 20 to 100 new images of such work per year, as long as they are of good quality, technically and aesthetically.

Selling Stock

There are essentially two ways of selling stock, either independently, by the photographer to the user, or through an agency.

Selling stock is no different than selling any other type of photography. Your first step is to define what kind of work you do.

Next, you must find out who uses this type of photography. You then put together an appropriate and professional portfolio of images, make contact with potential buyers, and try to sell them what you have. As you produce more work, you continue to contact the buyers on a regular basis. Once your specialties in subject or style are recognized, your clients will begin to contact you.

When sales are made, the photographer has to negotiate the terms. How long will the image be used? For what purpose will it be used, and how much will the buyer pay? How long will the image be held while decisions on its use are being made, and what payment will be made if the image is damaged through mishandling?

The benefits of independent selling are considerable: greater control over the use of the image, undivided attention to marketing the work, and the full fee paid by the buyer. But not all photographers have, or are willing to devote, the time to market their work. Nor are selling and negotiation skills part of every photographer's training and temperament. So some photographers hire someone to sell their work, while others give over their stock images to an agency.

A stock agency is an authorized agent for photographers. The good agencies are thoroughly professional. They have specific guidelines that they and

their photographers follow. These agencies are constantly contacting potential buyers. When a buyer submits a list of needs, the agency researches the images they have available, presents the images to the buyer, negotiates use and fee terms, and, in a timely manner, provides the photographer with payment for the photograph's use.

The commission most agencies charge for their service is 50 percent, although some charge 40 percent. If sales are made to foreign buyers and a foreign agency is used as an intermediary, the cut is usually based on what the domestic agency actually gets.

The fees charged for use of an image are based on the extent and duration of the project. For instance, if a picture of a jet is used in a textbook with a very small print run, the photographer can expect a fee of a few hundred dollars. If the textbook publisher wants to use it again when the book is reprinted or for other uses, such as on promotional materials for the book, there is an additional fee. If that same image were to be used by a national car rental company for a series of ads in major magazines, the fee would rise to a few thousand dollars.

There is no organization that sets fees, but the *ASMP Stock Photography Handbook* gives a listing of average fees charged for specific uses. These figures are guideposts to use in your negotiations or when an agency negotiates for you.

Independent Selling (What Sells and Who Buys)

To sell stock successfully, your first step must be self-analysis. Exactly what type of work do you do? Once you know that, you'll be able to refine your research and contact those people who are most likely to buy your work. In Rohn Engh's book *Sell and Re-Sell Your Photos*, there is an elaborate guide to this kind of imagery analysis.

When you have a thorough understanding of the type of salable imagery you do best, you must then analyze the market for that kind of work. Both Engh's book and Henry Scanlon's *You Can Sell Your Photos* describe how to find and approach specific markets, such as textbook publishers or advertising agencies. They both offer sound advice on the kind of imagery in demand and how to shoot for the current market.

As mentioned earlier, the *ASMP Stock Photography Handbook* publishes average fees charged for a great variety of uses. This handbook also contains samples of all the various contracts and forms you'll need when negotiating a sale.

If you have a computer, two on-line services are available for stock photographers. Both Photonet and PhotoSource International allow photographers to use their computers to scan listings of current wants by publishers and other photo users. The users are allowed to place their wants on the services' databases for free, and the photographers are charged a monthly fee for access to the information.

And, of course, primary research is another good way to find photo users. A visit to any well-stocked library should give you access to dozens if not hundreds of magazines, nature and travel books, and a fairly extensive collection of textbooks. By looking through these carefully, you'll be able to find quite a few that will be compatible with your world.

Stock Agencies

If marketing and selling your own pictures do not appeal to you, the stock agency route is more appropriate. As mentioned above, stock agencies take your photos, catalogue them, find buyers, negotiate and consummate the deal, and send you a check when it's over. They require, besides market-specific work of high quality and in sufficient volume, well-captioned pictures, and, whenever there is anyone recognizable in your picture, a model release. A release is especially important if the picture will eventually be used for advertising.

Deciding which agency to approach is very similar to deciding which photo buyer to approach. Once you've compiled a list of the various agencies around, begin to cull those that are inappropriate because of the type of work they represent. Some agencies are very specialized, such as Animals Animals (nature, wildlife, etc.) and Medichrome (medical) in New York City; others are more general, such as Comstock and The Image Bank.

The media they handle also varies. Color transparencies have, over the last few decades, come to reign as the preferred medium. Many agencies accept only color transparencies. This is especially true for the agencies that cater to advertising clients. Smaller, more specialized agencies and agencies that deal with editorial clients, such as textbook publishers, often accept black-and-white images.

Once you've narrowed your list down to those agencies most likely to use your photographs, call or write to them to request their guidelines for portfolio submission. When you receive them, follow them as exactly as possible.

When a portfolio review is scheduled, use it as an opportunity to interview the agency. Look around and ask questions. See how they handle work, how they respond to buyers' inquiries, how they report back to photographers, and so on. Working with an agency is a very real partnership; it's vitally important that you find one that not only handles your type of work, but is also compatible with your personality and your sense of professionalism.

Once you've decided to go with a particular agency, carefully review the contract they give you. If possible, have a lawyer review it with you. Many agencies require from 3 to 5 years of exclusive use of your images. Once the time period is up, it can take up to an additional year before your pictures are returned.

In all likelihood, you won't be receiving any money for your pictures until 6 to 12 months after the agency first receives them. This lag is due to the time it takes the agency to enter your pictures into their existing file, for the picture researchers to become familiar with your work, for the work to be submitted and used by a photo buyer, and for the billing process to complete a cycle. While some agencies pay monthly, many pay quarterly.

The best agencies keep in very close contact with their photographers. They provide continuously updated want lists and inform their photographers about current market trends. The photographers, in turn, provide, on a regular basis, new work that is fresh and responsive to those needs.

In the last 5 to 10 years, a growing number of photographers have been earning a large portion of their incomes from stock. Many, indeed, are full-time stock photographers. They see this profession as a chance to make the kind of pictures they want, to be totally self-directed, and to be involved in a financially rewarding business.

Resources

A number of organizations and publications are enormously helpful to photographers considering the stock photography business. Among them are:

American Society of Magazine Photographers (ASMP). The ASMP provides photographers with information about business practices, mutual support, and seminars. Other services to the photographic community include collective bargaining and making available information books. Books include the *ASMP Professional Business Practices in Photography* and the *ASMP Stock Photography*

Handbook. For information, contact ASMP, 205 Lexington Avenue, New York, NY 10016.

American Society of Picture Professionals (ASPP). The ASPP is an organization made up of picture researchers, editors, librarians, agencies, photographers, and designers. It provides a link between picture producers and picture users. ASPP has a number of chapters throughout the country that, individually, provide conferences and information to its members. For information, contact ASPP, Box 5283, Grand Central Station, New York, NY 10163.

Sell and Re-Sell Your Photos by Rohn Engh is a guide for the independent stock photographer. For a sample of Engh's newsletter *PHOTOLETTER* and other stock sales information materials, write PhotoSource International, Pine Lake Farm, Osceola, WI 54020. Photonet. 1775 Broadway, New York, NY 10019.

This article was reprinted from the Summer 1987 issue of CENTER Quarterly, published by the Center for Photography, 59 Tinker St., Woodstock, NY 12498. The CENTER Quarterly (sample $5; free quarterly index available) features articles on significant contemporary and historical issues in photography, as well as reproductions of new work, book reviews, news in the field, interviews with photographers, etc. The Center for Photography, founded in 1977, is an artists' space showing photography, film, video, and related arts. Experimental and innovative work by contemporary artists, as well as significant photographic work of historical interest, is displayed. The CFP also offers a professionally equipped community darkroom, archives, and an extensive library. An educational program includes classes, workshops, and lectures given by nationally recognized arts professionals.

Organizations Serving Artists

Church, 1991, Photograph, 10"x8", Vered Galor, Woodland Hills, California

Foundations

Creative Artists Network: A Working Alternative

Drew Steis

What would you say if you were offered five shows a year in a gallery with no commission taken from what you sell? AND introduced to gallery directors and owners, and other leaders in the art world. AND you were given some public commissions. AND sent to Europe to study for a month, all expenses paid. AND free legal and tax help.

What's the catch, you say?

There is no catch, if you are chosen as an affiliate with the Creative Artists Network, a Philadelphia-based nonprofit organization established to help artists gain public recognition.

"Our programs are geared to the different aspects of the problems artists face at an early point in their careers," said Erika Wood, associate director of the Creative Artists Network, or CAN as it is locally known.

"Our stated purpose is to help talented artists gain the exposure that they deserve and to give them time to work full time on their art. Most of the artists that we call emerging artists have to work day jobs and they really have to struggle. They don't have any money and are barely scraping by. We call them emerging artists but it is really their public careers that are emerging in terms of the quality of their art and where they are in their artistic ability."

Established in 1984 by Felicity Benoliel and Mati Rosenstein, the Creative Artists Network takes chosen artists under its wing for a two-year period. During his/her affiliation, the artist receives much more than career support.

Benoliel, a teacher, art professional and granddaughter of sculptor W.W. Storey, grew up with the arts. "She always had a feeling for artists and wanted to help them in the tough early years. She talked with her friend, artist Will Barnet, and

they decided that what would really be a useful service would be to give talented artists who have the ability the chance to get into a gallery because a lot of galleries will not take on an artist who hasn't had many sales," explained Erika Wood.

"They set up Creative Artists Network to personally back artists and to provide them services—the main one being exhibitions. An artist gets four to five shows per year where there is absolutely no commission taken—nothing—so they get 100 percent of their sale price. We do ask for a voluntary 15 percent from the buyer but that is voluntary." Exhibits are held in the CAN Gallery at the Barclay Hotel in Philadelphia or in other spaces such as corporate or legal offices, banks, and local museums.

The Creative Artists Network offers three other programs for those chosen to become CAN affiliates:

- Direct Dialogues, a seminar series with guest art professionals. Some of the recent speakers have been David Stevens of the Pennsylvania State Council of the Arts; Charles Bergman, executive vice president of the Pollock-Krasner Foundation; and Christopher Barnes, former director of the MacDowell Colony.
- Community Art, a program to pay artists for public projects such as the murals for the Anti-Graffiti Organization, and set paintings for opera productions at the Curtis School of Music.
- International Exchange, a 1-month study abroad program where the artist lives with a local family and is introduced to local artists, gallery owners, museum and other art professionals. Travel, room and board, and a small stipend are provided by CAN.

"To date, about forty affiliates have gone or are going through the program," Ms. Wood explained. "We have had as many as fifteen at a time but we don't have any sort of quotas. The number of affiliates is decided by our peer review panel, a distinguished group that also serves as our board of advisors and includes: Will Barnet, artist; Charles Bergman of the Pollock-Krasner Foundation; Xavier Corbero, sculptor; Richard Boyle, author, curator, and former director of the Pennsylvania Academy of Fine Arts; Joseph Castaldo, composer and conductor; Vincent Desiderio, painter; John Dobkin, former director of the National Academy of Design in New York; Janet Fleisher, critic and owner of Janet Fleisher Gallery; Louis Sloan, painter and instructor at the Pennsylvania Academy of Fine Arts; and Jamie Wyeth, painter.

"All of our graduates have found gallery representation or were offered representation," Erika Wood continued. "I think one artist chose not to place his work in any gallery."

There are a few restrictions: the artist must be out of school, working independently for at least three years, and have no affiliation or contract with a commercial gallery nor have had a solo show in a commercial gallery.

Artists must use the official CAN application packet when applying to become an affiliate. The submission should include a short biography and ten slides, one of which must be a detail of a larger included work, and one which must be a figure drawing. There is a $5 application fee which is the only fee associated with the affiliate program. Although applications are accepted year-round, official deadlines are three times a year: July 31, October 31, and February 28.

Ms. Wood said CAN is very interested in considering emerging artists from around the country for its affiliate program. She warns, however, "Our board of advisors is very strict and they really are looking for artists that show consistent excellence. They are really looking for solid artists who really deserve to be shown."

The Creative Artists Network operates on an annual budget of around $136,000 which is made up of grants from state and local arts agencies and corporations, and donations. To apply for an official CAN application procedure packet write to Creative Artists Network, P.O. Box 30027, Philadelphia, PA 19103, or call 215-546-7775.

The Solitude to Create:
The MacDowell Colony

Drew Steis

When Edward MacDowell wanted to compose music he went off to a secluded cabin on his 450-acre estate in New Hampshire. He found it so creatively rewarding that he founded the MacDowell Colony where today composers, writers, and visual artists can also find the solitude they need to create. "The MacDowell Colony is a working retreat for artists of all backgrounds," explained Edie Sabine, acting resident director. "We have writers, composers, filmmakers, photographers, architects, and all visual artists." Ms. Sabine, who is an art historian by

training, has been running the "Colony," as it is known, since the departure of Chris Barnes.

In its 83-year history, more than three thousand artists have come to MacDowell, including Milton Avery, James Baldwin, Stephen Vincent Benet, Willa Cather, Jules Feiffer, Frances FitzGerald, Max Frankel, Arthur Kopit, Sara Teasdale, Studs Terkel, and Alec Waugh. Aaron Copland wrote part of "Appalachian Spring" at the Colony; Thornton Wilder worked on "Our Town" in one of the studios; and Leonard Bernstein completed his "Mass" while there. More than forty-five Pulitzer Prize winners have been Colony Fellows.

Founded in 1907 outside Peterborough, New Hampshire, the Colony now numbers thirty-one individual studios—built some distance from each other. No interruptions is the rule, and artists are only called to the telephone for true emergencies. Residencies are up to 8 weeks with an average stay of 6 weeks. Colony Fellows live in one of four residences where breakfast and dinner are served. Lunch is delivered in a picnic basket to the studio and is left on the doorstep without disturbing the working artist inside.

Competition for a fellowship and studio space is stiff. More than a thousand applications are received each year, but only about ninety artists are chosen annually. Colony fellowships are open to "creative artists with professional standing in their field and/or newer artists of recognized ability," according to the application guidelines. Selection is made by an anonymous jury of peers who make their decisions based on samples of the artists' work.

"Work samples are the most important part of the application process," Ms. Sabine explains. Artists also must list the five most important professional achievements of their career and provide three references from authorities in the field who are familiar with the artist's work.

Costs for the sessions are based on what the artist feels s/he can afford. While the cost to the Colony is about $95 a day per artist, the average contribution from an artist is $10 per day. The difference is made up from grants made by federal and state agencies like the National Endowment for the Arts and from private and corporate contributions.

The Colony is nonprofit and has an annual operating budget of $740,000. The 1990 fundraising campaign is being conducted to "secure the endowment for the future." Contributions will be matched from a Challenge Grant awarded to the Colony by the National Endowment for the Arts.

Creative artists are encouraged to apply about 8 months in advance of the time they would like to spend at the Colony. There are three annual deadlines: January 15 for the summer session, April 15 for the fall session, and September 15 for the winter/spring session.

When asked what is the most important advice she has for Colony applicants, Ms. Sabine replied: "Perseverance. Not everyone can be accepted on the first application so my advice is perseverance and providing the best examples of your work."

Application guidelines can be acquired by writing to The MacDowell Colony, 100 High Street, Peterborough, NH 03458. Tax-deductible contributions to support the Colony may be sent to the same address.

Interview with Charles C. Bergman, Executive Vice President, Pollock-Krasner Foundation

Drew Steis

"If you are a Sunday painter or if you are a hobbyist, you certainly should not apply to us. We are only interested in serious working artists."

The Pollock-Krasner Foundation is more than just interested in helping serious visual artists. Since 1984, the Foundation has given 611 artists a total of $5.6 million. *[NOTE: This article appeared in the September 1990 issue of* Art Calendar. *As of March 1993, the total had climbed to 996 artists and nearly $10 million in support.]*

Lee Krasner, artist and widow of Jackson Pollock, wanted to provide for "worthy and needy artists" in her will. She donated her artworks and a number of Pollock's paintings and drawings to the foundation. That donation today has grown to over $42 million in value of which, according to federal law, 4.35 percent must be spent in grants yearly.

Charles Bergman was asked by the Lee Krasner estate to set up the foundation following her death in 1984. He stayed on to become its first chief operating officer and executive vice president. Charles Bergman understands both Lee Krasner's wishes and the nature of artists. He has designed a grant-making system that works very well.

"You don't have to be destitute to get a grant from us," explained Charles C. Bergman. "That is very important. You don't have to be in some dire catastrophic

illness to get a grant from us. Our grants are very, very much for artists and for the normal slings and arrows of outrageous fortune, as I like to say.

"Our grants are for studio rental, artists' supplies, casting materials, or money so that a single parent can get a baby-sitter to have time to do artwork," Mr. Bergman explained. "We are also very receptive and sensitive to emergencies and we are very, very concerned about the medical, dental, psychological, and surgical needs of an artist. Many artists do not have medical coverage and when illness, particularly catastrophic illness such as AIDS, hits an artist it can be devastating. We are the only private foundation that I know of in the country that is actually giving grants directly to individuals with AIDS, providing, of course, that they meet the artistic merit criteria."

The grant-making process is built on the twin pillars of Lee Krasner's last wishes: ability and need. "The delicate balance of artistic merit and financial need is our dual criteria for making these grants. And it is a tough call. But you could be the world's greatest artist and if the financial need is not there—and it need not be a catastrophic need and it need not be dire need but it must be a legitimate bona fide need—but if that need isn't there, we can't help you. Conversely, if somebody is dying on the street and their artistic merit is not discernible then we can't give them a grant. I don't mean they have to be recognized by the art world and I don't mean that they have to hang in great museums to get a grant—they have to, in the opinion of our committee of selection, have some excellence, talent, and competitive quality to their work."

Mr. Bergman said the foundation welcomes applications for grants and that there is no annual deadline. He walked us through a hypothetical grant submission.

"We get thousands of applications from all over the world. They come in willy-nilly all the time, either directly or sometimes—if it is from an Eastern European country or China—they are brought by people who expedite them, getting to us rather than through the vagaries of the international mails. Once an application is received, if it is complete—meaning that the narrative letter is there, the ten slides that we request are there, and the application form has been properly filled out—the next step is that the slides are seen by the committee of selection. Now we do something very special that we are very proud of because this is so important to the life and career and well-being of an artist: we insist that the committee of selection—which is a distinguished and anonymous

group—see all the slides individually. In other words, a member of the committee comes to the office for what we call their preview; privately, they see all the slides they will see at the next committee meeting and they score those slides on a master list.

"After all the committee members have seen the slides individually with a member of my staff, the full committee meets—usually a few days later—and then they see all the slides again. In that group interaction of the committee they can discuss, modify, or change their decision as to the artistic merit of those slides.

"If the candidate survives the committee of selection's scrutiny, then the next step is to be investigated by our very dedicated and competent staff to determine that the material—the information contained in the dossier—is, in fact, correct. We have to be sure that when you say you have a serious illness, or you have had a studio fire, or whatever is the nature of your need, it is legitimate and authentic. We require tax returns and financial data which are held, of course, in strictest confidence."

Charles Bergman receives staff recommendations which he reviews with the investigators. "Then I meet with the board of directors and give them my recommendation which is based on a combination of the committee's input, the staff investigation, and my own judgment. The ultimate responsibility for making a grant rests with the board of directors and they can accept, deny, or modify my recommendation." The Pollock-Krasner board of directors consists of two long-time friends and advisors of Lee Krasner: Eugene Victor Thaw, the president of the foundation and Lee Krasner's art dealer, and Gerald Dickler, chairman of the foundation board and Lee Krasner's attorney.

"I would say our grants average $10,000-12,000 roughly but they are based in every case on the individual needs of the artists," Mr. Bergman continued. "We have given grants from $1,000 to $30,000."

According to the foundation's guidelines, painters, sculptors, graphic, mixed media, and installation artists may apply. Not eligible are commercial artists, photographers, video artists, filmmakers, craft artists, or artists "whose work falls primarily into these categories." The foundation also does not fund travel expenses or give grants to pay for "past debts, legal fees, the purchase of real estate, moves to other cities, or to pay for the costs of installation, commissions, or projects ordered by others."

"The foundation sees its role as aiding, for a one-year period of time, working artists internationally, who have embarked on professional careers. It does not make grants to students nor fund academic study."

There are no submission deadlines and an artist should hear about their grant application in "two to three months. But in the case of a life-threatening emergency we are able to move dramatically and very, very quickly. We have even used messengers to get the slides around to the committee members so we could act quickly," Mr. Bergman said. His advice to an artist in need of a grant is very direct. "Send us the best slides you possibly can, recognizing that slides at their best do not always do justice to an artist's work." Original art is not accepted and studio visits and personal interviews are also out. "Our concern is to be absolutely fair, impartial and nondiscriminatory wherever an artist is anywhere in the world. So I put great emphasis on the quality of those slides and they obviously have to be marked and labelled as we indicate in the application."

"Secondly," Mr. Bergman continued, "the narrative letter need not be a literary effort but an honest, concise, accurate statement of why I, the applicant, need the money. And thirdly, and most important of all, the application information—particularly the financial information—must be accurate and honest."

Guidelines for the Pollock-Krasner Foundation grants may be acquired by writing the Pollock-Krasner Foundation, Inc., 725 Park Avenue, New York, NY 10021.

Residences

ArtHouse: Finding
Live/Work Spaces for Artists

Drew Steis

ArtHouse was started in 1986 to stem the exodus of artists who were leaving the San Francisco Bay area because of the high cost of studio space.

And it worked. Now, four years later, not only is ArtHouse succeeding, it is being expanded into Oakland and Los Angeles. It is a concept that can work anywhere, given the proper planning and energy.

"The California Lawyers for the Arts (CLA), a nonprofit group of attorneys, had been representing artists in legal issues since 1974. It became clear by 1986 that the housing issue specifically was a major problem for artists," explained Jennifer Spangler, project manager for ArtHouse.

"At about the same time, the San Francisco Arts Commission conducted a survey of artists' housing needs in the area which showed that about 80 percent of the current artists' community of the city was considering moving out of the city because of high rental rates. As a result of that survey, it was clear that either some kind of assistance be provided or else the city would lose the artists."

The assistance was the establishment of ArtHouse, which was a joint project of the San Francisco Arts Commission and California Lawyers for the Arts. ArtHouse facilitates the renting and/or purchasing of artists' studios or live/work spaces. It acts as a clearinghouse for housing information, and is a respected liaison for artists seeking live/work space and for the landlords, architects, developers, and other real estate professionals who control the housing.

ArtHouse has installed a housing telephone hotline, available at no cost to artists, which provides listings of available spaces for rent or sale. Property owners are charged $50 to list live/work spaces or studios. The service logs about twelve hundred telephone calls a year. Another ArtHouse service is the staging

of periodical informational seminars conducted to better inform and bring together artists, landlords and city planning officials.

In its first two years in business, ArtHouse assisted approximately six hundred Bay area artists with housing issues ranging from finding affordable spaces to negotiating lease agreements.

Jennifer Spangler is well suited by training and temperament to guide ArtHouse. She has a degree in art management and has worked for art organizations, art galleries, and a commercial real estate appraisal firm. Her cross-cultural qualifications also include a love of painting and a license in real estate.

"Artists are the only segment of the population that can turn a vacant warehouse into a comfortable, unique, functioning live/work space for themselves," Ms. Spangler said. "Very few people can take a raw space like that and divide up the space and decorate and make the improvements that are necessary to turn it into a wonderful live/work space."

The California Lawyers for the Arts were instrumental in winning passage for legislation that permitted artists to occupy live/work spaces in San Francisco in buildings zoned for commercial, industrial, or manufacturing use. Ms. Spangler sees that as a crucial plus for the artists.

"Having artists occupying a vacant warehouse in an industrial area 24 hours a day can really be an incentive for security reasons. In addition, building out the space to live/work building codes is a lot less expensive than building it out to the residential building codes—you only have to provide a hotplate instead of a full gas stove and you can also leave the space relatively unfinished as far as the floor and wall covering and so it is cheaper to rent to artists."

There are other reasons for accommodating artists in housing. "Artists can provide a real solid buffer between industrial areas and residential areas," Ms. Spangler continues. "In addition, artists are, in general, one of the few segments of the population who will rent in a higher crime or more rundown area of the city because of economic necessity and also because those kinds of areas give artists the large, undivided areas and raw spaces they need for their work."

ArtHouse operates on an annual budget of $60,000-80,000 and accepts grants from businesses and foundations. "The hotline actually is an income producer, and our book and survey sales generate income." One innovative money maker which is just getting underway is a real estate referral service where

ArtHouse will refer artists to approved real estate firms for a finder's fee in the event of a sale or lease. "The artists are pretty happy with this because we only select agents who really understand live/work and know what artists are looking for and can afford."

Ms. Spangler has good advice for those wishing to use the ArtHouse concept in their own areas. "First I would encourage them to talk to their local arts council or arts commission and get support from them. Make sure you enlist the city or local community in the project because having the support of the mayor's office, planning commission, or development commission is really key to getting low-cost, affordable live/work space.

"Start with a two-day seminar that includes panelists from city agencies as well as real estate professionals, arts professionals, and bankers to get people involved. From there, the whole idea of developing live/work space can be pulled together by an advisory group made up of those kinds of professionals."

For those interested in learning more about ArtHouse or how to go about duplicating the ArtHouse success, Ms. Spangler has prepared a free packet of information including how to order the fifth edition of the ArtHouse publication *Live/Work: Form & Function.* Jennifer Spangler can be reached at ArtHouse, Fort Mason Center, Bldg. C, #255, San Francisco, CA 94123, 415-885-1194.

Staging an Exhibition Texas Style: Interview with Sandra Gregor, Executive Director, Texas Fine Arts Association

Drew Steis

There is one very simple reason why the Texas Fine Arts Association—80 years old this year—requires a submission fee from artists seeking to enter their national juried exhibitions: "We would not be able to pay for the cost if it were not for the entrance fees," says Sandra Gregor, the association's executive director. "While I regret that we have to charge entry fees for our exhibitions, we simply would not be able to produce the shows without entry fees. The good side is that we haven't increased the fees in four years."

There are a number of other benefits for those chosen to show work in either of the two major Texas Fine Arts Association national exhibitions each year.

"We have found that our exhibits are a good place to look at fresh talent or under-recognized talent," says Ms. Gregor, who has been executive director of the association for the last 8 years.

Art Calendar talked with Ms. Gregor as she and her small staff were busy sending out eleven thousand calls for entry for a juried exhibition "At the Edge II," which featured contemporary prints and drawings and was juried by Wendy Weitman, assistant curator for prints and illustrated books at the Museum of Modern Art in New York City.

"In the last survey Texas ranked third, after New York and California, in the number of working artists and by now, I'm not so sure that we are not neck-and-neck with California," Sandra Gregor continues. "Our last exhibit, 'New Art: Paintings from New York, Texas, California,' was a tri-coastal look at what is going on on the three coasts."

That exhibit was a success and it is not surprising. All of the recent Texas Fine Arts Association exhibits are successful simply because of planning. Sandra Gregor leaves nothing to chance in her preparations for an exhibit.

"The first important ingredient is a well-designed call for entries," she explains. "Next you need very good jurors who can recognize under-recognized talent. The exhibit must be installed well in a fine space by experts and the catalog must be of professional quality. Then invitations must be sent out and a nice reception held."

All of this costs money, Ms. Gregor admits, and that is one of the reasons why the Texas Fine Arts Association charges an entry fee of $15 for three works for association members and $22 for non-members. Annual membership in the association is $25.

Ms. Gregor estimates it costs "around $35,000" to mount just one of the association's national exhibits. She shared the following budget information:

"Printing of the call for entries, the catalogs, and the invitations accounts for just under one-third of our exhibit budget. We mail the call for entries to around five thousand artists and six thousand others in college and university art departments, at national and state arts organizations, to all the Texas art groups, and to *Art Calendar* and other publications. Mailing can cost two to three thousand dollars more.

"The juror's fee including all expenses usually runs from $2,000 to $2,500. Our advertising accounts for another $1,000 and the exhibit opening reception

costs $700 with an additional $1,000 spent on the juror's reception with the selected artists and patrons.

"The rest of the budget goes to pay for staff time and to hire contract labor to do the various mailings, organize slides, open the crates, hang the exhibit, and staff various functions.

"It takes two months of solid work over a six-month period for each exhibit. It takes two months of solid work to put it all together."

That work is paying off. The "New American Talent 1989" exhibit attracted 1,185 artists who sent 4,650 slides to be judged by John Caldwell, Curator of Painting and Sculpture at the San Francisco Museum of Modern Art. He chose 52 artists for the exhibit.

In the fall of 1989, "New Arts: Paintings from New York, Texas, California" was responded to by 692 artists who sent 2,600 slides. Juror Henry Hopkins, Director of the Frederick R. Weisman Art Foundation in Los Angeles, picked 42 artists for the exhibit.

"For 'New American Talent 1990,' 1,201 artists sent over five thousand slides and forty-four were chosen for the spring exhibit," Sandra Gregor explains.

"I wish we didn't have to charge entry fees but the fact of the matter is that we haven't raised the entry fees in four years and we haven't raised the membership dues in four years. We keep them as modest as possible to give the artists the best value possible.

"The last couple of exhibits have covered expenses but they haven't always. We have started to get more entries than we did. The fact that we are getting so many artists entering the shows may work against us, for we may have reached the point where people say 'Well, it's not worth it to enter because of the numbers,' but that is wrong.

"Everyone who enters gets something out of entering, sometimes as little as encouragement—knowing that their work was seen by a nationally-known juror. For others it is being picked out of more than a thousand artists. We have had artists accepted by galleries because the juror liked their work and stayed in touch and one day they sat down and telephone calls were made and it worked.

"Artists are selected by a gallery because someone has seen the catalog or seen the show. The shows have come to be seen as a good place to see real fresh talent."

For those who have not been selected for an exhibit, Ms. Gregor says don't give up.

"This is one juror's view of what they think makes a representative show from one set of slides. Another juror would not necessarily make the same choices, and artists need to know that. We have artists who enter three years in a row and all the time their work is improving and at the same time the jurors are changing and I don't think anybody would say that three people will look at the same set of slides and pick exactly the same show."

Sandra Gregor tells artists who have not been selected to come to the exhibit. "That gives you more information about how to compare your own work with the show. Some say, 'I can see why this juror did not respond to my work.' Others see work that is as good as theirs and think the juror should have responded, and some realize that the exhibit work is better than their work."

She encourages artists to enter juried shows wherever they are available.

The following is juror John Caldwell's introduction to the catalog of the New American Talent 1989 exhibition May 6-June 4, 1989, at the Laguna Gloria Art Museum, Austin, Texas, and is reprinted with the permission of the Texas Fine Arts Association. John Caldwell died of a heart attack in March 1993 at the age of 51.

One day in early February of this year, twelve enormous boxes arrived in my newly occupied office at the San Francisco Museum of Modern Art. Even though I knew to expect approximately five thousand slides of artists' work from the Texas Fine Arts Association, I was slightly taken aback because no one had ever brought anything quite so massive into any office I'd ever had as a museum curator. The bulk of the material was exaggerated somewhat, because the Association's staff had very considerately placed all the slides into carousels ready to be mounted on top of a projector. But still, five thousand slides, to be somehow winnowed down into an exhibition of sixty or so works of art, represented an extremely daunting, one might say overwhelming, task.

What followed during many nights and weekend days of slide viewing, was a curious experience. I felt, first of all, the extraordinary bravery of the hundreds of artists who sent out their work, inevitably poorly represented by slides somehow to be judged. Each work represented an important part of the self of each artist, and simply to call it, in the usual term, the artist's "vision" does not go

nearly far enough. All artists are trying to communicate with the rest of us, and most of them know that this means they must reach deep into their hearts as well as their minds for what is most individual and personal, and sometimes most painful and private. To do this and launch the results out into the world is inherently difficult, often even heartrending, a little like sending a child off to school for the first time. Then to impersonally and anonymously send off a few slides to someone you've never met, who sees only a poor reproduction of the work itself without even having the artist's name, at least at first, and who can hear not a single word of explanation—"the slide is too blue," "the texture is very important here," etc.—is an act of simply enormous bravery. And for what reward, after all? Of necessity, hundreds of artists receive back only a postcard with a polite notice that their work has been rejected—even a child on the way to school would hardly receive such peremptory treatment. For this juror, at least, the necessity of one-way communication—of artist to curator but not vice versa—was perhaps the greatest single frustration inherent in the process. Yet how could it have been otherwise? Even so, again and again I wanted to offer words of encouragement, to say this is technically accomplished, for example, but suggest that the artist search for meaning with more determination; other times I wanted simply to applaud the directness and immediacy of a particular vision. The hundreds of letters and phone calls this would have taken were clearly impossible, so I would like to take this opportunity to say, overall, to all the artists who submitted their work for consideration: Bravo!

This praise comes with two bits of advice or, if you will, of criticism. First, for most artists, it is better to avoid taking one's own wife or husband, children or pets as subjects. Perhaps we all see our most beloved too partially to depict them with the truth of objectivity. Or perhaps it is instead that the likeness of one to whom we are very close carries far more meaning for ourselves than for others. In any case, most of the work that consistently just missed had as its subject the artist's family.

Second, there is the problem of the merely pretty. This is perhaps more difficult to explain or to justify, but the fact remains that for most serious critics today attractiveness by itself is not enough in a work of art. Think, for a moment, of the natural photographs on the Sierra Club calendars. None of these, I venture to say, would ever be purchased as original prints by an art museum. Somehow, today, such beauties seem contrived, like a *Playboy* nude,

and therefore meaningless, whereas good art aspires always toward meaning, no matter how difficult or sometimes bleak.

What to say, then, about the work that was selected for the exhibition, or that deserved honorable mention and accompanies it in the form of a slide presentation? The curator of "New American Talent 1988" made the interesting remark that every regional style except Manhattan's was represented in the exhibition. This year that is not the case. I can easily imagine seeing work by Amy Blakemore, Camille Cornelius, Donald Forsythe, Jack Hanley, Lynn Hurst, Brian Portman, Dean Ruck, and Wm. Lateef Yoder, to name only a few, in a New York art gallery, and of these artists five come from Texas, two from California, and one from Pennsylvania.

The whole idea, in fact, of a regional style, at least among the best younger artists, may be losing its relevance. This decline of regionalism is due, of course, to many causes, one of the chief being the increasing homogenization of American culture as a whole. Another factor contributing to this change is the growing interest in, sophistication about, and access to contemporary art in all parts of the country. As an example, Texas contains some of the great public and private collections of contemporary art in the nation. Further, among its many artists are some who are viewed outside the state simply as artists who happen to live in Texas, and not as Texas artists. Michael Tracy and Vernon Fisher, to name only two, are seen as important figures in American art, and it is really as Americans, not as Texans that their work is respected around the world.

If "New American Talent 1989" is not a collection of work in regional styles, then, what is it? Primarily, it is the work of younger artists, since only nine of the fifty-two artists included are over forty, but this is probably because only younger artists tend to submit work to juried exhibitions. There is a slight preponderance of male over female artists, but nothing like what would have been the case only a few years ago. Texas, probably, is somewhat disproportionately represented among the artists selected, but this is almost certainly due to the location of the exhibition, which means that it is best known in Texas and thus drew more entries from the state.

Although one would like to characterize the exhibition in stylistic terms, the work does not submit to easy characterization. One reason for this, of course, is the way it was selected—on an individual basis, artist by artist and slide by slide—with the sole guide being the perceived quality of the work. Since

there was no attempt to create an exhibition representing a particular style, there is none evident here, at least to me. What I hope, however, is that something of the sense I had four months ago while looking at those five thousand slides remains. I hope that some indication of the bravery and courage of the people carrying on as artists, despite all the odds, has come down in this collection of works representing the best of those submitted. I hope, moreover, that the feeling of the whole group over many hours in a dark office in San Francisco somehow infuses the exhibition as a whole. For me, these works embody a real passion for expression, a cry almost of human communication, that tells us something strong and meaningful about each artist, about his or her experience and, of course, about ourselves.

— *John Caldwell*
Curator of Painting and Sculpture
San Francisco Museum of Modern Art

The A. Salon
Drew Steis

A. Salon is an interesting and effective hybrid. It is not a conventional co-op gallery arrangement, nor is it a conventional artists' membership organization. Yet, it fulfills many of both functions, and does so at reasonable prices.

When A. Salon was founded in 1979, it was because a small group of metropolitan Washington, D.C. artists needed a gallery, classrooms, and low-cost studio spaces.

Today, A. Salon has not one but two locations—a former elementary school and an additional 35,000 square feet of gallery and studio/classroom space in a building two blocks from a subway stop.

"Affordable studio space, accessible exhibition space, and teaching space were our goals because it is tough to find space that is inexpensive enough for artists," explains Letitia Grant, a past president who now heads the group's development committee.

"In 1980, in partnership with the Corcoran School of Art, A. Salon opened the Jackson School Art Center in an empty elementary school in Georgetown. The Corcoran taught classes in approximately sixty percent of the school. A. Salon had studios, a gallery, and a classroom in the other forty percent."

It was a successful partnership with A. Salon holding eleven shows a year at the school as well as organizing exhibits at other locations.

"By 1985, A. Salon had a very long waiting list for studio spaces, so we went looking for another space to lease," Letitia ("Tish") remembers. "We opened the Takoma Metro Art Center in 1986. Then last summer we learned we would have to vacate the school, but we haven't received our eviction notice yet so we still have both spaces."

A. Salon still carries on the flavor of an artists' organization rather than a conventional artists' co-op. Membership is now eighty-six artists, three nonprofit groups, and two arts-related businesses. Studio spaces are available on a first-come, first-serve basis; according to Ms. Grant, unlike other art groups, "We do not jury for membership or for studio space."

Membership is in two tiers: full and associate. A full member may hold studio space and may appear in two- and three-person shows while both full and associate members are eligible for group shows, receive discounts on classes, and receive notification of upcoming shows.

A. Salon tries to keep costs low. The only paid professional is a part-time bookkeeper. Both dues and studio spaces are reasonable. Full membership costs $25 per month with members expected to give the organization three hours of work per month or $15 more in dues. Associate members pay $40 a year. Studio rent is also reasonable: "Our cost to the artist for space at Takoma is $7.70 a square foot a year," Ms. Grant explains. "A three-hundred-square-foot studio would therefore cost $192.50 in monthly square footage fees or $217.50 with dues. This is the lowest we know of for the amenities we offer: heat, air conditioning, security, safe neighborhood, easy street parking, plus a fenced lot across the street for $17 a month extra, and good public transportation. There is the added amenity of working in a building full of other working artists, and having the cross-pollination and stimulation that provides."

It is a small but busy membership. Besides life-drawing classes once a week, various members give individual and group art lessons in their studios. "In 1989, we conducted a survey of artist's spaces in the Washington, D.C. area for the D.C. Commission on the Arts and Humanities and the Meyer Foundation," Tish Grant adds.

"In our gallery we have also recently offered shows by the clients of the Life Skills Center [retarded adults] and by the students of the Fillmore Art

Center and by Fillmore teachers." Upcoming shows include "a show by A. Salon artist-teachers, and juried shows open to members and non-members."

"We have continued negotiations with the school system to stay at the Jackson School and, as of April of 1990, we are still there. The hope of extending our lease and continuing occupation there seems, at this point, not beyond the realm of possibilities, but nothing is certain," Ms. Grant continues.

"We are on a month-to-month basis at the school but we have studios available at the Takoma Metro Art Center and our membership is open and unlimited."

Artists interested in learning more about A. Salon may contact Tish Grant at A. Salon, Ltd., Takoma Metro Art Center, 6925 Willow Street, N.W., Washington, DC 20012, 202-882-0740.

Legal Issues

All That Was Promised, 1990, Sculpture assemblage, 32"x17",
Suzanne Alexander-Ferrera, Little Rock, Arkansas

Copyright

Legal Definitions:
Their Importance

Peter H. Karlen, Attorney-at-Law

Many artists, dealers, and collectors don't fully realize the economic and legal implications of categorizing works of art. For example, an artist may create a work without considering whether that kind of work is protected under copyright, customs, moral rights, and resale royalties legislation—not every work is protected under various laws affecting the arts.

For example, moral rights legislation, protecting the physical integrity of artworks and the artist's rights to credit, generally applies only to paintings, drawings, sculptures, prints, and certain photographs, depending on the statute. The resale royalties law in California is limited to paintings, drawings, sculpture, and original works of art in glass. Customs duty exemptions often are limited to traditional works of "fine art" such as paintings, drawings, and sculptures. Even copyright laws do not apply to every work of art, e.g., certain conceptual works.

Therefore, in creating, selling, and purchasing works of art, artists, dealers, and collectors should carefully consider the legal protections for the kind of work involved.

Here are some cases.

In one case, an artist had created a mosaic installed in a building. Under the art preservation statute involved, only paintings, drawings, sculptures, and works in glass were protected. The mosaic was created with tiles of ceramic tile rather than glass; the individual tiles were not hand-painted, although the artist did create a pictorial work in an entirety by arranging the individual colored tiles. Perhaps from a distance the work might even look like a painting. Nonetheless, technically speaking, there were serious questions as to whether the work was a "painting" protected from destruction.

In another case, the artist had created a wall relief which was certainly not a painting but would have to be qualified as a "sculpture" under an art preservation statute. However, although the work could be described as a "sculptural work" and drew its artistic content from its shape and configuration, it wasn't necessarily a "sculpture" under the statute—most people thinking of a sculpture conceive of a three-dimensional work, standing on its own, without any required background. A wall relief is just as much a mural or ornament as it is a sculpture.

In a recent case, a Los Angeles Superior Court judge ruled that a mural was *not* a "painting" otherwise protected under the California Art Preservation Act (Civil Code Section 987). Unbelievable! Fortunately, the result was reversed on appeal.

Good legal definitions are hard to devise, and even the best definition leaves a lot out. When Diogenes defined man as a "featherless biped," he was not inaccurate—but there is a lot more to say for man than comparing him to a chicken. Following are some bare-bones legal definitions for essential art terms.

A "drawing" is a work of art created by applying linear or curvilinear marks, using a dry or wet substance (such as lead or charcoal), to a relatively flat surface.

A "painting" is a work of art created by applying colors in a viscous medium to a relatively flat surface.

A "sculpture" is a three-dimensional work of art created by the assembly of three-dimensional components and/or by the shaping of a three-dimensional mass. Specifically excluded are structures such as works of architecture.

The problem is that state legislators were shortsighted in drafting statutes protecting only traditional art forms. The federal Copyright Act was much more advanced in this regard. It protects all "works of authorship" fixed in a tangible medium even if the medium doesn't presently exist. For the visual arts, copyright protection extends to "pictorial, graphic, and sculptural" works, much broader categories than "paintings, drawings, and sculptures." For instance, the category "pictorial" includes paintings, drawings, mosaics, collages, and other works depicting shapes and figures in a two-dimensional form, even including photographs.

The reader might think this advice is only for artists. However, it is also important for collectors and dealers. Customs regulations in many jurisdictions

may still depend on whether a work falls into a traditional category. Investing in large numbers of non-qualifying works, for purposes of customs or otherwise, can have severe disadvantages.

Definitional problems can also play a role in artist/dealer relations. For instance, in many contracts an artist promises a dealer exclusivity with respect to a certain medium of expression. Then it becomes crucial to determine what is a painting and what is a sculpture. I even encountered a recent divorce case in which the spouse secured an interest in present or future "sculptures" created by the artist. For this latter purpose, should the term "sculpture" include models, structures, other architectural works, and wall reliefs?

There are many, many works that fall into the cracks. In my view, a pastel is more clearly a drawing than a painting. A mosaic may be a painting if the individual pieces are hand-painted. Murals, if "painted," are paintings, but I doubt whether any neon piece could be classified as either a painting or a sculpture.

The lesson to be learned is this: don't presume that all art you buy or sell will be treated alike; rather, presume they will be like "apples and oranges" and that traditional forms will enjoy more legal protection, for better or worse.

Final Word on
Works Made for Hire?
Peter H. Karlen, Attorney-at-Law

On June 5, 1989, in *Community for Creative Non-Violence* v. *Reid*, the U.S. Supreme Court decided, and defined, when a work is "made for hire" (so that its copyright is automatically owned by the employer). The question before the court was, when is a work "prepared by an employee within the scope of his or her employment" such that it is "made for hire"? The court had four tests from which to choose, each coming from different Circuit Courts of Appeals in the federal appellate system:

1. The hiring party retains the right to control the product.
2. The hiring party has actually wielded control with respect to the creation of a particular work.
3. The hired party is actually an "employee" within the meaning of common law agency rules.
4. The hired party is a formal, salaried employee.

The choice was number (3). Here is why.

The Present Law

Under present law, the actual creator of a work is usually its initial copyright owner. This creative person can only "lose" copyright ownership if s/he transfers the copyright (for which a written instrument is required) *or* if the work is created "for hire." It is advantageous for the hiring party to own the work outright as a "work made for hire" rather than take a transfer from the hired party. For example, when the work is considered "made for hire" the employer is not only the owner of the copyright but also the *author* of the work. This means that to register the work the employer need only indicate its own name and contribution to the work on the registration form. On the other hand, if the hiring party takes by transfer, the names of all the original authors and transferors along with the nature of their respective contributions must be listed. For collaborative works involving contributions by numerous co-authors, registering a work whose title is consolidated by written transfers from all the authors can be very troublesome and expensive.

Another disadvantage of taking title via transfer rather than as a work-made-for-hire is that the hired party may exercise a termination right (i.e., the right to terminate the transfer) beginning 35 years after the date of the initial transfer. Additionally, the right to renew the term of statutory protection for works protected under the 1909 Copyright Act can depend upon acquiring title as the author rather than merely as a transferee.

A disadvantage of acquiring title via the work-made-for-hire doctrine is that there are state laws that turn the hiring party into an "employer" responsible for paying certain taxes and employee benefits, whereas the hiring party as a "transferee" is not so responsible.

The policy of the law is to make employers the copyright owners of works created by employees. The reasons are obvious. The employer not only pays the employee to create the work but also usually supplies the materials, know-how, ideas, facilities, and support needed to create the work and therefore has "paid for" ownership.

Thus, Section 101(1) of the Copyright Act says that a work "prepared by an employee within the scope of his or her employment" is a work made for hire, and Section 201(a) says that the employer is not only the copyright owner but also the author.

However, the law goes further than merely protecting traditional employers. Hiring parties can also acquire *ownership* and *authorship* via the work-made-for-hire doctrine under the following three conditions: (1) the work is specially ordered or commissioned; (2) there is a *written* work-made-for-hire agreement; and (3) the work falls within nine categories, all within the publishing trade and entertainment industry, namely, a contribution to a collective work (e.g., a magazine issue), a part of a motion picture or other audiovisual work, a translation, a supplementary work, a compilation (e.g., a database), an instructional text, a test, answer material for a test, or an atlas. For these purposes, a supplementary work is a work that explains, introduces, illustrates, concludes, comments upon, or assists in the use of another work such as an index, foreword, appendix, or illustration.

Allowing "work-made-for-hire" treatment of works prepared by independent contractors resulted from a historic agreement between authors' organizations and user groups in the publishing trade and entertainment industry. Without the right to acquire ownership through the work-made-for-hire doctrine, as mentioned above, motion picture producers and publishers would be seriously inconvenienced by having to procure written transfers from all contributors and mention the names of all contributors on copyright registration forms. They would also be subjected to requests for termination of transfers by the numerous co-authors.

The Reid Case

By the time the *Reid* case reached the Supreme Court, there was a split of opinion among the various Circuit Courts of Appeal, especially resulting from employers' claims that a work was created for hire merely because the employer *controlled* or *supervised* the hired party's performance, even though the hired party may not have been a traditional employee. *Reid* was a classic case enabling the Supreme Court to end the division of authority. In *Reid*, the plaintiff, Community for Creative Non-Violence (CCNV), was a nonprofit organization dedicated to alleviating the plight of the homeless; the defendant, James Earl Reid, was a sculptor. CCNV commissioned Reid to create a sculpture depicting a nativity scene comprised of homeless people. CCNV and its founder, Mitch Snyder, gave Reid their ideas for the sculpture and throughout the project made suggestions as to the form and content of the sculpture. Reid was paid $15,000, although the

amount only covered costs—the artist donated his services. The artist used his own materials, workshop, and independent contractors to help him.

The Supreme Court held for Reid. Perhaps one of the principal reasons for doing so was that the legal standards proposed by CCNV (based on the right to control or actual control over the product) could be applied to either true employees or independent contractors, whereas Congress had clearly differentiated between independent contractors and true employees. The court didn't opt for the simple standard (choice (4) above) that the hired party be a formal, salaried employee. Rather, the court selected the common law agency rules regarding who is an employee. According to the court, the factors to be considered in determining whether a work is "made for hire" are:

1. The hiring party's right to control the manner and means by which the product is accomplished
2. The skill required
3. The source of the instrumentalities and tools
4. The location of the work
5. The duration of the relationship between the parties
6. Whether hiring party has the right to assign additional tasks to the hired party
7. The extent of the hired party's discretion over when and how long to work
8. The method of payment
9. The hired party's role in hiring and paying assistants
10. Whether the work is part of the regular business of the hiring party
11. Whether the hiring party is in business
12. The provision of employee benefits
13. The tax treatment of the hired party

What does this mean to writers and other artists?

Art Community's Concerns

Here is what all this means to artists, dealers, collectors, and other persons creating and commissioning works of art. If the person commissioning artwork has control over how the artist works, provides the equipment and office space to work in, establishes a continuing relationship with the artist, has the right to assign additional projects to the artist, specifies work hours, pays a regular

check, does not require the artist to hire his own assistants, commissions the work as part of a regular business, offers employee benefits, and otherwise sees that the artist is taxed as an employee, then almost certainly the artist has created a "work for hire."

However, if the artist is a highly skilled individual, using his own office facilities and equipment, working at home, helping the hiring party with only one project, having control over how long he will work, paying his own assistants, and being paid as an independent contractor responsible for his own benefits, then without a written work-made-for-hire agreement, the work is probably *not* "made for hire." There are no quick rules of thumb. All thirteen factors set out in the *Reid* case must be considered. Perhaps the only way to predict the status of the work is to have a written agreement.

There are also related concerns, not directly connected to "work made for hire" status, which come up when a work is commissioned. One such issue is joint copyright ownership. For example, in the *Reid* case, CCNV was successful in having the matter remanded to the trial court for a determination that CCNV was a joint author and co-owner of the copyright on the ground that CCNV's contributions to the sculpture (e.g., ideas, concepts, themes, etc.) may qualify it as a joint author. Any time the hiring party specifies the theme, subject matter, form, or content of a work, or suggests important changes, that party may become a joint author and co-owner of the copyright without even putting pen to paper or hands on clay. The artist as an independent contractor who wants to avoid this result must either ensure that the hiring party have a negligible role in creating the work, or must secure a written agreement whereby the hiring party waives its rights to claim joint authorship.

Another concern is ownership of the physical art object. One problem in *Reid* was that, when the sculpture was delivered to Reid for repairs, he refused to return it to CCNV. However, Reid was forced to return the sculpture. Here, the artist, even if the sole copyright owner, is not usually the owner of the art object as well, absent a statute to the contrary. After all, the hiring party has paid for the artwork and in most jurisdictions does not need a written instrument to transfer title to the art object. There are exceptions. Under California Civil Code Section 998, whenever exclusive or non-exclusive copyright rights are conveyed, ownership of the physical art object remains with the artist unless there is a contrary written instrument.

Finally, even if the artist owns the copyright because the work is not "made for hire," the hiring party has the right to use the work for all purposes explicitly or implicitly agreed upon when the work is first commissioned. Wherever an illustration is created for reproduction on posters, the hiring party has reproduction rights for posters even absent a written agreement. The problems always arise when the hiring party reproduces the work on greeting cards or in another related medium. To avoid this problem, the hired and hiring parties should have a written agreement delineating permitted uses.

Conclusion

Because artists often work at home or at their studios on a project-by-project basis, more artists will own copyrights in their works under rules enunciated in the *Reid* case. But *Reid* also shows hiring parties what their rights are as joint authors and as owners of physical artworks. Moreover, collectors, government agencies, and others commissioning artwork are not helpless. They usually have the bargaining power to secure written copyright transfers or written work-made-for-hire agreements to protect their interests.

The Visual Artists' Rights Act of 1990
Peter H. Karlen, Attorney-at-Law

For well over a decade, attempts were made in Congress to enact federal moral rights legislation giving artists rights to claim and disclaim credit and to protect the physical integrity of their works. These efforts finally succeeded on December 1, 1990, when President Bush signed legislation amending the copyright laws, entitled the Visual Artists' Rights Act of 1990 (the "Act") originally sponsored by Senator Kennedy in the Senate and Representatives Kastenmeier and Markey in the House.

The legislation, effective June 1, 1991, creates dramatic new changes in the law of moral rights not only for jurisdictions that never recognized these rights before, but also for those already having moral rights laws.

Subject Matter

In addition to traditional fine art such as original paintings, drawings, and sculptures, the Act also covers signed and numbered limited edition fine art

multiples for editions not exceeding 200, and original signed photographs produced for exhibition purposes only including photographs in signed and numbered limited editions not numbering over 200. Some jurisdictions, notably California, had not provided coverage for limited edition prints and sculpture castings, nor photographs.

Specifically excluded from coverage are: any poster, map, globe, chart, technical drawing, diagram, model, applied art, motion picture or other audiovisual work, book, magazine, newspaper, periodical, database, electronic information service, electronic publication, or similar publication.

Also not covered are "any merchandising item or advertising, promotional, descriptive, covering, or packaging material or container."

As you can see, publishers, advertisers, and ad agencies had their say before Congress in excluding commercial art.

Most importantly, works made "for hire" are excluded. Thus, when an artist creates a work within the scope of employment, i.e., as an employee, it won't be protected.

Finally, one trick. Works not subject to copyright protection don't get federal moral rights protection. The problem here is that works accidentally falling into the public domain under copyright laws (e.g., because of failure to use copyright notices before March 1, 1989, the effective date of the Berne Convention in the U.S.) arguably may not enjoy protection.

The inclusion of photographs is bound to bring artists' groups into the battlefront regarding moral rights. It could not have come at a better time, especially when the computerization of photographic media allows changes to be made in photographs stored on disk. The question, of course, arises: Does the alteration of an image via computer constitute a forbidden distortion if the original print or negative is not changed? The answer is usually no. The rights usually do not apply to reproductions, depictions, portrayals, or other uses of a work in connection with many ordinary commercial items, so that using altered artwork in an advertisement may not be a violation of the artist's rights under the Act.

Integrity Rights

Under a number of state statutes (e.g., New York and New Jersey), the artist does not have the right to prevent physical mutilation or destruction; rather, the artist can prevent the public display of a mutilated work in order to protect

his/her reputation. The new Act follows the California and Massachusetts precedents and gives the artist direct remedies for distortion, mutilation, modification, or destruction of the work. However, in case of distortion, mutilation, or modification, the artist must prove that the alteration was caused intentionally and would be "prejudicial to his or her honor or reputation." With destruction, the artist must prove that the work was of "recognized stature" following the California precedent which requires "recognized quality"; however, the conduct may be either intentional or grossly negligent.

The Act resolves some of the difficulties with earlier state legislation. For example, it says that modification of a work that is a result of the passage of time or the inherent nature of the materials is not actionable. Also, modification of a work that results from conservation efforts or public presentation (e.g., lighting or placement) is not actionable without a showing of gross negligence. Unfortunately for the artist, this rule may create difficulties if the owner or other user installs the work where it is likely to suffer injury or deterioration. Thus, if a sculpture meant to be displayed indoors is put outdoors and deteriorates over time, the artist may sometimes have no remedy.

Crediting Rights

Crediting rights under the Act generally mimic those under state laws. The artist is given the rights to claim authorship of a work s/he did create, and to disclaim credit for any work that s/he did not create. Additionally, the artist can disclaim credit for an altered work in the event that a distortion, mutilation, or modification of the work would be prejudicial to his/her honor or reputation.

Works in Buildings

Whenever a work is incorporated in or made part of a building so that removing it will cause its destruction, mutilation, distortion, or modification, as elsewhere defined in the Act, the artist's rights apply unless before the effective date of the Act the artist consented to the installation *or* after the effective date the owner of the building secures a written instrument signed by the artist consenting to the installation and reciting and acknowledging that removal of the work may subject it to destruction, mutilation, distortion, or modification.

For a work removable from a building without such a written instrument's existence, the rights apply unless the building's owner makes "diligent, good

faith" attempts to give notice to the artist of the impending removal or actually gives written notice and the artist fails to remove the work or pay for its removal within 90 days of giving the notice. To facilitate such notification of artists, the Act establishes a central recording system at the Copyright Office so that artists can record their identities and addresses.

I don't fully agree with the rules regarding works that cannot be removed without damage or destruction. Even though I am an arts attorney, not a "building owner's" attorney, in some cases it may be unfair to burden the building owner with securing a written consent from the artist for the installation that specifies that the work would suffer injury upon removal. Whenever the artist knows that the work is to be installed in a building, s/he should usually be aware of the consequences of removal. Moreover, the building owner who inadvertently fails to get a written consent may be prevented from renovating or demolishing a building that contains a work of art without facing a moral rights lawsuit.

Naturally, if the artist is unaware that the user of the work intends to install it in a building, then a consent to installation is fully justified.

Please remember that state laws on "non-removable" works are often the converse. The artist must usually secure a written reservation of moral rights from the building owner or otherwise lose the rights. In my opinion, this is the better rule for works that the artist knows are to be installed in buildings.

Transfer and Waiver

Because moral rights are generally considered "personal" rights, not "property" rights, the Act does not allow transfer—i.e., only the artist and the artist's heirs may exercise the rights, not an assignee. But the rights may be waived by a written instrument signed by the artist and specifically identifying the work and the uses of the work to which the waiver applies. Thus, general waiver language not specifying uses may not suffice, nor will an oral waiver have any effect.

Whenever there are two or more co-authors of the work, any such artist alone may effectively waive moral rights, a rule I strongly disagree with. In my opinion, only a unanimous waiver by all joint authors should be effective. After all, imagine a subsidiary co-author waiving rights and allowing a work to be destroyed against the wishes of the principal co-authors.

Enforcement and Remedies

Although these moral rights are embedded in federal copyright laws, the rules for registration and remedies are sometimes dissimilar to those that usually apply to copyrights. To bring a moral rights lawsuit under federal law, the artist need not first procure a copyright registration for the work as is usually required in a copyright case. Moreover, the artist who fails to secure an early registration (e.g., before the date of the violation) may still recover attorney's fees and statutory damages, which is not the rule for most copyright infringements.

Also, unlike copyright cases involving willful infringement, criminal remedies for willful violation of moral rights are not available.

By the way, because copyright rules sometimes apply, the "fair use" defense will be available to violators, e.g., those who alter the work for purposes of commentary, criticism, review, scholarship, or classroom teaching.

Preemption

The legislation specifically preempts all state laws granting rights equivalent to those mentioned in the new Act. This means that all state law artists' rights equivalent to the rights granted under the Act will have to be enforced only under the federal statutes. Naturally, pre-existing causes of action based upon violations occurring before the effective date of the Act will not be affected.

Therefore, the importance of legislation enacted in many states (e.g., California, New York, Massachusetts, Maine, New Jersey, Pennsylvania, New Mexico, Louisiana, Rhode Island, and Connecticut) is greatly reduced. Only a few peripheral rights under the state statutes will survive and be enforced by living artists via state law. One important role for state legislation is that it will provide *post mortem* protection. The Act creates rights that last only for the life of the artist, but the preemption clause makes it clear that there is no preemption of state statutes that regulate "activities violating legal or equitable rights which extend beyond the life of the author." Thus, the heirs will still have recourse under state statutes, which often allow them to enforce the rights for a limited term (e.g., 50 years after the artist's death), with one exception: For works created before the effective date of the Act and title to which has not been transferred before that effective date, the duration of the rights under the Act is the term of copyright protection, which is generally the life of the artist plus 50 years. Thus, because federal moral rights protection for these older works may

last 50 years beyond the artist's death, there is little room for state law *post mortem* protection.

The advantage of a uniform federal standard arising from preemption is to create a national body of law giving the artist the same rights throughout the United States. This makes sense because works of art pass through interstate commerce, and the artist should not have to depend upon the vagaries of local laws.

On the other hand, the virtues of experimentation at the state level will be mostly lost. There will be few incentives to make innovative changes in state laws when these rights are being enforced using federal copyright laws.

Conclusion

Effective in 1989, the United States became a party to the Berne Convention for the Protection of Literary and Artistic Works, an international system for providing copyright protection to owners of creative works. Article 6*bis* of the convention requires signatory nations to provide moral rights protection under their own laws, and although experts testified before Congress that U.S. law already provided similar protection for creative persons using doctrines arising from unfair competition, defamation, privacy, and other laws, nonetheless, failure to enact federal moral rights legislation gave the impression that the U.S. was not living up to the letter or spirit of the Berne Convention.

Having enacted national moral rights legislation, the United States can now take pride in being more of a full-fledged party to the convention. Such legislation establishes a certain measure of predictability both for artists and the users of their works; it also helps the U.S. trade position since foreign artists, dealers, and collectors can rely on U.S. national standards rather than subjecting themselves to the vagaries of state laws.

Although the legislation is certainly well drafted, it will probably take at least another decade of litigation and amendments to establish sound interpretations of the Act. After all, the Act as it presently stands leaves many issues to be decided. For example, we can anticipate litigation on the issues of joint ownership of moral rights, definition of "work of recognized stature," and "honor or reputation" of the artist.

Please note that the above is only an abbreviated analysis of the Act; the rules are actually much more complicated.

If you would like to receive a copy of the entire Act, send a self-addressed stamped envelope to Peter H. Karlen, A.P.L.C., 1205 Prospect St., Suite 400, La Jolla, CA 92037.

Censorship

Restrictions on Artistic Expression: Obscenity

Peter H. Karlen, Attorney-at-Law

The artist's right to freedom of speech is not only impaired by defamation laws and other laws that protect individuals, but also by laws that purportedly protect society's interests. In obscenity cases, however, it is not the private individual who brings the legal action, but the government agency, acting on behalf of the community at large.

Obscene statements and materials are not protected under the First and Fourteenth Amendments to the United States Constitution, which guarantee a certain degree of freedom of speech. The main reason why obscenity is not protectable "speech" is that it offends the community and at the same time does not further important social dialogue in the areas of science, art, literature, politics, and education.

Obscenity Standards

In *Miller* v. *California*, 413 U.S. 15 (1973), the United States Supreme Court, speaking through Chief Justice Burger, imposed three tests to determine if material or speech is obscene, especially for purposes of criminal action. The three questions that the court must ask are:

1. Does the material appeal to the prurient, i.e., unhealthy, interest in sex?
2. Is the material offensive according to contemporary (local) community standards?
3. Does the material have serious literary, scientific, artistic, or educational value?

As far as the first test is concerned, the prosecution must usually show that the work is "hard-core" pornography, perhaps amounting to "patently offensive representations or depictions of ultimate sexual acts, normal or perverted,

actual or simulated, or patently offensive representations or descriptions of masturbation, excretory functions, and lewd exhibition of the genitals."

For the second test, the prosecution must show that the work is "offensive" according to the standards of the local community, not necessarily according to "national" standards. If the local standard is more stringent, the artist or other creator of the work may be in trouble. The reason is that the creator of the work may never be sure about the morals of any particular local jurisdiction, and if the work is published or exhibited in many jurisdictions, it may be successfully defended in most such jurisdictions and yet cause its creator to be convicted in one or two jurisdictions that have stricter standards.

For artists, the last test is the most controversial. Even if the prosecution shows that the work is offensive, hard-core pornography, there is still no conviction without proof that the work lacks serious artistic value. But what is *serious artistic value*? A traditional work of art by an established artist, using an established format and medium and having a clear artistic purpose and some aesthetic value, will not usually be the cause of a criminal prosecution. On the other hand, a work by an unknown artist, created for or reproduced in a "sexploitation" publication, will be at risk.

Perhaps some examples will suffice to illustrate how the law usually works. Most nude photographs, paintings, sculptures, and drawings will not result in liability even if reproduced in calendars and similar commercial items unless the poses are extremely provocative. Furthermore, even the most offensive works—for example, offensive works of performance art—will not result in prosecutions if undertaken by established artists and presented to sophisticated audiences. However, offensive works aimed at minors or displayed to unrestricted audiences are more likely to attract the attention of prosecutors.

Types of Obscenity Laws

Obscenity cases arise under a multitude of federal, state, and local statutes and ordinances that regulate the performance, distribution, and display of works of the visual and performing arts. Thus, it may be a crime not only to display a copy of an obscene work, but also to sell it, send it through the mails, or otherwise transport it in interstate commerce. Of course, the creation of an obscene work is not necessarily illegal, and it is not usually a crime to keep an obscene work at home for one's own private viewing.

It is possible that the publication of an obscene work may simultaneously violate provisions of several state codes or may subject the violator to prosecution by federal, state, and local officials. The only comfort for the defendant is that each and every element of the prosecution's case must be established beyond a reasonable doubt, including the requirement that the work lacks serious artistic value.

Private Censorship

Government officials are not the only censors of obscene works; private institutions also censor. For instance, a museum or gallery may refuse to show a work that it deems offensive, notwithstanding a contract with the artist to display that artist's work. In such a case, there is not much that the artist can do to force the museum or gallery to show the work. In situations where there is a contract to display the work, the artist's only claim may be for damages for breach of contract. The reason why private institutions can get away with censorship is that First and Fourteenth Amendment rights of artists reach only to government agencies and not to private individuals.

If the artist's work is censored by a museum or other quasi-public entity, it is incumbent upon the artist to prove that the censor is really a public entity subject to controls imposed on governmental entities. The fact that the entity receives federal grants will not usually suffice, nor will a demonstration that the entity's board of directors is partly composed of ex-officio government employees. Something more is needed as an indication that the government staffs, finances, and controls the entity.

Fair Market Value
Peter H. Karlen, Attorney-at-Law

Every artist, dealer, and collector is faced with economic evaluations of works that they buy, sell, lose, or give away. There are many standards for valuation, including replacement value, wholesale price, retail price, liquidation value, auction value, cost price, and even sentimental value. For customs purposes there is transaction value, deductive value, and computed value. But the most frequently used standard is fair market value.

Fair market value is the standard for evaluating art in connection with estate and inheritance taxes; charitable donations; insurance claims and claims

against other parties in the wake of loss, destruction, or theft; pricing in the context of sale or exchange; gift taxes; and security interests. After all, fair market value is supposedly the price that a property will fetch in an open market, in an arms-length transaction.

The formal definition of fair market value is: "The price at which the property would change hands between a willing buyer and a willing seller, neither being under any compulsion to buy or sell, and both having reasonable knowledge of the relevant facts."

Determining Factors

There are many factors used to determine the fair market value of a work of art. The primary physical and temporal considerations include (1) identity of the artist, (2) date and period of creation, (3) physical condition, (4) quantum of restoration, (5) subject matter, (6) medium, (7) physical dimensions, (8) authenticity, (9) rarity, (10) artistic value, (11) aesthetic value, and (12) other factors peculiar to the physical creation and physical existence of the art object.

Because value is based upon a "market," the physical aspects of the work are then related to past and present market considerations such as (1) past sales prices for the same or similar works, (2) provenance, (3) offers to purchase, (4) prior appraisals, (5) state of the economy and market in general, (6) size and extent of local, national, and/or international markets for the type of work in question, and (7) changes in fashion and taste that affect demand for the work or works like it.

And, of course, there are legal considerations affecting value such as impediments and restrictions imposed by co-ownership, import and export laws, claims made by other persons relating to the art object, and the artist's rights in the work of art.

The physical and temporal considerations are easy to understand. Obviously, the more famous the artist and the better the condition of the work, the more valuable it will be. As far as medium of expression is concerned, oils tend to be more valuable than watercolors, and bronzes more valuable than terra-cottas. Also, larger works are usually more valuable than smaller ones, and indubitably authentic works are clearly more valuable than questionable ones.

Market considerations are also not difficult to understand. With provenance, we know that works formerly owned by famous collectors tend to be

more valuable. Moreover, since the present owner of the work is part of its provenance, his/her identity might also contribute to fair market value. For example, a work from the private collection of a famous artist may be much more valuable than a comparable work owned by someone else. Obviously, if prior appraisals or sales proceeds from the work were high, fair market value is probably high absent a decline for that particular type of work.

The legal considerations theoretically pose difficult problems, however. Undoubtedly, the market value of a work in the hands of someone whose title (ownership) is questionable may be reduced since it may be difficult for the owner to sell the work. However, try telling that to the IRS when evaluating the work for estate tax purposes. A work subject to conditions restricting its sale, perhaps because the work is jointly owned, may also have impaired market value. The same may be true of a work subject to restrictions on use because of artists' legal rights, such as moral rights arising from statute. Again, try arguing this point with the IRS. Also, a work that has its best market in a foreign country but which cannot legally be exported to or imported into that country may have a lower market value. All these legal considerations are difficult to evaluate monetarily.

Because of the multiple factors affecting fair market value, the appraisal process is not a simple one, especially for older works, or at least it is not a simple process if the appraiser is doing a proper job.

Following are some special valuation problems facing artists, dealers, collectors, and their appraisers.

Art-Related Material Such as Portfolios

A problem for artists is making a claim for loss or destruction of portfolios and other promotional materials. The problem is particularly acute because, for example, the portfolio by itself usually has no "market" value since it has no worth to anyone else. Moreover, reimbursement for replacement cost is not often a viable solution because the materials sometimes cannot be replaced.

The only valid assessment is based upon the peculiar value of the materials to the artist. Perhaps the only way of measuring the value of a portfolio is the extra income the portfolio would have generated for the artist over its useful life. Even this amount is virtually impossible to measure. Who can state which museum exhibitions and gallery shows the lost portfolio would have secured for the artist and how these shows and exhibitions would have benefited the artist?

Collectors and dealers have similar problems with documents and other materials relating to authorship and authenticity. For example, if certificates of authenticity letters written by the artist are lost or destroyed, how can the collector evaluate this property when making an insurance claim? Again, unless a letter or certificate of authenticity has an independent value, perhaps as a historical curiosity, there is no value other than that arising from its effect on the value of the work itself. If the work is not salable because an authenticity document has been lost, perhaps a claim would be justified for the full value of the work when subject to authentication.

Choice of Market

When most appraisers evaluate property, they do so as if the property were to be sold in their part of the country. After all, the appraiser is most familiar with prices where s/he lives. However, most trained appraisers know that the measuring stick is really the market in which the property would fetch the highest price. For example, if a work were salable for only $5,000 in Los Angeles but could sell for $15,000 in New York, then fair market value would be measured by New York prices. This approach is justified because the art market is truly an international market.

Of course, there should be reasonable constraints on this method of evaluation. If the property is immovable or otherwise not subject to transportation or sale in another market without unreasonable cost, then perhaps local market prices should apply.

Unidentified Objects

A tough challenge is to appraise an unidentified art object. An object may not be identifiable because its creator, date of creation, or other essential information is unknown. The problem is aggravated when the work has no prior sales history.

Here, the appraiser confronts the ultimate appraisal, namely, an assessment of aesthetic value.

Piece As Part of a Set

Special problems arise when a piece is part of a set, whether the owner owns the complete set or not. If a single piece is stolen or lost, the real injury to

the owner of the entire set is not measured merely by the independent value of the single piece. Rather, the owner's loss is the reduction in value of the entire set, if that amount is greater than the independent value of the single piece.

Moreover, sometimes the converse may be true. If the owner of a single piece makes a charitable donation to an organization that owns the rest of the set, perhaps the donation should be measured not by the independent value of the single piece, but rather by the increase in value of the recipient's entire set.

Conclusion

The fair market value of any property is its value in relation to all other properties in the world. A thing can have value only in relation to other things already having assigned values, all values ultimately stemming from things that have values as utilitarian objects.

To evaluate art within this framework, the appraiser must consider a very wide variety of factors, in fact such a wide variety that it almost boggles the mind.

Typically, most appraisers actually consider very few of the factors enumerated above and yet arrive at relatively accurate appraisals. They often get away with this because they can point to past sales prices for the same or similar items and disregard the other variables entirely. After all, certain basic considerations frequently overpower all the others.

Usually, however, when an appraiser uses only a few of the considerations I have mentioned, he is taking a shortcut, something he can get away with until he confronts a battery of IRS or insurance appraisers who won't forget to go through a long checklist of factors.

Express and Implied Licenses
Peter H. Karlen, Attorney-at-Law

One of the best ways creative persons make money is by licensing their works. The most common license is a copyright license whereby the artist lets someone exercise one or more of the artist's exclusive rights under the copyright. For example, the artist can permit someone else to reproduce, adapt, publicly distribute copies of, publicly perform, or publicly display the work.

Copyright licenses are either exclusive or non-exclusive. Exclusive licenses, which are not legally binding unless granted in writing, give the

licensee exclusive rights to exercise the rights. Not even the licensor, the artist, can exercise the licensed rights. Non-exclusive licenses, which may be granted orally, allow persons other than the licensor to exercise the rights.

A very important but sometimes ignored differentiation between licenses has to do with *express* and *implied* permissions.

An express license or permission is one where the grant itself is specifically mentioned either in writing or orally. For example, every time you have a formal agreement granting a license, this is an express license or permission, and even an informal letter agreement that mentions a grant of rights is an express license. When someone tells you orally that you can exercise certain rights under their copyright, you have an express license or permission.

An implied license, however, arises out of the circumstances of the transaction. For example, if a commercial artist were commissioned to create a logo for a restaurant sign but no further grant of rights was specifically mentioned, nonetheless, one could infer that the artist gave the restaurant the right to reproduce the logo at least in some advertising materials, such as materials showing the restaurant sign in the front of the building.

Artists and writers who contribute to collective works, such as magazines, implicitly grant various rights to the publisher. The Copyright Act itself even mentions a type of implied license when it says at Section 201(c):

> Copyright in each separate contribution to a collective work is distinct from copyright in the collective work as a whole, and vests initially in the author of the contribution. In the absence of an express transfer of the copyright or of any rights under it, the owner of copyright in the collective work is presumed to have acquired only the privilege of reproducing and distributing the contribution as part of that particular collective work, any revision of that collective work, and any later collective work in the same series.

We had a very interesting case involving implied permissions. Jackie Estes, a noted stained-glass artist living in the Bay area, had created a pattern book of stained-glass art designs. The pattern book was sold to the public with the obvious intention that the patterns could be reproduced by anyone who wanted to recreate them for their own home use. However, nothing in the book specifically granted a license or restricted the scope of any granted

license. Clearly there was an implied license to reproduce the work at home. However, the question was whether a large stained-glass manufacturer could mass-produce and commercially exploit the Estes patterns.

The stained-glass company that marketed these designs argued that the pattern book was meant to be copied by anyone. The issue was, did the circumstances of the transaction (i.e., the publication of a pattern book intended primarily for home reproduction) allow for a broader implied license?

Our contention was that they did not. We argued that, in the absence of an express license, any doubt as to the scope of an implied license should be resolved in favor of the artist. This is because, in the absence of an express license, the user presumably has infringed, and the burden of proof in establishing the defense of permission should be on the user. It is not up to the copyright owner to prove the absence of permission. After all, the burden of proof for most defenses in copyright cases is on the defendant/copyist.

This principle is important to remember in all licensing situations involving fine and commercial art. For example, if you paint someone's portrait or take a photo portrait, usually there is no implied license allowing the subject to reproduce the portrait for promotional purposes. For example, in one case we handled, a photographer took a portrait photo of the subject, and the subject let a nationally circulated magazine use that portrait on the cover for an issue. This was held to be a copyright infringement.

A commercial artist who creates artwork or a photograph for an advertisement does not necessarily implicitly permit use of the artwork for any other purpose. Also, an artist who grants rights to use his/her artwork in greeting cards does not necessarily implicitly license the right to reproduce the artwork in posters or other commercial items.

Conclusion

My advice is to avoid controversies about implied licenses by specifically delineating what is and is not permitted when you sell or license your artwork. Remember, silence could be construed as a "permission" rather than as a withholding of permission.

The Psychology of Creativity

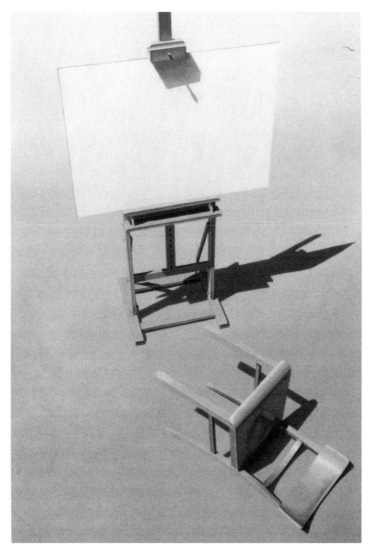

Drawing a Blank, 1992, Casein, 36"x24", Walker Moore, Coaldale, Colorado

Creative Insight

Apertures, Filters, and Fields
Bruce M. Holly, L.C.S.W.

Human beings come factory-equipped with five senses, a brain, and, some say, a soul. With these tools, we construct our personal understanding of the universe, and add our perceptions and experiences to the pool of history. When our tools wear out, we disappear except in memory and in the concrete work we leave behind.

In a way, our tools for perception are similar to the mechanisms of a camera—auto-driven, constantly clicking away. The workings of our minds as we make something of our perceptions correspond to the darkroom efforts of a tireless but sometimes confused photographer, unsure of his aims, working on frame after frame of ever-incoming film, recognizing on occasion the subjects being imaged, but often out of touch with their meanings. The images thus produced are so varied in composition, content, and quality that our life's creative work is similar to that of a photo editor, culling the exquisite from the mundane, deciding how to frame it, and where and when, and if, to publish it.

For each of us, life enters our awareness through sensory apertures that are amazingly similar from person to person. Yet each is subtly unique. Our senses admit the raw data of life, light, heat, and raw feeling to our minds, where images are apprehended, developed, and catalogued. In our individual catalogues, each of us has similar basic experiences, beginning before birth.

We see and feel the same sun rising and setting, and thus become accustomed to a similar daily rhythm. Rich and poor, we all learn to honor our bread. We all hear wind and the crash of thunder, and learn to become intrigued by storms or terrified of them. Our common experiences and basic similarity with each other allow for a common language in communicating about life.

Our individual sensory differences, however, color and tune each and every experience. Thus, in truth, no experience is the same for any two people. Even when we listen intently to the same drummer, we all march to different drumbeats. At the same time, however, if we choose to, we can march in step with each other.

As we grow, most of us add filters through which life must pass before we process it internally. These filters are usually unwittingly constructed and usually serve protective functions. Consciously, we believe that these filters, like the filters on a camera, serve to heighten our perceptions, increase contrasts, and ultimately clarify things.

Like all filters, however, they unavoidably diminish the potential power of that which they screen. Their usefulness is usually very specific, and our ability to consciously control their influence is often very limited. Some, like the ability to concentrate, allow us to focus in a world where in the quietest corner, a thousand things are always happening. Others, like racial prejudice, allow us to protect our personal inadequacies and misconceptions at the cost of human dignity.

To continue the analogy with photography, the fields of our experience are very influential. Like a camera, what we are exposed to is what we use to form our understanding of the world and to form the specific language with which we respond to it.

When one is born in a pulp-mill town in rural New Hampshire, one's images of the world begin with the vertical shadows of mountains and smokestacks, the pungent scent of wet wood pulp, and the feel of factory cinders in air-dried clothing. With no other experience, it is entirely possible to write a story, or paint a picture, or compose music that describes human passion, joy, pain, and sorrow which someone from driest, flattest Saudi Arabia could comprehend. However, it would be unlikely that the New Hampshireman in question could convincingly use images of the desert he has never seen or felt or smelled, but with which the Bedouin in his audience is intimately familiar. For the most part, we use best that which we know best. And we know life best by being exposed to it as directly as possible.

Further, our ability to take in the material in front of us varies, much like a camera with various lenses. With a wide-angle lens, one can include a great deal of a scene and its many aspects, and convey much about the context in which the image is found. With a telephoto lens, one can see into the distance clearly

and apprehend detail, at the expense of context. Similarly, many of us see the forest much more clearly than the trees, while others of us can exquisitely describe the intricate molding of the bark on a single tree's branch, unaware of the forest burning around it.

In a recent book that captures this variety of field and focus in human creativity (*Uncommon Genius*, Viking Press, 1990), Denise Shekerjian uses interviews with recipients of the MacArthur award, a no-strings financial grant given to outstanding people in a variety of fields, to explore the workings of creative minds.

Out of these talks with artists, playwrights, scientists, community organizers, and many others, several common themes emerged. As Shekerjian describes it, the creative among us commit themselves to using their talent, refining it as they go, sticking with it over a long haul. They accept risk in the pursuit of a personal vision, and learn to stay loose, often delaying resolution of problems until various possibilities and perspectives are explored. In general, they seem able to connect ideas in unusual ways, to see the linkages between disparate ideas, in much the same way as a creative photographer sees common scenes uniquely.

As individuals, these creative people tend to deliberately set up conditions that foster creativity in themselves. Some seek noise and bustle around them, others seek quiet. Some need the smell of ripe apples nearby, some need plenty of coffee. As a group, they are aware of, and prepared to deal with, the realities of the environment and times surrounding them. They do not necessarily take pictures typical of the culture around them, but they do work at learning how to get their work seen and published.

Above all, they value the doing of their talent above the preparing to do it. They clean and calibrate their tools, their apertures and lenses, as they go. They are aware of the filters they use and give thought to which are helpful and which need to be removed. They tend to work assiduously and deliberately at widening the fields of their experience through travel, study, and contemplation.

Shekerjian further notes that these folks tend to be pattern-seers and reframers of accepted perceptions. Many of them habitually twist and turn every idea and statement of accepted reality, like a photographer moving around a subject, until they can see things from new perspectives, before making any effort at closure. In discussing what seems to foster creativity in these individuals, it seems

we can define what limits it in others. We can also learn what happens in the interface between these folks.

The risks of creativity are intimately familiar to most of us. By definition doing new things means confronting ourselves, and those around us, with being unsettled, unresolved, and uncomfortable. At some point, we all struggle with a reflexive desire in ourselves and others to keep life familiar, to keep it understandable in light of what we already "know." Interestingly, the conflicts engendered by these pressures and constraints can make for strange bedfellows, and alternatively, place people with similar values about life at loggerheads as to the expression of their individual visions.

It seems useful at these junctures to remember that a variety of solutions are likely to exist for any human problem, if we keep ourselves open to their existence and to each other. Narrow apertures, heavy filters, and limited fields of view—when not used carefully and consciously—can make for meager, dark, and underexposed ideas, in photography and in life.

Choices
Bruce M. Holly, L.C.S.W.

We are born, we make choices, and then we die. We play with the cards we are dealt, but we largely choose how to play our hands, and what stakes we will play for. We decide whether we will play our cards straight, or whether we will bluff. We determine how we will see our fellow card players—as friends involved in the same game, or as opponents to be feared or defeated at all costs. And ultimately, we alone decide if we have won or lost the game.

The same holds for art and artists. At every turn, art is a process of making choices. We as artists are decision-makers by definition, choosing to create— that is, to do something new in the world, and to keep at it until we decide our work is done. And then we choose if, when, and how we share it with others.

What then are some of the aspects of choice?

Ambiguity is the hallmark of an "adult" problem. As we mature, choices tend to become more complicated and less clear-cut. We become more aware of subtleties, variables, and alternatives; we have more information, advice, and experience to draw from. But we can easily draw contradictory conclusions from this knowledge.

Moreover, alternatives often include their own opposites. We are exposed to these notions daily, from the crass to the sublime: "You have to spend money to make money," "Every cloud has a silver lining," "We make our own luck," "They gave their lives so others might live."

Most human choices involve "either/and," "either/or," or "all of these/and," or "neither/none of these" situations. Absolutes are very hard to come by, and emerge only out of acts of faith.

As we grow, the decisions we make usually have increasingly important, often far-reaching consequences. These decisions often involve others, and usually involve pain as often as they involve gain.

And, because life is fluid, far fewer choices are final than we believe at the time. Failure, like success, is fleeting. So too are the decisions we make that lead us to failure or success. We can, we do, we must change our decisions as life goes on. Even the most rigid and stubborn among us do so because nothing in our existence stays the same from minute to minute.

Do these notions apply to art and the creative process?

Human experience is a multi-level affair. So with art. Choices never have one level. Our experience is made complex because of our conscious and unconscious natures and because of our ability to think—that is, to step out of ourselves and contemplate our condition. We do this at every turn, in every second of our existence. What for an animal is a straightforward decision, e.g., "Do I eat this?" is for us, inexorably, a moment of moral significance in each and every instance—and, in the end, this is the central difference between Jackson Pollock and an ape.

Consider the clichéd notion of art as a metaphor for human life. It is a cliché precisely because it is so valid. Art is the result of a decision-making process that yields creative action. Art is a fluid entity, with boundaries and parameters that change through time, yet it is an entity which also transcends time. And finally, art is fraught with ambiguity, many levels of meaning, and risk.

Consider the characteristics of artistic choice. The immature artist acts as if choice were simple—an illusion brought on by ignorance and lack of experience, to be sure, but useful in allowing action to take place—and creates expressive but crude and limited work. We expect no more from the neophyte, and are awed by the occasional youngster whose work is technically or expressively beyond expectation.

With experience and growing maturity, the committed artist evolves a personal style, language, and expressive facility. This in turn yields a body of work that is evocative and informed by the artist's ability to deal with the ambiguity, subtlety, and limitations of his subjects, materials, and processes. His choices are no longer perceived as simple, whether they are made in an intuitive, impulsive style, or in a more deliberate, thoughtful, perhaps "scientific" manner. Complexity and ambiguity, and the artist's unique treatment of their existence, become an essential part of every artwork's impact.

What personal characteristics influence our artistic choices? There are many. For instance, some of us are "right brain" people: intuitive, illogical, impulsive. Our decisions are made often without our being fully conscious of the process we use to make them, and we are hard-pressed to describe the variables we consider in making them. On the other hand, some of us are "left brain" thinkers, deliberative, and demanding of ourselves that each choice be based on consciously considered, pragmatically evaluated, and solidly logical reasons. While one type is more likely to be an "action" painter, the other may more easily embrace pointillism. One artist will plow into thick impastos of images and textures that document changing thoughts and feelings of fleeting moments caught on the run; another consults color studies and tries color combinations on scraps before committing to a new hue in a pointillist painting that is years in the making.

Further, there are those of us who tend to see life as a glass that is half-empty, and who characteristically feel on guard against potential threat. Our art will likely express this stance in many ways: in subject matter, indirectness of expression, and mood. On the other hand, those of us who optimistically see the glass half-full, and function as if the world were a safe, warm, and friendly place to live, will similarly demonstrate this frame of mind in our artistic choices. There are many exceptions here, however. A depressed artist may paint bright bowls of flowers in an attempt to transcend his black mood, and a well-adjusted, materially secure artist may create pictures of surpassing anguish and horror, perhaps out of a need to identify with other less fortunate humans, perhaps out of a sense of relief at feeling different, or perhaps out of unconscious personal pain.

Some people are inclined, given a choice, to explore the rare, the new, the frontiers of experience. Others prefer to study the known and familiar objects of

everyday life from unique personal perspectives. Some of us prefer to declare our visions, others are more comfortable suggesting them. Taking the offensive comes easily to some, while others prefer to defend.

Within a wide range, these characteristics define our unique approaches to living, and give us as individuals the eccentricity that makes life interesting. At their extremes, however, these "styles" of living and the choices they engender can be pathological, in that they hamper people's lives severely. In psychiatric terms, these are people with personality disorders, who are paranoid, avoidant, hysterical, obsessive-compulsive, narcissistic, and so on. For these folks, readjustment often includes intensive therapy and self-exploration over a long period.

In art, similarly, our styles of aesthetic decision-making can serve us well in defining our uniqueness, so long as we can be productive. It is when we find ourselves restricted or unable to move artistically over a long term that we need to consider the fundamental changes that may be necessary in order to return to productivity. It is here that the commitment to art and the commitment to life often overlap significantly, for change is not easy in this area.

For some of us, the risk of choosing and failing in life and in art is a loss of self-esteem that outweighs the potential satisfaction of success so completely that we are locked into immobility by fear. It is this that causes creative death far more frequently than heart disease. There is a quiet courage demanded of all of us with each breath we take. In art, this courage is manifested each time we choose to move toward a new creation.

To be artists, we must decide to accept ourselves as we are at the moment, with faith that we can confront the problem at hand, and that we can repeat the confrontation over and over again until we have reached a creative end. What helps is being able to give ourselves permission to try, and permission to have accidents, and permission to build on the work of others.

In the end, it is our full relationship with ourselves and others in the world, and what we choose to use of it, that is our real palette.

Foundations

Bruce M. Holly, L.C.S.W.

Humans are relatively inefficient organisms. On average, we use a minuscule amount of our potential. Yet each of us is so outrageously potent that, given one

day of maximum output from every member of the human race, the possibilities are almost unimaginable.

The "I" in each of us is the result of genetics, luck, and learning. We pass the world through filters of cognition, emotion, memory, and mood which are custom-built into our psyches from the minute of our conception, and tuned for the moment at hand until the hour of our death.

Each time we allow ourselves to respond to the world we are engaged in a creative process. As unique as snowflakes, we perceive and interpret reality in a highly idiosyncratic manner. Creativity occurs when we report these perceptions and interpretations to ourselves or to other human beings.

In a sense, creativity is simply life being communicated. Every conversation, scribble, and movement is a new creation in the universe, heretofore unseen and unheard throughout the ages.

There is another level of creativity accessed by some but not all—the realm of art and creative science. The price of entry: becoming as open (and thus vulnerable) as possible to the fullness of our experience, and being willing to describe it to others, as honestly and originally as possible.

Even in art, this natural law applies: we cannot create something from nothing. The unique reality each individual perceives is rare earth to be built upon and tunnelled in search of new forms. In addition, we stand on our ancestors' shoulders. We exist today atop an ever-growing mountain of our forebears' experiences, of their un-enacted ideas, concepts waiting to be connected, and visions waiting to be described.

Ultimately, we have only two choices: we can either sit atop the heaving mass and passively watch it grow, or we can reach in, grab the clay closest at hand, and expand the universe with our own creative work.

There are two deep, rich mines in this mountain of raw material: our conscious and unconscious experience as individuals and as a race. Moreover, the boundary ground between the two mines constantly shifts, and is far from barren itself. Artists and scientists play with the boundaries here, and dare enter the pits. We learn that the interfaces are where the action is. It is how we see colors that don't exist yet. And hear music that doesn't fit on any staff yet.

Consciousness, according to Freud, is our "instrument of psychic exploration." Our awareness provides us with access to the details of life itself, the patterns and interrelationships that ultimately form the tight weave of the universe.

Our conscious imaginations serve as time machines at our immediate beck and call, and the past and future become our present. The minds of the weakest among us are still powerful enough to reach the end of the universe and return, within the beat of a heart. Any of us can select, arrange, visualize, and recon-strue whole scenes in the time it takes to put the dot on an "i." The artists among us distinguish themselves by using this power to guide the action that follows thought, and the true limits are in our tools for action rather than our ability to imagine.

Consciousness provides us with the means to control our tools and shape our perceptions, to orient, prioritize, and select what we decide to enact. We can pick our pleasure for the moment, and tighten our focus on goals at the horizons of human experience.

What then of the unconscious realm? Does it even exist? What can it hold for us?

In simple fact, we are unconscious of the larger part of our human experience. In any given moment we attend, we can *only* attend to a small part of the universe that affects us. We can alter our conscious awareness, we can shift it and focus it, we can do almost anything but attend to *everything* that is going on. As an example, consider: when you concentrate on an itch at the end of your nose, you may be unaware of the beat of your heart and the rise and fall of your chest, and that the draft in the room continues to chill you, and the radio continues to play, and so on. But do these experiences not continue?

Our unconscious functioning is constantly nourished by information we don't realize we have, and operates free of the constraints of logic, criticism, and conscience that guide our conscious thought. Intuition, dreams, "aimless" action—these are pathways to our unconscious life. By allowing our conscious focus to relax, we can enter this tacit dimension of knowledge, described by Michael Polany, where ideas are "born of the imagination seeking discovery," where sentience itself emerges as a source of unreasoned truth. Here, opposites marry without censure and the full raw power of our feelings and fantasies marshals itself for expression.

Artists have been described by researchers as possessing thin, permeable psychological boundaries between their selves and the world about them. In fact, what makes artists unique among the race is their acute vulnerability to the awe of the world, *and* their ability to act in response to it. That creative work is

produced by these individuals is a testament to the courage and focus required to be productive rather than frozen in the face of intense physical, mental, and emotional stimulation.

When I was a kid, I remember thinking that every thought I could possibly have had probably already been thought by someone else. How could *I* be creative? How could I be an artist?

Recently, I heard a friend explaining why he didn't concern himself much about others taking "his" ideas and using them. He had determined that, even armed with good ideas, very few people ever *enacted* them.

Somewhere in the world today there breathes a person capable of creating the equivalent of fire, given some time and perhaps a cup of tea. Will this person act upon his/her thoughts? Will s/he press and mold his/her new visions into concrete reality?

Seen from afar, we must all look very similar. Shades of difference fade with distance, and the only thing that can be distinguished is who moves and who doesn't.

The artists among us are the movers.

Creative Block

Creative Blocks
Bruce M. Holly, L.C.S.W.

Creative blocks—writer's blocks, artist's blocks, conceptual blocks—in general the failure to do any kind of creative work when we consciously want to and are equipped to do so—how do they happen? What can be done to reduce or eliminate them?

Most of us procrastinate at some point in our daily lives. We put off doing things we find unpleasant, tedious, or fearsome. Sometimes, we put off actions when we are irritated or dissatisfied with a person who would benefit from what we do. And sometimes we are confused about what to do; as we become aware of this confusion, our anxiety builds until it seems overwhelming, and rather than take action to clarify the situation, we avoid it completely. In another type of procrastination, we sometimes avoid doing pleasurable activities. Who has not put off doing something fun in order to prolong the anticipation? Moreover, the tension of not quite knowing what will happen is often seductively pleasurable in its own right.

Similar forces operate for artists engaged in creative activity. Many of us go through periods of inactivity when, if we feel confident, we merely say we are fallow, allowing ourselves to rest before moving on to new work. Temporary resistance to action can often be a useful experience and sometimes serves as a conscious or unconscious means of protecting ourselves from action we are not ready to take. The very notion of being "blocked" as an artist can be reassuring, as only people with the capacity for creativity are able to feel blocked.

However, when we are less sure of our resources, we often call ourselves "blocked" to describe feeling thwarted by an imaginary wall that separates us from the ideas, processes, and products we desperately want to engage in and create. At worst, it feels like we are literally cut off from the very activities that

define our identities as artists—blind to ideas, deaf to the music waiting to be created, and mute when we *want* to sing.

Images abound for the experience of being blocked: the "blank canvas," the "white page," the wall-like immobility of the eternal second before doing. Creative blocks have been the stuff of legend in the art community since art began. Art is a solution to humanity's need for beauty, and the first purposeful chip of a stone beyond that called for by utility freed us all from the original creative block. As with sin, however, blockage of creative expression has manifested itself in various forms, unique to each individual sufferer, down through the ages.

Some artists speak of blocks that arise from fear—of failure, of success, of being criticized, and so on. There is a parallel between artistic blocks related to these fears, and the phobias that inhibit people in other areas of life. Fears and phobias often arise and can be understood as rational responses to commonplace events that make us feel threatened, rejected, or abandoned in some fashion. For artists, negative criticism, skeptical or inattentive audiences, and lack of personal focus and understanding are potent sources of anxiety. When fears become phobias, and fearful self-doubt becomes a barrier to art, however, we are dealing with irrational intrusions and limits on functioning, which often become sources of further anxiety in themselves, feeding a cycle of fear and avoidance.

For very few people, however, is a creative block a life-or-death matter, a means of protecting oneself from a self-destructive process that makes creative use of extraordinary sensitivity, and in so doing consumes the identity of the doer. For these few, the failure of art is protective, for madness happens when there are no defenses, when the dancer and the dance are one, and no more; when the author is his story, and no more; when the painter and his image have no surrounding frame, and the actor acts alone.

Others speak of blocks as arising because of the absence of structure. In unbounded situations, with a myriad of potential choices, we can often feel overwhelmed by our freedom. As in the dreams people have of being alone in the midst of a wide open plain, going in any direction is possible, but the first step seems so hard to take. We anticipate feeling, in the vastness, as if we haven't moved at all. Or we fear that by making a choice, we lose options which might be more valuable than the one we are taking. And so, we stand frozen.

Pursuing this image, what can often change things is to mindlessly force a first step, and then turn around and appreciate the single track we have made for its full impact on the situation. By making one step, we can learn concretely that we close off no potential alternatives, and in fact we define and give meaning to the entire environment by our action. We are no longer frozen points on an unchanging plane; we are pilgrims on a pathway.

The mark of a creative person is that he or she is willing to stay with anxiety and do something, anything, in response to an evolving situation. According to Rollo May, an artist and psychologist intimately concerned with creative processes, "The anxiety we feel is temporary restlessness, disorientation; it is the anxiety of nothingness . . . [the creative person] does not run away from non-being . . . but by encountering it and wrestling with non-being, he forces it to produce being. He knocks upon silence and meaninglessness until he can force it to mean."

Some describe blocks as an experience of emptiness of energy, ideas, the ability to employ discriminatory skills—a sense that the well, once full, is now dry, or sealed off. Engaging creatively in art takes a subtle form of courage, commitment, and energy. Fear, exhaustion, sometimes anger and emotional confusion—many things can drain these elements, at least temporarily. The task becomes to take care of the drain, either by giving oneself permission to be fallow for a while, taking a creative rest, or taking the initial action of taking care of oneself by whatever way works: acts of faith, self-discovery, therapy, changes of life—to allow the action, then to shift to the stroke that begins the painting, the word that starts the novel, the note that begins the new song.

In a nutshell, then, movement around or through a creative block is a matter of doing something, *anything*, and then solving the specific creative problems created by that action, and so on and on to a conclusion. One can make this initial action possible by realizing that in every case, one can choose to do *some*thing. Thus, "I can't draw (write/sing/act/etc.)" is inaccurate: it is more truthful and more useful to realize that "I won't draw (write/sing/act/etc.)."

The most minute, and often sloppy, careless, and awkward action begins the process. There is no such thing as wasted time, effort, or material in art, if one continues to act long enough. And in the moment one acts, one becomes an artist, a pilgrim on a plane of unbounded possibility.

It is important to realize that creativity is an activity of the spirit entering unknown ground. Staying in familiar territory is the work of artisans. It is also

important to realize that as all people are unique, we all have creative potential, and if we act long enough on it, creativity then becomes unavoidable.

Inner Voices
Bruce M. Holly, L.C.S.W.

At times, I am clinically "social phobic." That is, I suffer from an exaggerated fear of being evaluated or judged by others, and an intense desire to avoid scrutiny. So why do I write and paint and lecture? All of these activities are at best challenging, and at worst, excruciating for me.

The obvious answer is the right one, for me: I want the rewards these activities bring me, and I'm willing to pay the price for them. But why is the price so high?

Most people tighten up a bit when they face situations where they expect others to evaluate their performance, even when there is no question that they are talented and competent. Most are able to tolerate the discomfort and perform in spite of it, and with time and experience the feeling diminishes. What's going on that allows this to happen?

Artists, probably more than most people, face the fear of being scrutinized and found wanting. We face it in many contexts: in our definitions of ourselves as artists; in what we show of ourselves and our creative and technical competence in each work we turn out; in our efforts to have our work seen and understood; and our efforts to learn and expand our work. We draw, paint, write, dance, play music. We subject our work to the criticism of peers and critics. We mail off slides and carry portfolios around to galleries in hopes of acceptance. We give talks about our art. Some of us enjoy the interchange, and learn from it. Others of us cannot hear much of it: for some, praise falls on deaf ears, and for others criticism is ignored as irrelevant, even when it is warranted and could be useful. Many of us so fear the risks involved that we avoid these situations completely, hoping all the while for someone, an agent or benefactor who will see our talent and protect us from all the pain involved in looking for an appreciative audience.

Our images of ourselves develop over time, beginning early in our lives. At first, we are helpless and almost completely dependent on our mothers and fathers, or their stand-ins. If, during this period, we are fed with attention and care when we are hungry, we begin to learn that we can expect attention and

care as a given. If we are comforted when we are frightened, we learn that even fear can be dealt with. If we are encouraged and praised when we take our first steps in the world, we keep on walking, despite stumbles and bumps.

On the other hand, to the extent that no mother or father is perfect, we also learn that sometimes life is unpredictable, unfair, painful, and scary, and we won't always be rescued, or even supported in our struggles. Sometimes, we will even be blamed or criticized for having been inadequate or foolish. Sometimes we will be left to learn alone from our experience. And sadly, sometimes, some of us are abandoned at an early age to fend for ourselves emotionally, or targeted as the cause of our parents' problems. Overwhelming guilt is a painful but common legacy in many families.

As we grow, many people enter our lives in the posture of parents: teachers, friends, lovers, critics, bosses. We tend to try to make life understandable by making it familiar, so we tend to expect these folks to either act like the parents of our early experience, or we wishfully expect them to fill every deficiency and void in that experience. In either case, the present becomes shaped by the past. Sometimes, our wishes come true to some extent: our accumulated experience with people who accept and respond helpfully to us allows us to see ourselves as capable, lovable, and potent human beings, and we begin to act that way. Often, however, we are so attuned to what we have learned to expect, and so anxious or resigned to it, that our perceptions are distorted, and instead of having new experiences, we have old experiences repeated with different players. Margot Adler, a reporter with National Public Radio, recently said of a man she interviewed: "Like a survivor of an earthquake, he has learned to walk while trembling." Humans are resilient beings, from infancy. We can survive a lot. We require only adequate, not perfect, parenting in order to make our way in the world. We are all born innocent and lovable, and creatively potent. How much of that innocence, love, and potency survives into our adult lives is a function not only of the adequacy of our early experience, but of our own ability to understand that experience and modify its impact on ourselves.

An artist friend of mine refers to having "critical parents" inside her as she works or writes or speaks; they influence how she feels about herself, and at times seem to almost kill the joy she feels in being a creative person. Psychoanalysts have long described how we seem to internalize our parents'

images and directives at an early age, and how these internalized perceptions continue to guide and influence our thoughts and feelings throughout later life. More recently, persons recovering from alcohol and other substance abuse have often used a related metaphor of the "inner child" in each of us who continues to need and seek nurturing and attention in our adult lives as a result of our child-hood experiences.

It is as if we unconsciously retain our perspective as a small child in our adult lives. We respond to internal voices that make us feel good or bad, secure or shameful, competent or inept. The voices we "hear" can be helpful and energizing, or they can be resolutely critical, abusive, or fearful, chanting: "You can't, you shouldn't, you'll fail" at every opportunity. They can be conditional: "If you don't do things my way, whatever you do is bad." They can be pervasive: "You've always been clumsy in everything you do, and you'll always be that way."

Cognitive therapists such as Aaron Beck postulate that thoughts like these flash across our minds as we prepare to take action, and give rise to anxiety and irrational fear. As a result, we struggle harder than necessary, or we misread the reality around us, resulting in over- or under-reaction to it. Once we become aware of these distortions and misperceptions, however, we can correct them. In effect, we can change the "tapes" we listen to about ourselves, and free ourselves for new behavior.

How can you begin to help yourself? First of all, take inventory of the beliefs you have about yourself. For instance, you can do this by tuning in to the thoughts you have just before trying something new. Listen to whether you start off sentences about yourself with "I can't," "I shouldn't," "I don't."

Next, question each and every one of these beliefs as you become aware of them. Ask yourself: "What if I said the opposite about myself?" Then do so, and see what happens.

Finally, be very curious about where these beliefs and attitudes have come from. Trace them back to where, when, and from whom you first learned them. And when you have done so, realize that if an attitude or feeling you are studying diminishes you in any way, this in itself is a signal that it arose out of a mistake someone made rather than a useful observation, and you can now correct that mistake for yourself. It does not matter that you have lived with it for a long time because your mother or father made it when you were a child, or an inept

teacher did it in junior high school, or your friend did it yesterday. What matters is that you recognize it as a distorting, limiting factor in your life today. Now you have an opportunity to choose new perspectives to live by—a chance to be your own "nurturing parent."

Irony
Bruce M. Holly, L.C.S.W.

A friend of mine defines irony as paradox with a twist. Webster's *New Collegiate Dictionary* speaks of irony as the often humorous play of opposites, when what is said or done is the opposite of what is expected, or where the meaning of a message is the reverse of its content. Further, irony can refer to the "feigning of ignorance in argument." Socratic education is the paradigm of this type of irony. And finally, irony can connote the apparently straightforward, simple meaning of "[being] like, or containing iron."

This is a contest. Find the ironies embedded here:

At first the screen is white—blazingly, unrelievedly white. The camera pulls back, into focus, and moves up to a dead-flat horizon far in the distance, formed by a clear, blue sky above an immensely wide, snowy steppe.

Gliding slowly into the vastness, inches above the ground, the camera travels for a distance before detecting a slight, indistinct variation in the white-blue interface. Now the camera approaches the scene, a small hillock, where, in a patch warmed by the ascending sun and protected from the prevailing wind, a small group of bright red and purple flowers is shooting up through the melting snow.

With no hesitation the camera glides inexorably through the flowers at ground level. The screen becomes filled with flashing, violent colors, as if the viewer is plowing slowly through a thick jungle of giant flowers, effortlessly overcoming the resistance of taut stems and leaves and rich moist earth. The camera emerges at the top of the hillock, and the vast emptiness again stretches out in all directions. The camera moves on, unimpeded, unstopping. Fade focus. Fade to white . . .

It could be said that irony is almost unavoidable in human behavior and communication, especially in art. That is, we have to work at *not* being ironic, and in most instances, we will fail if we try. This is because the world in all its subtlety is fraught with ambiguity and ambivalence. Little is truly black or white; the gray areas by definition contain a little of both black and white. If art, at its most powerful, makes us aware of the meanings wrapped in every nuance of life, then awareness of the ironies involved is central to its success. We live thick with counterpart, counterpoint, contrast, and complementarity. When as artists we seek to communicate about life in any fashion, we must soon deal with the dualities of both the subject and process in which we are engaged.

Often, art is the act of becoming aware of these dualities and expressing them as directly as possible. Or we seek to add clarity to the central irony of our subjects. Or we use it as a symbol for other, similar ironies. In the visual arts, we use visual irony in the clash of color, texture, or composition as techniques to convey our awareness of complementary meanings. In music and drama, counterpoint and dissonance, unexpected volume, tempo and rhythm serve similar purposes.

In everything we do, there are cores of meaning, similar to the iron core of the world. We may not always discern them, but they are there. We seek a way to find these cores, and sometimes we employ devices that indirectly indicate their existence. Like magnetic compasses in the presence of iron, these devices—art, meditation, psychotherapy, moral philosophy, theology—often merely twitch erratically when they detect the presence of these core ideas, without revealing their nature and essence. But at least, and this is so significant, we know then they are there.

I am a member of a generation of people who when young behaved as if convinced we were immortal, while equally convinced we would never live to see ourselves middle-aged. And today, a new group is seemingly convinced that they will live on without aging at all. We care for our parents who lived, apparently, for the good life in retirement, only to find the aches, pains, and problems we are now learning to name: Alzheimer's, cancer, heart disease, and so on. The subtlety of life is the source for irony here, and for transcendence too.

Recently, I sat next to my son at a concert as we listened to Peter, Paul, and Mary sing "Puff, the Magic Dragon." I became aware of my son singing with them, and at that moment I began to weep. I was aware of many, many things: I

was alive, ecstatically alive. I was 41 years old. I had a wife and children. I was sitting next to a son, my son, whom I never imagined having for much of my life. At the same moment as I wept for happiness I was aware I was also crying with sorrow, in the spell of a song that speaks of dragons that "live forever, but not so little boys." And, moreover, as we sang, Puff the Magic Dragon became, in my memory, a dark converted cargo plane with banks of miniguns on either side, flying through the humid, moonlit night, capable of spraying swarms of bullets into every square foot of acres of Vietnam, through whatever and whoever lay there. A real, terrible dragon.

God has his little jokes, and as I lay on the grass at the concert, I tried to appreciate the one I had become aware of. Love and obscenity often look and sound the same. The meaning alone is different.

Art is in itself ironic. It is ironic that the gestures of any puny human could possibly carry such power across time. Art cannot ever be meaningless: inaccessible, yes; banal, yes; uncommitted, yes; poorly executed, yes. But even then, these qualities become meaningful in themselves, meanings we dislike and seek to improve upon, or to avoid, or to vilify, according to our own perceptions.

Art can be more than ironic; it can be transcendent. Witness the timeless grace of a cathedral rising amid ruins. Witness the drawings done by battered, starving people at the limits of life in the moral hell of concentration camps, drawings before which even their monstrous captors had to flinch. Witness the audacity of any portrayal of nature in art. It is inconceivable, but true, that art can at its best amplify our understanding of the vast majesty of life itself.

Art can also fail. Irony can become raw mockery. Connections can be so obscure they are impenetrable, idiosyncratic, and serve to close out rather than engage the audience. The connections and contrasts in a piece can be so clumsily handled, with so little respect for the subject, the material, or the audience involved that the work is obvious, mawkish, or sloppy. The work itself can be false, a kind of multiple irony or mockery of the process of art itself. A forgery has this quality. No matter the level of skill required to render the piece in question, the ultimate lie involved is that one human is trying to pass for another. Some forgeries are "successful," in that the lie is undetected and the piece is admired and associated for purposes of valuation and context with the particular author or artist who had nothing to do with the piece. The forger alone knows the true extent of his or her artifice. However, s/he can only be

known as a person who would hide, whose contempt of self or fear of failure outweighs their unique sense of place in the world. Their talent is in artifice, not art. While the pieces these people create often stand alone as well-executed works, they stand alone as perhaps the only true bastard children in the world, living under an unseen cloud. Once their illegitimacy is discovered, they are identified forever not by their merits, but by their corrupt birth.

Irony often implies humor. At times, a bitter humor, to be sure, but humor is what gets us through life without going crazy, especially if we strive to be aware of the contradictions and paradoxes contained in our everyday existence. In fact, humor is what allows us to attend to and cope with the bitterest realizations.

In the movie *Last Tango in Paris* there is a scene where a life preserver is thrown into the water . . . and sinks. Allow yourself to smile. It is what will allow you to examine your own life preserver without being overwhelmed.

The Observing Self
Bruce M. Holly, L.C.S.W.

Artists are active observers. We become aware of our experience of life, and in some fashion, we act on the awareness. Sometimes this means we pay attention to our interior feelings, and we paint, or dance, or act, in consonance with them. Sometimes, we become willing to confront, experience, and express our perceptions and interpretations of the universe around us. And sometimes we allow ourselves to see, or feel, or touch parts of ourselves and our world that we, and our fellows, would consciously rather avoid.

There is a raw, basic quality to life that lives with elemental intensity and power in each of us. Most of us spend much of our lives attempting to shape and buff this rawness into socially acceptable, personally comfortable dimensions. We must do this as a matter of course in order to make life tolerable. Otherwise, we would be constantly grappling with the razor-edge issues of reality, at every moment aware of the animal violence and pain surrounding us as we stand in apparently serene forest glades, unable to bathe happily in our occasional fountains of joy because of the next dry, sad season we so assuredly expect.

Of the many ways we employ to cope with this intensity, I think one of the most interesting is our ability to stand outside ourselves in our experience of life. Our ability as human beings to do so both protects us from being overwhelmed

by feelings, painful events, and catastrophe, and allows us to clarify the meaning of those events for ourselves. Moreover, the ability to do art is, I believe, a functional expression of this ability to experience, observe, and act as if from a detached perspective.

We have a varied vocabulary to describe this phenomenon. When a doctor is able to sew up a child's gash in spite of the child's cries, whimpers, and obvious pain, we speak of his "professional detachment." We are struck numb by grief when a loved one dies, yet are able to graciously handle the chores and social demands of a wake and funeral, though at times feeling "as if in a dream." We read of the "out-of-body" experiences of the dying. We talk of "getting a grip" on ourselves, "stepping back" from a situation to view it more clearly.

As in most things human, there is the potential for pathology in our ability to dissociate aspects of ourselves from the events at hand. To live constantly "as if in a dream" is unsettling, and past a certain point, brings many people into therapy. To feel like the events of one's daily life are not quite real is to experience a loss, which when continuous, is seriously disorienting. These conditions are referred to psychiatrically as depersonalization disorders when they are persistent and severe enough to cause discomfort and concern. Other related psychiatric conditions include psychogenic fugue, the abrupt leaving of one's home or work, forgetting one's past, and assumption of a new identity. Psychogenic amnesia, the loss of a portion of one's personal history, also occurs with some frequency. And most of us are familiar, from accounts such as *The Three Faces of Eve*, with multiple personality disorder, wherein a person develops several distinct and separate personalities, each with his or her own perceptions, behavior patterns, and attitudes.

For most of us, however, self-observation in the form of "stepping outside ourselves" is a consciously used tool in business, athletic performance, and in relationships. In psychotherapy, and especially in hypnosis, there are many times when a patient is asked to become aware of him/herself from a new perspective, or to lend aid to him/herself as if s/he were dealing with a separate person. Art and literature are replete with the work of people *in extremis*, using their talents in the service of gaining some personal detachment and giving meaning to their experiences. When a dying man makes a journal entry he becomes a chronicler of life, rather than simply a victim.

Sometimes, in often very interesting or significant ways, our ability to project our awareness and point of view outside ourselves manifests itself in *déjà*

vu types of experiences. We observe ourselves having an eerily familiar experience, and at times we cannot clearly perceive the chain of associations or memories that link immediate events to our past experience. In some cases, there is no discernible link. In others, the link immediately becomes obvious. One characteristic of these experiences seems to be that our sense of "observer status" in the immediate situation is heightened.

A personal example of this sensation of observer status: I used to be a paratrooper. The army unit I was with tended to jump in small units, often at night. One day, however, I climbed onto a plane with soldiers from another branch of the service. The plane approached our drop zone, and I jumped out, along with the others in our group. After a few seconds, my parachute opened with a jerk, and I looked around. Suddenly, the experience was transformed for me. It was as if I had a front row seat in a movie, rather than actually being suspended in a chute harness several hundred feet in the air. The bright sky was filled with hundreds of parachutists, from many airplanes. Almost immediately, I was aware that the scene around me was associated with photographs I'd seen as a child of mass parachute drops during World War II. I was filled with childlike awe, and felt like a spectator. At the same time, I was aware of my own sensations and feelings, and noticed that it took some effort on my part to accept the reality of my own participation in the drop.

Artists share this most human ability to observe a scene and to include themselves in the observation. Artists take the experience one step further: they act on it, and make it concrete and communicable to others.

Some artists are consciously self-observant, and their art is an expression of their self-perception of emotions, sensations, and thoughts. Self-portraiture is a good example of this form of self-observation, and common is the artist's using himself as a model on occasion.

Others literally include themselves in the scenes they depict, often as spectators: Michelangelo's self-image appears in the frescoes of the Sistine Chapel ceiling, present at the Creation. The French Impressionists painted themselves and each other into street scenes, often painting each other painting the Paris scene, and so on.

There is also another form of self-observation, the unconscious activity we call intuition. For some artists, the activity of art is in itself the art. The apparent spontaneity and immediate energy of some abstract art arises from the artist

intuitively, without conscious thought, or in some cases, in spite of it. In other cases, an artist makes an aesthetically pleasing piece without being able to consciously account for the piece's success. The artist is unaware of being anything other than a vehicle for the expression. Yet, in all of these cases, the basic, key factor is that the artist puts him/herself at the service of creative activity, in essence observing him/herself as "artist" at the critical juncture in history when the artwork in question could appear.

Art, then, can be seen as the tangible expression of human beings willing to observe in themselves the creative potential that exists in all humanity. We can use our ability to stand outside ourselves consciously as a tool for new perspectives, and we can use our ability to observe our interior motives as a means to put ourselves in the path, at the right time, of creativity waiting to happen. In either case we have an ability that distinguishes us from all other living beings.

Creative Energy

Sublimation
Bruce M. Holly, L.C.S.W.

Traditional psychoanalysis views art as a process of displacing the expression of primitive, direct, instinctual drives into forms that are more socially acceptable. This process is referred to as sublimation. Arguably a limited notion of the creative process, it is nonetheless useful to contemplate.

Sublimation is distinct from simple displacement of effort or attention. The former implies a significant alteration/expansion of focus and goals, and an intense encounter with some aspect of the artist's life. Displacement, on the other hand, has a more defensive function, in that it helps one avoid facing particular problems or issues.

In the half-light of human awareness, artists become facilitators. Images are brought from the threshold of consciousness—the field of not-yet-known possibilities—into perceptible forms. At times, these forms become sublime in their power to inspire deep feeling, even awe or exaltation.

Edith Kramer, an artist, author, and therapist, describes sublimation in art as a "largely unconscious transformation of feeling into form."

In Kramer's view, artists are faced with two general problems in their work. First is the search for engaging subject matter. Then there is the struggle to give it a form that expresses the tensions of the engagement—encompassing the private experience, or feeling, of the encounter—in a format accessible to others.

The artistic process is by nature pleasurable. Rollo May speaks of this intrinsic pleasure as joy in one's potential becoming actualized. But it is not always satisfying. Kramer points out that the pleasure of creative sublimation is often more lasting and "exquisite" than the pleasure in direct gratification of hunger, sexuality, aggression, and the like. Yet, she says, artistic pleasure cannot

be as intense, because one must renounce *complete* gratification of instincts in order to have energy available to create.

In Kramer's words, "artist and audience travel together in two directions, from the primitive source of the creative impulse toward its final form, and again from the contemplation of form to the depth of complex, contradictory, and primitive emotions."

This assertion has an existential connotation that is at the core of what art provides us as humans. In a paraphrase of poet Stanley Kunitz's words, the hard inescapable phenomenon to be faced is that we are living and dying at once. Our commitment is to report that dialogue. Simply put, we share this reality: we are all born to die.

This fact of life consciously or unconsciously organizes our every action and thought, throughout our lives. We have a basic instinct to *live*, over and above mere survival. Ultimately, it is this instinct that provides us with the core of our creative power, and, in a sense, with our central mission as artists.

In our will to live, we have the energy available to cope with mortality in the present, and the force to bridge to past and future generations. Art provides us with a means to convert our instinctive responses—our wishes, desires, and will to live—into products that live forever, beyond our own mortal ends.

In art, we transcend time.

Imagine a tree. Imagine looking through a lens, up through branches. Imagine these branches growing, splitting, splaying, in fast-motion.

A child is born. The child branches out, lean and supple. Have the sounds and soft words, the warm, wet piquancy of infancy left their marks on memory and personality? The harsh experiences? You bet.

Scroll forward a bit—the tears of adolescence frame eyes that behold a world, parts unsafe, parts unfair. He has all the accoutrements of growth—friends, enemies; stubbed fingers, accomplished hands; failing parents, growing siblings.

Through the rolling moaning fast-motion, images stick, some pinned firm to his memory, some hanging at the edge of consciousness, tenuous as eggs on a shaky table. Some—they have a half-glimpsed sheen that distracts the eye—are almost hidden by the darkness in the cracks of the mind into which they have fallen.

Are the images recorded? Yes. Replayed? Mercy, yes. He paints, drawing out tube-thick lines to mark the edges of the images.

But which way is the flow? His life, recorded beneath awareness, every branching way—is that the source?

He grows older. The body of work is mature, too. Many artworks; universal messages, in unique vessels. His work has had its changing tempos: long, airy pauses; misshaped passages; missed notes; tortured, awkward beats. And phrases of clarion beauty, clear as crystal, its moments hearkening to immortality.

Long after he dies, his paintings—his experiences made immortal—are like branches, intertwining with the searching limbs of other children of the world. They are seen by other sons and daughters, and they intertwine with their lives, their own private half-shaped visions.

Which way does life flow now? Core to branch and back to core—the gaps fill in. The universe expands.

The Trances of Infancy
Bruce M. Holly, L.C.S.W.

I am indebted to Richard Shane, a therapist in Boulder, Colorado, for the idea that one's personality is a trance. It's Halloween night as I write this, the one time of year when many of us give ourselves permission to alter these personality trances, at least for a little while. Nine-year-old penguins, goblins, and ghosts are vying for elbow room on our front porch with 45-year-old space aliens who are late for rounds at the hospital.

Halloween is an ironically creative event, coming as it does in the trailing weeks of harvest season and setting a macabre but festive tone for the advent of winter. Little kids and adults alike perform what for many of us is the most aesthetically creative act we will do all year, when we Design Our Costumes. We allow ourselves to take on alter egos, bring hidden parts of ourselves out for others to see, and take on the identities of Boogie Men we secretly still fear on other nights of the year.

But on Halloween, we own the night. Fake fear takes the place of real fear. We willingly surround ourselves with terrifying images, and march confidently from door to door throughout our neighborhoods knowing that we will be welcomed, even by folks we barely speak to the rest of the year.

What's going on?

We are all master hypnotists. We can convince ourselves of almost anything. Because we need to feel safe, we can convince ourselves that we are safe on even dreaded Halloween night, a pagan feast of demons and the dead. On calm, beautiful nights we can convince ourselves that by the next dawn, the world is doomed. We can convince ourselves of our omnipotence, and we can equally well convince ourselves of our utter impotence.

To ourselves, we are what we believe we are. We feel as we believe we feel. Witness in memory the children we all once were, feeling helpless and alone. Cowering in the dark, many of us were often sure beyond all doubt that our bedroom floors were covered with snakes, and beneath our beds, ogres lay in hungry wait. Our fears were real by any definition, even if the snakes and ogres were not.

Infancy and early childhood is a period where our main tool for understanding the world is fantasy. It is what defines our internal reality, and organizes but distorts our ability to accurately perceive the outside world. It is only much later in our development as human beings that external reality serves to effectively influence our internal perceptions.

The latest thinking and research on human development suggests that from our earliest glimmerings of sentience, even before our actual births, each of us is active in attempting to organize our world into a meaningful whole. As infants, we are not passive recipients, helpless and inert—we are, in the words of Samuel Slipp, a psychoanalytic author, "active, stimulus seeking, and creative" in our efforts to make sense of life.

We go through predictable stages in our early development. Initially, we learn to distinguish between ourselves and the outside world. That seemingly simple act in fact lays the foundation for our identities, and is accomplished within the first six months of our lives. Not all succeed, and some spend lives in the confusion and chaos of an unboundaried world of autism, where the self and all things seem to remain an amalgam of undifferentiated "star stuff."

Usually by our second birthdays, we learn to distinguish between ourselves and other persons, and then between others in terms of their relative "goodness" or "badness." Failure to accomplish these learning tasks leaves many of us perpetually vulnerable to primitive, utterly bottomless feelings of deprivation and helpless anger. The term "borderline" is a clinical designation for people suffering from arrest at this stage of infantile development, and evokes a haplessly accurate image of these unfortunate folks, living on the

bleak and dangerous borderline of life, chronically unhappy, raging helplessly at the emptiness they sense within.

The next general phase, which most of us pass through by our third birthdays, is the learning that individuals around us, as well as ourselves, can at times be both "good" and "bad." Even those we love and trust can fail us at times. And we ourselves can behave badly on occasion, while maintaining a sense of being cared for and valued by others. Those who get stuck here are unable to experience this sense of worth and approval from within, and narcissistically seek, far beyond normal needs, the constant approval and attention of others as their only means of simulating self-esteem.

With these learnings, and the myriad sensory and emotional experiences that accompany them, the foundations of our personalities are largely complete even before we acquire the ability to speak. Our conscious memories seldom predate our third year, yet the indications are that we largely form and solidify our notions of who we are by the time we reach our third or fourth birthday.

Hypnosis is a familiar process to each and every one of us. It boils down to gaining access to our internal resources by relaxing conscious control of our awareness. There are many names for this condition of access: trance, an altered state of consciousness, deep relaxation, half-sleep, daydreaming, reverie. Every time we become absorbed in something, whether it is a novel, a movie, a conversation, or a thought, we are in an altered state of consciousness. Driving a car is hypnotic. So is watching a fire. Many of us are clinically "in trance" at least as often, during an average day, as not.

What happens in these instances? As we let go of deliberate direction of our awareness, we become aware of our interior experiences, the sensations, feelings, perceptions, fantasies, and visions of ourselves that exist within our minds as a subtext to our every minute's conscious thought. By allowing ourselves to become aware of these experiences, we can gain the benefit of their wide range and depth. Whether we are guided into trance by a therapist's induction, or we self-induce it by simply relaxing and slipping into reverie, we gain access to a level of experience outside of consciousness, full of visual, kinesthetic, auditory, olfactory and gustatory sensations, and invested with the same level of informativeness, intelligence and native wisdom that we enjoy consciously.

The implications are momentous. We begin, probably before birth, to hypnotize ourselves into an understanding of the world and of who we are, based

on sensations that, when "consciously" organized, are at best fantastic distortions. Unconsciously, however, we are also gathering gut-level data that in years to come continues to exist, and is accessible through imagination and intuition to allow us to resourcefully modify our self-perceptions and re-create our own personalities. This in essence is the basis of hope in psychotherapy, and the basis of "truth" in creative experience.

The creative process is a kind of trance. And imagination is simply our interior experience of the possibilities of life itself. The work of the creative person is to provide permission for his or her imagination to emerge into concrete reality.

Unconsciously, from our first moments of existence, we are constantly monitoring our environment with every fiber of our being. None of the information we thus gain goes to waste. It remains with us, a resource of experience that provides the basis for what we may later call intuition or creative vision, to be applied to ourselves, and to our art.

Wandering Among Ideas
Bruce M. Holly, L.C.S.W.

When I set out to write this column, I had a fair idea of what I wanted to write about: ideas. What they are, where they come from, how they manifest themselves to us, and how we use them. It seemed a fine project until I tried to write things down. Almost immediately, I lost focus. I lost direction. I censored my ideas about ideas as too obvious or too fuzzy before I even completed my thoughts, much less committed them to paper.

And so, I cast about. I needed something specific to write about in the worst way.

Originally, I had thought of writing about some of the observations about children's art I had come across in an article by Ellen Winner, a psychologist with Project Zero at Harvard University. In the article, research is cited indicating that children even as young as two years of age are attempting to purposefully represent their experiences in their scribbles. Gesturally as well as pictorially, a child's drawings are, according to Winner, the "glimmerings of the idea that marks on a page can stand for things in the world."

Describing how children proceed developmentally in art, Dr. Winner cites a variety of research with various hypotheses about why children draw the way

they do—for instance, she notes that "artistic" children characteristically demonstrate more visual-memory skill than children who are not artistically productive. They remember more visual detail about their subjects, and put it into their drawings. According to Dr. Winner, "apparently, children with drawing talent simply cannot forget the patterns they see around them, just as musicians often report being unable to get melodies out of their minds."

Children, like adults, attempt to simplify and select elements in attempting to represent them—they do it freely, and with few limits, responding to their own interests in the subject matter. As they grow, they typically develop more investment in "realism" in their work, and are increasingly able to draw out the increased detail, perspective, and differentiation that characterizes most people's work at later developmental stages.

However, this growing investment in "getting things right" also exposes the developing artist to the risks of becoming enslaved to a particular "right" way to see and draw. While this stage opens the door to growing technical competence, for many young artists it is also the stage at which many abandon artistic activity as too hard, or internalize so many rules about what is correct or incorrect that their artwork loses life while gaining accuracy.

At the end of her article, Dr. Winner quotes Picasso's statement, "I used to draw like Raphael, but it has taken me a whole lifetime to learn to draw like children."

I couldn't seem to maintain interest in responding to the article. Much as I wanted to, much as I could see that it applied to a discussion about ideas, I couldn't stay with any thought long enough to write it down.

In a fit of absent-minded desperation, I picked up an English translation of psychologist Jean Piaget's *Play, Dreams, and Imitation in Childhood*. After a brief bout, Piaget's prose—dense, involuted, referential—won handily over my ability to concentrate. I was left, however, with a phrase: "the joy of being the cause." And a thought: in criticizing another psychologist's theory of what play is, Piaget reviews the notion that in children's play, "the pleasure of being the cause reminds us that it is we who are creating the illusion. This is why play is accompanied by a feeling of freedom and is the herald of art, which is the full flowering of this spontaneous creation." I stopped with the thought. It seemed to ring true for me.

There is a "joy in being the cause" of something's existence, whether it is a thought, an action, an artwork, or a person. It is as close to being as free and

God-like as we can humanly come. But for the joy to come, the work of causation has to begin.

Moreover, it can be a fragile joy, if we allow ourselves to be aware of the uncounted times others have thought, or done, or made things similar to our efforts. Some of us struggle with the illusion that there is nothing really new under the sun. At worst, we accept it as a truth. As a result, we discount and discard our own efforts as redundant, irrelevant, or insignificant.

What we also tend to discount is that we are only aware of the thoughts and actions of those people who choose to do something to communicate them. And they, in the vast scheme of things, are a minuscule minority of the population, made unique among their peers by their actions.

I wandered into town, and walked into a bookstore, for want of anything better to do. I was frustrated, out of sorts, and felt tied up tight. It's a feeling familiar to me when I go into art galleries too, on occasion. Sometimes, being exposed to the concrete reality of books, paintings, and sculpture that others have done stimulates me to unbind myself. Sometimes—less often, thank God—I'm intensified in my stuckness, and leave a gallery with an empty sense of banality about my own work and most everyone else's. There's a certain unpredictability about which effect will occur, and I often feel that going into these places is a bit of a dice roll.

On this occasion, I spent a lot of time in the cheap book section, the area where they sell books for a buck or so. People give their ideas a shot, and then they end up in disheveled stacks, cloaked in anonymity, victims of poor sales. I've bought a number of good books there. Sometimes I even get the message that these ideas count too.

I walked up and down each aisle, sometimes looking for a particular book or author as if for an old friend. I passed the Impressionists, into the food section, through the mysteries, into the children's area. I sneaked peeks into sexy books like a guilty kid, and wondered how many others had done so. I became aware again of a thought I'd had in different guises before: I was walking past and through a vast pile of accumulated knowledge that could be mine. All that was needed was for me to attend to it. That's what a bookstore is for me—a dream world of real knowledge.

Dreams are, according to Freud, the images of our fulfilled wishes—displaced, distorted, and disguised—the products of our minds unfettered by

limits of reality or conscience. At the heart of it, they can be seen as our efforts to recover the basic security and well-being of an ideal childhood.

Others, more recently, have looked at dreams as the sputterings and mis-firings of nerve endings and leftover sensory images that our brains, not fully out of gear even in sleep, attempt to organize.

In either case, our dreams are significant, as significant as the play and art of children, as significant as our half-unconscious meanderings through a life filled with patterns, messages, and meanings. Either as messages in themselves or as stimuli for us to form meanings, these experiences give us the potential for expression of ourselves, and for connection with our fellow humans.

John Rosenthal, a poet, recently noted: "You don't write poems when you live in Eden—you write poems when you've left and you can't find your way back." I know the feeling.

Dot & Charley (with artist posing), 1991, Basswood and mixed media,
78"x120"x48", Jack Dowd, Sarasota, Florida

About the Contributors

Carolyn Blakeslee, an oil painter, was the founder and editor-in-chief of *Art Calendar*. She lives on the Eastern Shore of Maryland's Chesapeake Bay and works in the pro-life movement.

Carolyn Fiene, of Lake Tahoe, Nevada, is a free-lance writer and artist. Besides showing regularly at craft and art fairs, Fiene collects art and has organized successful fairs herself.

Karen Gamow and her husband, David, own the Whispers from Nature Photography enterprise based in Nevada City, California. Their photographic work can be seen in gift shops and galleries nationwide.

Brenda Harris is a senior consultant with Administrative Arts in Orlando, Florida, an art advisory firm that works with architects, developers, designers, and corporate clients.

Bruce Holly, L.C.S.W., an *Art Calendar* contributing editor, is an artist and psychotherapist with more than twenty years of experience in addressing issues of creativity and human growth. Mr. Holly specializes in work with creative artists in a private practice in Great Falls, Virginia.

René Joseph, a painter who lives in Minneapolis, Minnesota, has shown around the country, and her work is in several university and private collections. She includes instructions and guidelines with her sold paintings to ensure their archival treatment.

Peter H. Karlen is a co-author of *The Artist's Friendly Legal Guide*. He practices art, literary, and entertainment law, including the law of copyrights, trademarks, and nonprofit organizations, in La Jolla, California.

Sharon Kennedy is a free-lance writer living in Laurel, Maryland. Her articles have appeared in *New Art Examiner, The Washington Times* and other publications. She also provides P.R. services to artists in suburban Maryland.

Caroll Michels is the author of *How to Survive and Prosper as an Artist*, published by Henry Holt and Company, Inc. She lives in New York City, where

she is a career development consultant to visual artists, performing artists, and writers.

Dorothy Roatz Myers lives in New York City and, besides being an artist, judges art exhibits nationwide. She is also a free-lance writer.

Harold Simon is a well-known photographer.

Drew Steis was the publisher of *Art Calendar.* He has worked as a consultant to three chairpersons of the National Endowment for the Arts, a UPI reporter and editor, and editor of a number of newsletters, magazines, and medical and other textbooks. He is currently the editor-at-large for *Art Calendar.*

Patricia Thompson is the artist whose brainchild was the Artists' Co-op gallery in Germantown, Tennessee. The gallery has been operating smoothly and successfully for more than seven years now.